500
POSES *for*
Photographing
Brides

A VISUAL SOURCEBOOK
FOR PROFESSIONAL
DIGITAL WEDDING
PHOTOGRAPHERS

Michelle Perkins

AMHERST MEDIA, INC. ■ BUFFALO, NY

Front cover photographs by Dawn Shields.
Back cover photograph by Regeti's Photography.

Published by:
Amherst Media, Inc.
P.O. Box 586
Buffalo, N.Y. 14226
Fax: 716-874-4508
www.AmherstMedia.com

Publisher: Craig Alesse
Assistant Editor: Barbara A. Lynch-Johnt
Editorial Assistance: Sally Jarzab, John S. Loder, Carey A. Maines

ISBN-13: 978-1-58428-272-3
Library of Congress Control Number: 2009903898

Printed in Korea.
10 9 8 7 6 5 4 3 2 1

Table of Contents

About This Book

Determining the best way to pose a subject—a way that is simultaneously flattering, appropriate, and visually appealing—can be one of the biggest challenges in designing a successful portrait. This is especially true when creating portraits of brides, where the photographer may be called on to create anything from a very traditional head-and-shoulders pose to a more adventurous full-length look straight out of the pages of a fashion magazine. Quite simply, the variations are almost limitless—as is the pressure to perform flawlessly throughout this once-in-a-lifetime event.

This collection is a visual sourcebook designed to address exactly that problem. Filled with images by some of the world's most accomplished wedding photographers, it provides a resource for professionals seeking inspiration for their own work. Stuck on what to do with a particular bride or unsure how to make use of a location? Flip through the sample portraits, pick something you like, then adapt it as needed to suit your tastes. Looking to spice up your work with some new poses? Find a sample that appeals to you and look for ways to implement it (or some element of it) with one of your brides.

For ease of use, the portraits are grouped according to how much of the subject is shown in the frame. Thus, the book begins with head-and-shoulders portraits. Next are waist-up portraits, featuring images that include the head and shoulders, arms and hands, and at least some of the subject's torso. Moving on to three-quarter-length portraits, the examples feature subjects shown from the head down to mid-thigh or mid-calf. The balance of the book features full-length images—the most complex portraits to pose because they include the entire body. Both the three-quarter- and full-length portraits are additionally subdivided into poses for standing subjects, seated subjects, and reclining subjects. As much as possible, images are also grouped thematically to demonstrate poses for photographing the bride with her bouquet, displaying her rings, showing the back of the dress, etc. In these subgroupings, it becomes particularly obvious how even subtle posing changes can completely transform an image—and how differently photographers can approach the creative process of posing.

It can be difficult to remain creative day after day, year after year, but sometimes all you need to break through a slump is a little spark. In this book, you'll find a plethora of images designed to provide just that.

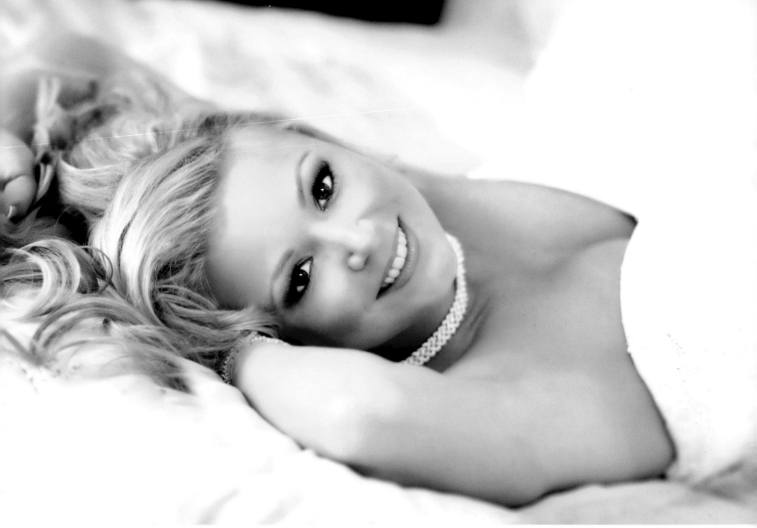

PLATE 1. PHOTOGRAPH BY TRACY DORR.

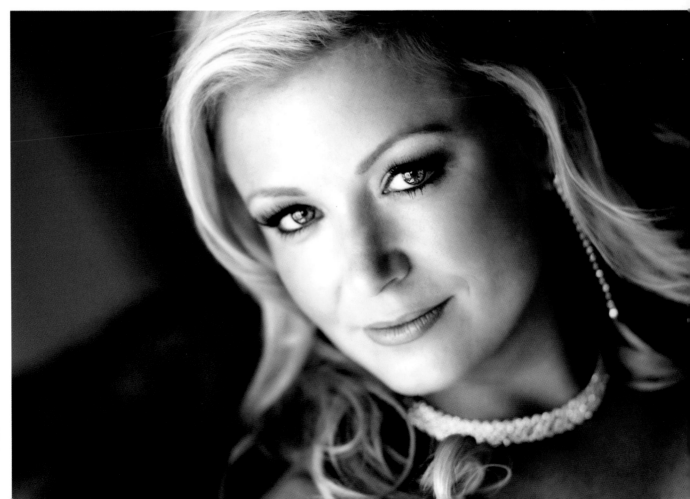

PLATE 2.
PHOTOGRAPH
BY TRACY DORR.

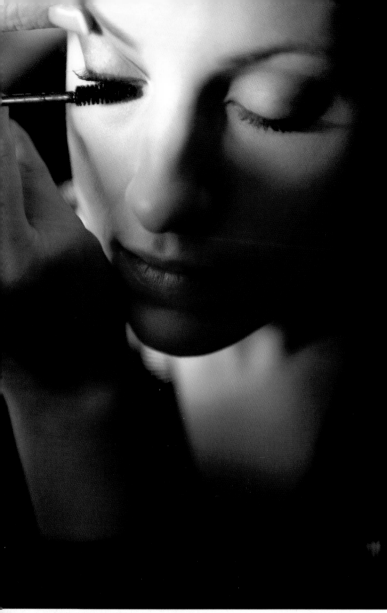

PLATE 3. PHOTOGRAPH BY DAVE AND QUIN CHEUNG.

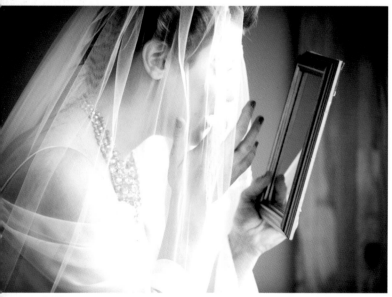

PLATE 4. PHOTOGRAPH BY KEVIN KUBOTA.

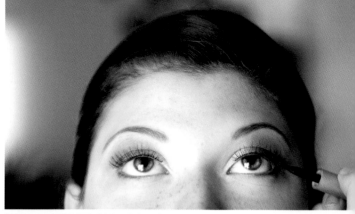

PLATE 5. PHOTOGRAPH BY DAVE AND QUIN CHEUNG.

PLATE 6. PHOTOGRAPH BY DAVE AND QUIN CHEUNG.

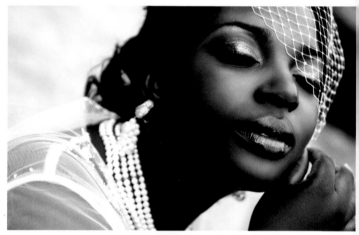

PLATE 7. PHOTOGRAPH BY DAVE AND QUIN CHEUNG.

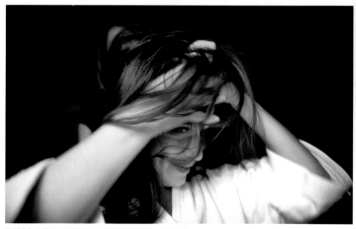

PLATE 8. PHOTOGRAPH BY DAVE AND QUIN CHEUNG.

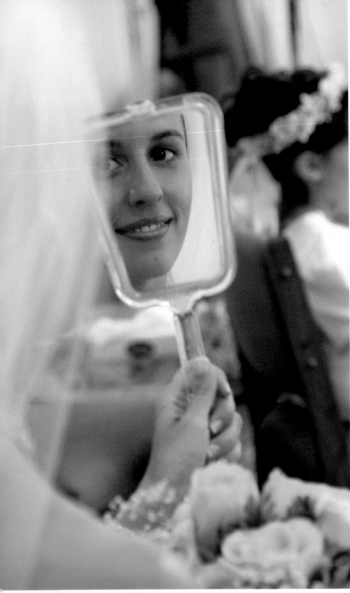

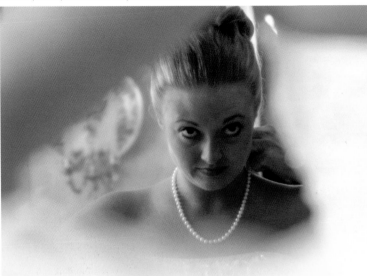

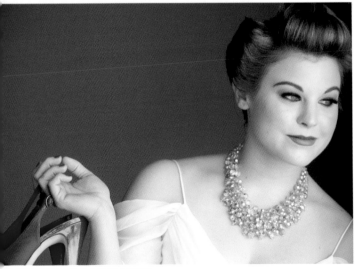

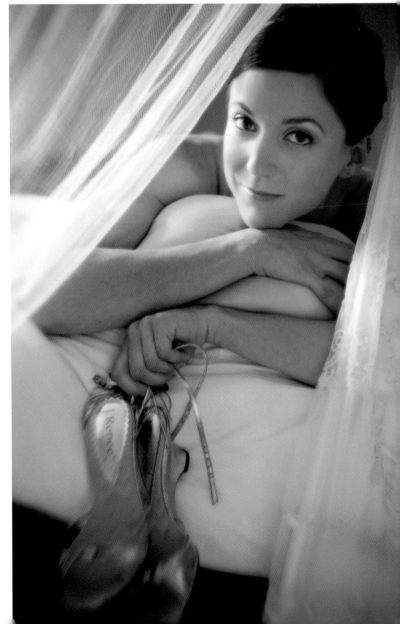

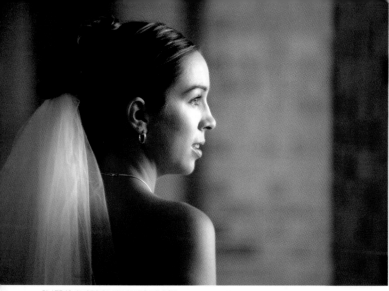

PLATE 13. PHOTOGRAPH BY DOUG BOX.

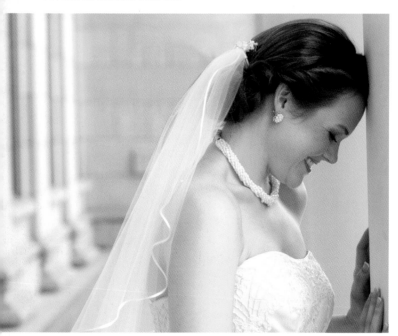

PLATE 14. PHOTOGRAPH BY MARK CHEN.

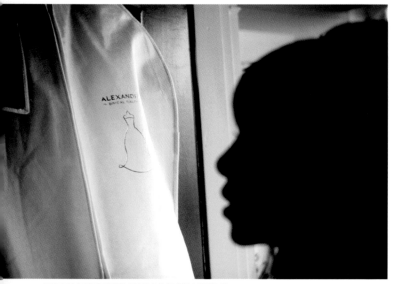

PLATE 15. PHOTOGRAPH BY DAVE AND QUIN CHEUNG.

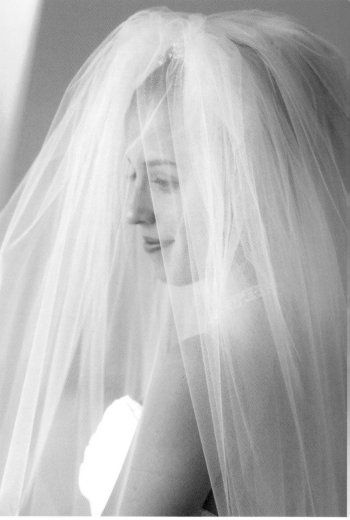

PLATE 16. PHOTOGRAPH BY JEFF AND KATHLEEN HAWKINS.

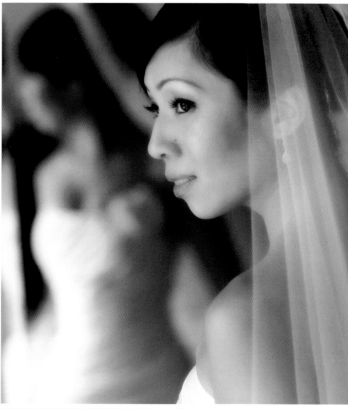

PLATE 17. PHOTOGRAPH BY JEFFREY AND JULIA WOODS.

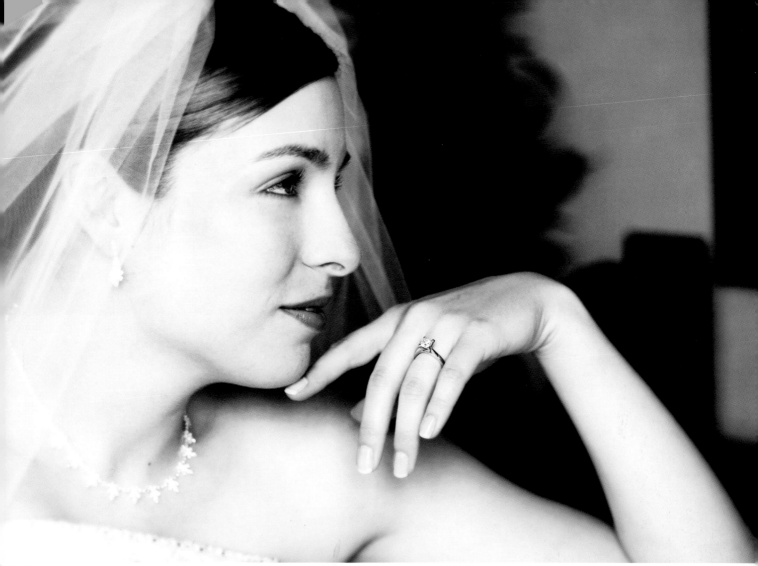

PLATE 18. PHOTOGRAPH BY TRACY DORR.

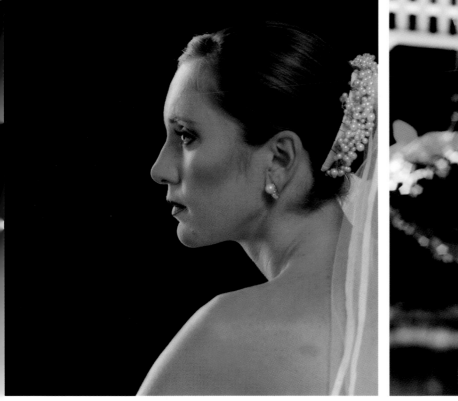

PLATE 19. PHOTOGRAPH BY RICK AND DEBORAH FERRO.

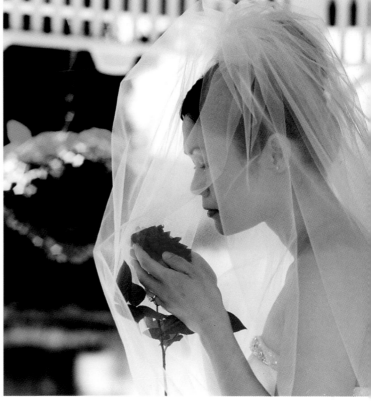

PLATE 20. PHOTOGRAPH BY RICK AND DEBORAH FERRO.

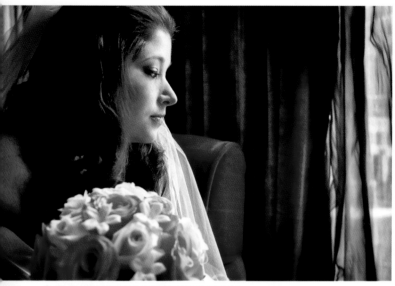

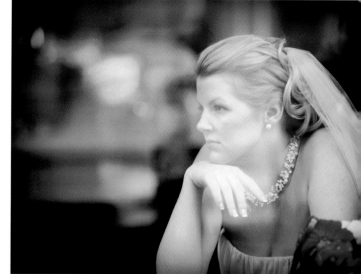

PLATE 21. PHOTOGRAPH BY JEFF AND KATHLEEN HAWKINS.

PLATE 22. PHOTOGRAPH BY REGETI'S PHOTOGRAPHY.

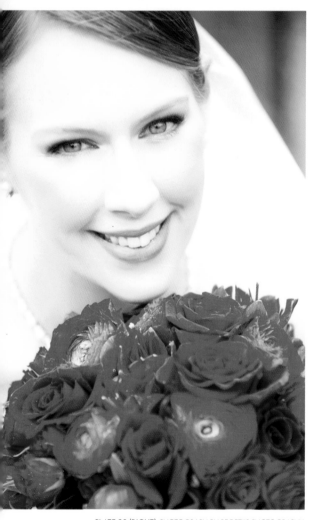

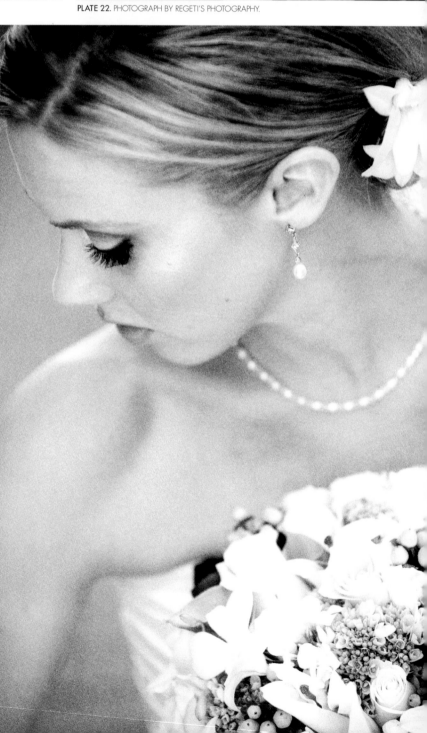

PLATE 23 (RIGHT). PHOTOGRAPH BY REGETI'S PHOTOGRAPHY.

PLATE 24 (ABOVE). PHOTOGRAPH BY REGETI'S PHOTOGRAPHY.

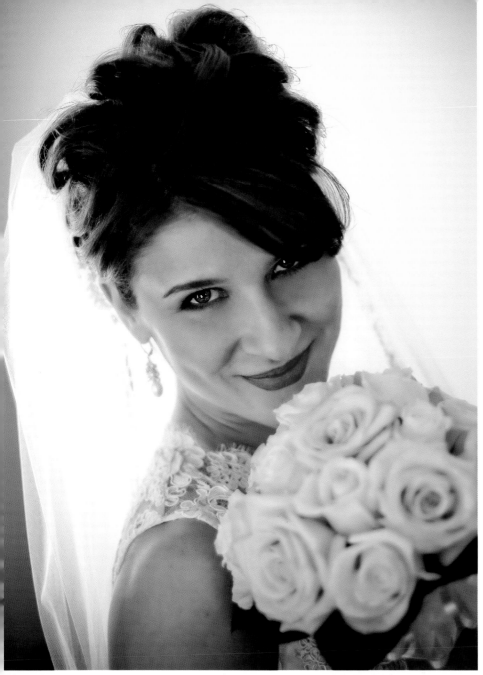

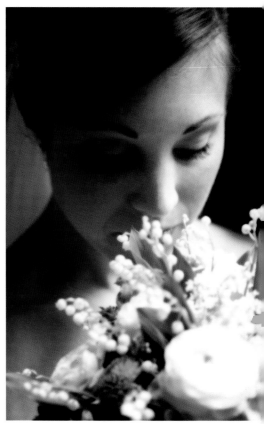

PLATE 25 (LEFT). PHOTOGRAPH BY TRACY DORR.

PLATE 26 (ABOVE). PHOTOGRAPH BY JEFF AND KATHLEEN HAWKINS.

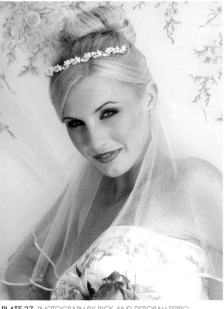

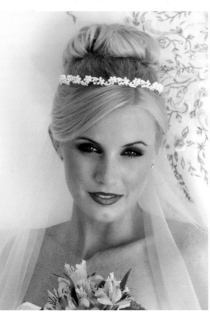

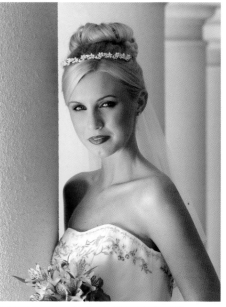

PLATE 27. PHOTOGRAPH BY RICK AND DEBORAH FERRO.

PLATE 28. PHOTOGRAPH BY RICK AND DEBORAH FERRO.

PLATE 29. PHOTOGRAPH BY RICK AND DEBORAH FERRO.

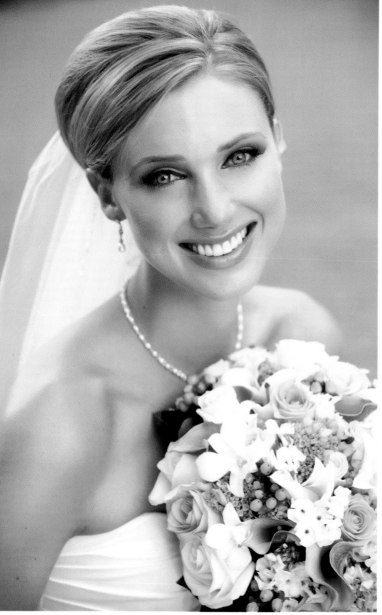

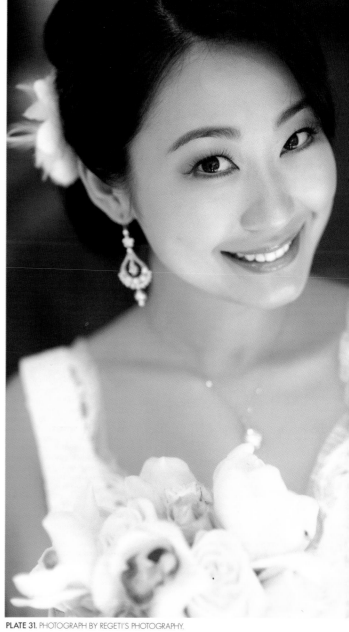

PLATE 30. PHOTOGRAPH BY REGETI'S PHOTOGRAPHY.

PLATE 31. PHOTOGRAPH BY REGETI'S PHOTOGRAPHY.

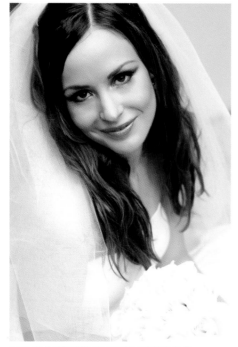

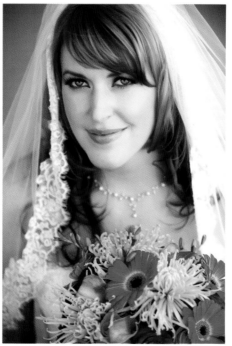

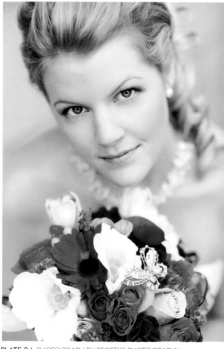

PLATE 32. PHOTOGRAPH BY REGETI'S PHOTOGRAPHY.

PLATE 33. PHOTOGRAPH BY REGETI'S PHOTOGRAPHY.

PLATE 34. PHOTOGRAPH BY REGETI'S PHOTOGRAPHY.

"After we leave the bride's house, I shoot photojournalistically until we do the family portraits after the ceremony. The one exception is the shot I create when the bride arrives at the church. To prepare for this, I advise the bride to **remain in her car when she arrives**. By letting her know exactly what to do, I can capture great moments of the groom and guests waiting inside without having to worry about missing the bride's arrival."[1]—*Marcus Bell*

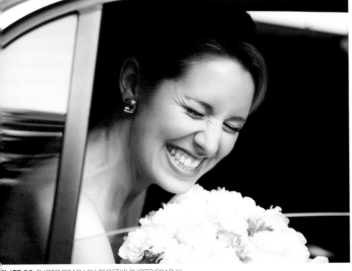

PLATE 35. PHOTOGRAPH BY REGETI'S PHOTOGRAPHY.

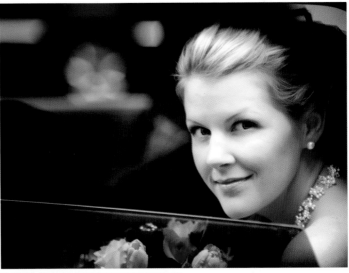

PLATE 36. PHOTOGRAPH BY REGETI'S PHOTOGRAPHY.

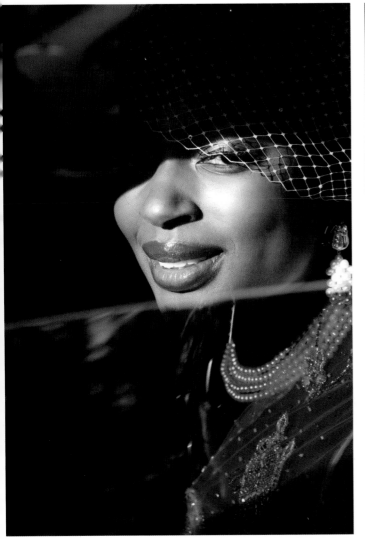

PLATE 37. PHOTOGRAPH BY DAVE AND QUIN CHEUNG.

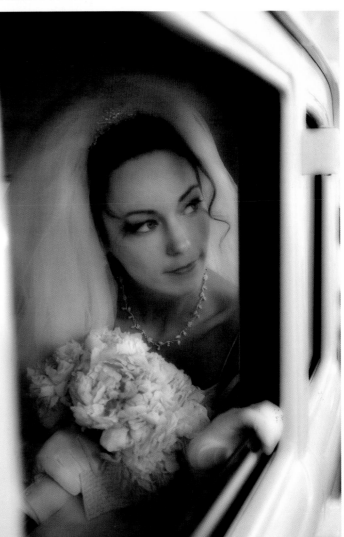

PLATE 38. PHOTOGRAPH BY JEFF AND KATHLEEN HAWKINS.

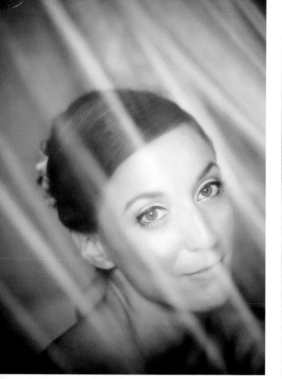

PLATE 39. PHOTOGRAPH BY KEVIN KUBOTA.

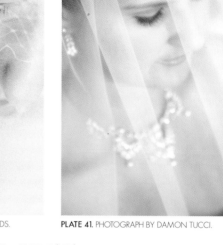

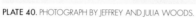

PLATE 40. PHOTOGRAPH BY JEFFREY AND JULIA WOODS.

PLATE 41. PHOTOGRAPH BY DAMON TUCCI.

PLATE 42 (LEFT). PHOTOGRAPH BY JEFFREY AND JULIA WOODS.

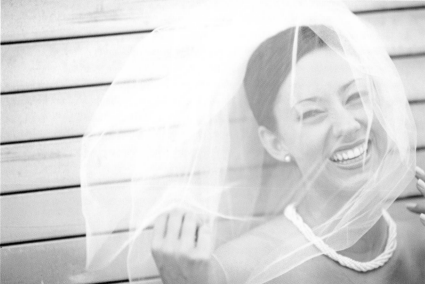

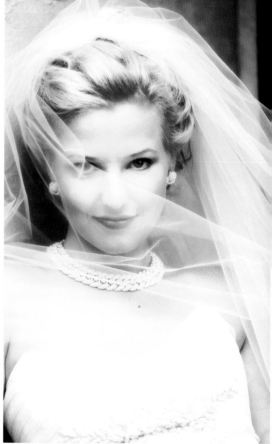

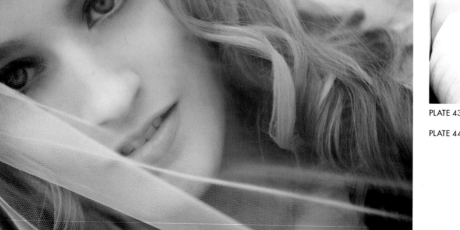

PLATE 43 (LEFT). PHOTOGRAPH BY DAWN SHIELDS.

PLATE 44 (ABOVE). PHOTOGRAPH BY JEFFREY AND JULIA WOODS.

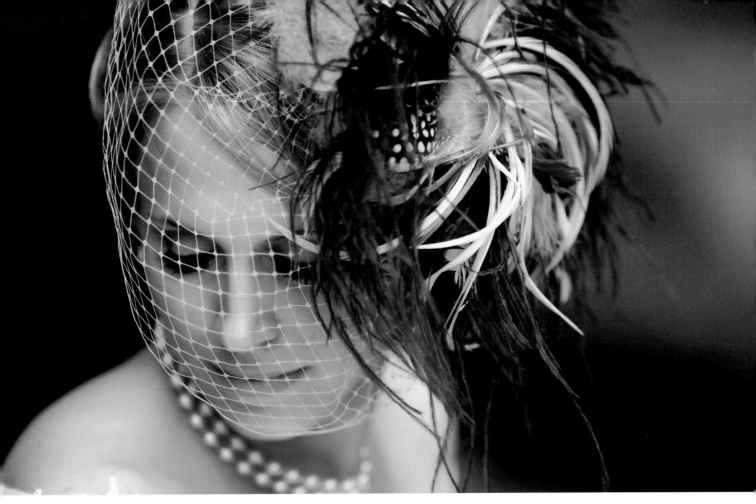

PLATE 45 (ABOVE). PHOTOGRAPH BY REGETI'S PHOTOGRAPHY.

PLATE 46 (RIGHT). PHOTOGRAPH BY CHERIE STEINBERG COTE.

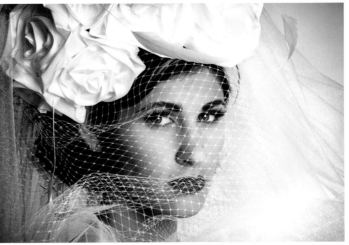

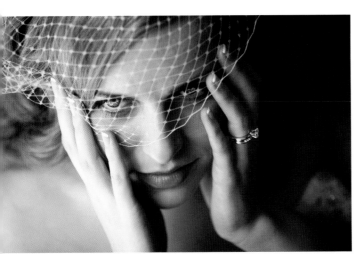

PLATE 47 (ABOVE). PHOTOGRAPH BY DAVE AND QUIN CHEUNG.

PLATE 48 (RIGHT). PHOTOGRAPH BY MARCUS BELL.

PLATE 49 (FAR RIGHT). PHOTOGRAPH BY REGETI'S PHOTOGRAPHY.

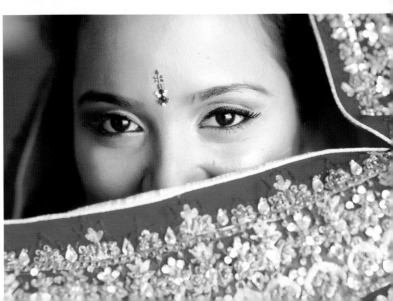

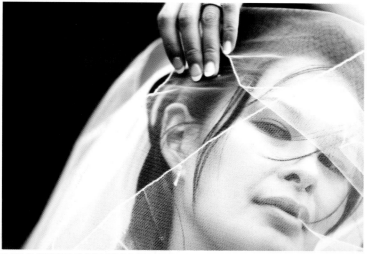

PLATE 50. PHOTOGRAPH BY DAVE AND QUIN CHEUNG.

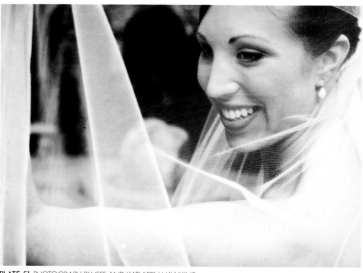

PLATE 51. PHOTOGRAPH BY JEFF AND KATHLEEN HAWKINS.

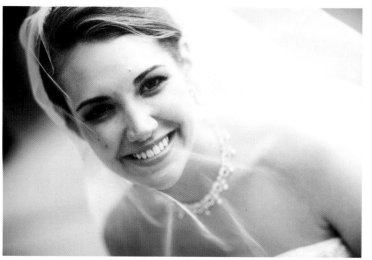

PLATE 52. PHOTOGRAPH BY DAWN SHIELDS.

PLATE 53 (BELOW). PHOTOGRAPH BY JEFF AND KATHLEEN HAWKINS.

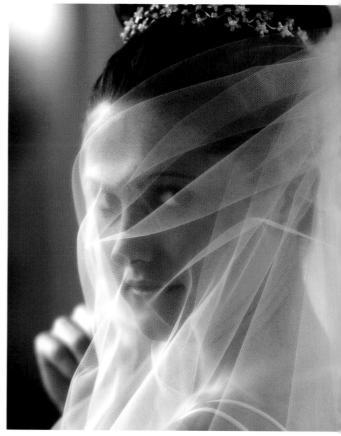

PLATE 54 (BELOW). PHOTOGRAPH BY JEFF AND KATHLEEN HAWKINS.

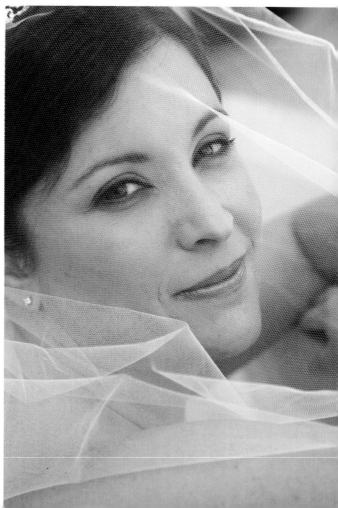

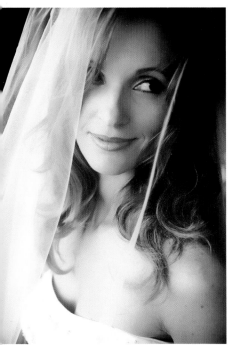

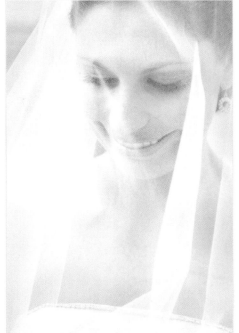

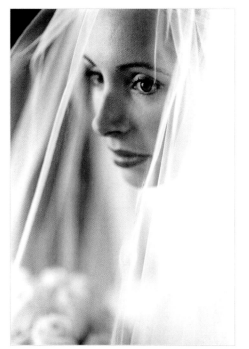

PLATE 55. PHOTOGRAPH BY DAWN SHIELDS.

PLATE 56. PHOTOGRAPH BY MARCUS BELL.

PLATE 57. PHOTOGRAPH BY JEFF AND KATHLEEN HAWKINS.

"The dress and veil are important, symbolic parts of the wedding day. Treat them gently and **style them** with care for every image."[2]—*Rick Ferro*

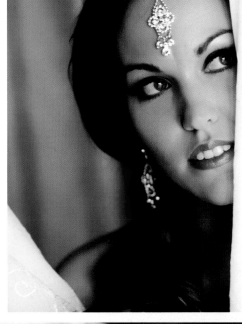

PLATE 58 (RIGHT). PHOTOGRAPH BY DAWN SHIELDS.

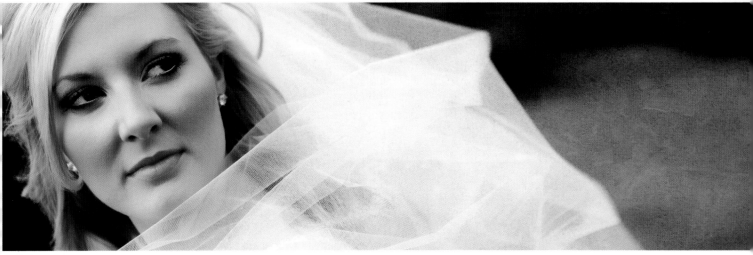

PLATE 59. PHOTOGRAPH BY DAWN SHIELDS.

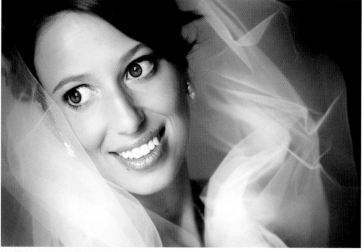

PLATE 60. PHOTOGRAPH BY DAWN SHIELDS.

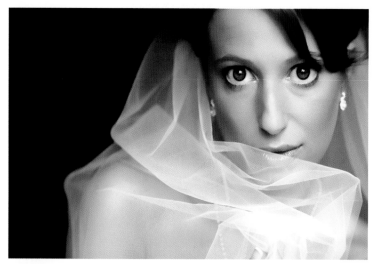

PLATE 61. PHOTOGRAPH BY DAWN SHIELDS.

PLATE 62. PHOTOGRAPH BY KEVIN KUBOTA.

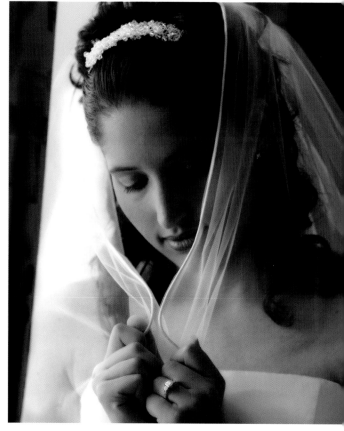

PLATE (BELOW) 64 PHOTOGRAPH BY TRACY DORR.

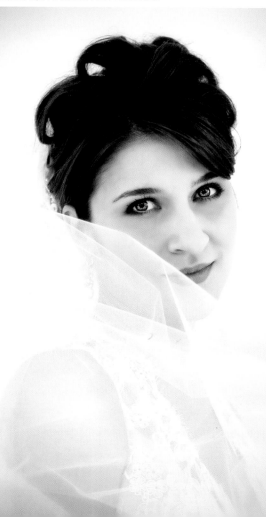

"I'm young and in shape, so I do whatever it takes. If I have to climb a tree, **I climb a tree**. [The couple] has seen me doing it at the engagement session, so they know I'm kind of nuts that way."[3]—*Riccis Valladares*

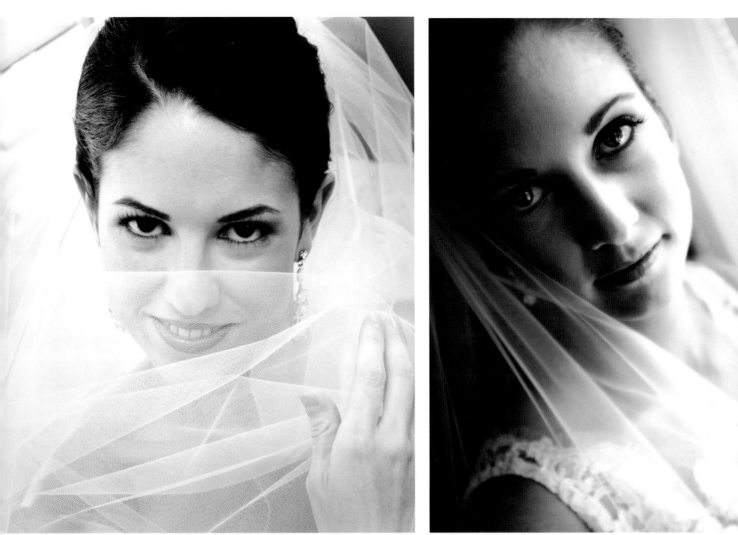

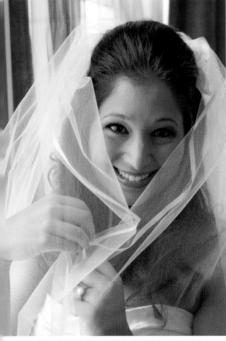

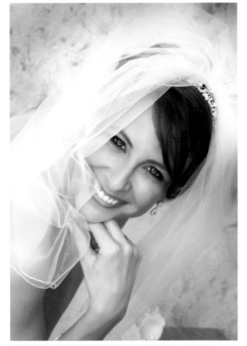

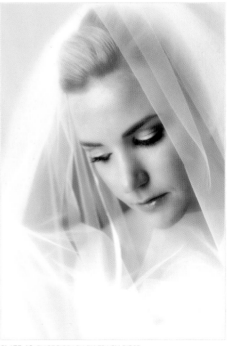

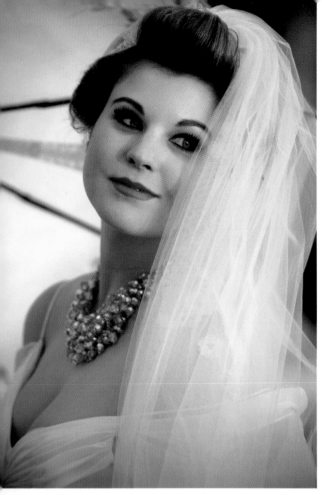

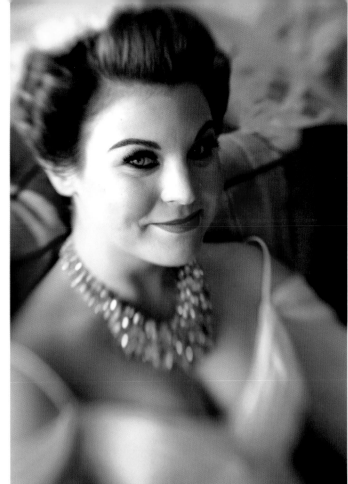

PLATE 70 (FAR LEFT). PHOTOGRAPH BY KEVIN KUBOTA.

PLATE 71 (LEFT). PHOTOGRAPH BY KEVIN KUBOTA.

PLATE 72 (BELOW). PHOTOGRAPH BY KEVIN KUBOTA.

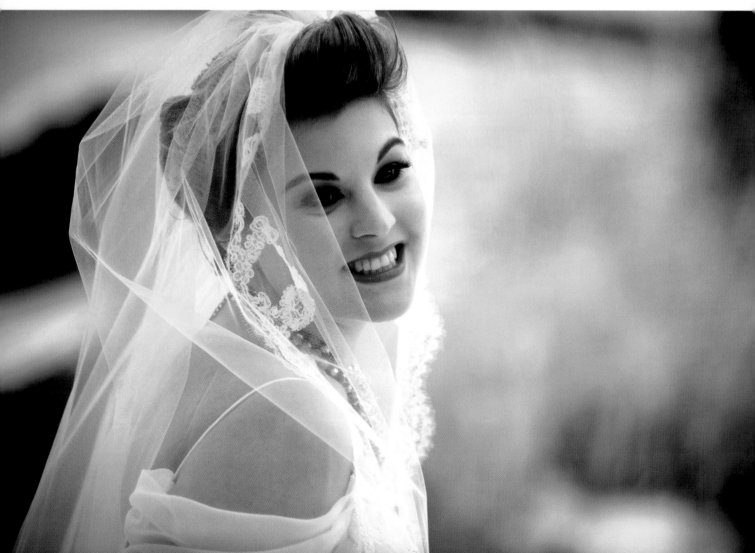

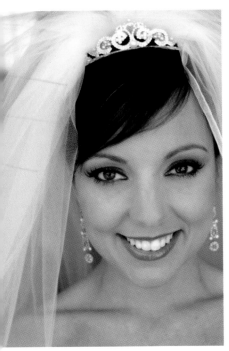

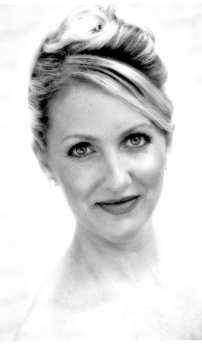

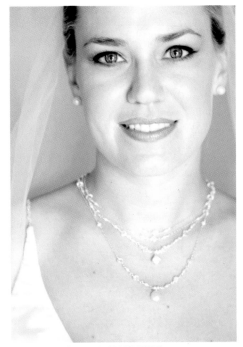

LATE 73. PHOTOGRAPH BY DAMON TUCCI.

PLATE 74. PHOTOGRAPH BY DAMON TUCCI.

PLATE 75. PHOTOGRAPH BY DAMON TUCCI.

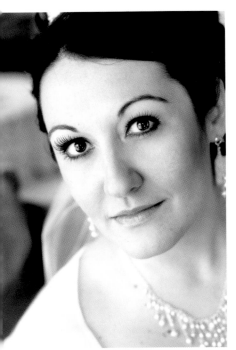

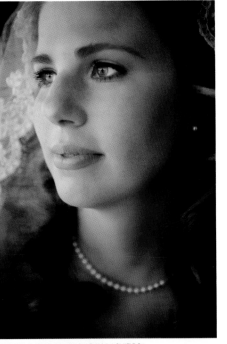

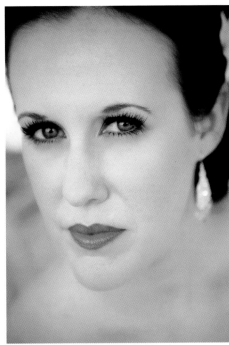

PLATE 76. PHOTOGRAPH BY TRACY DORR.

PLATE 77. PHOTOGRAPH BY DAWN SHIELDS.

PLATE 78. PHOTOGRAPH BY DAWN SHIELDS.

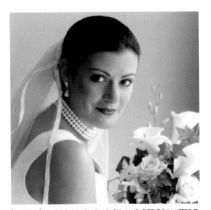

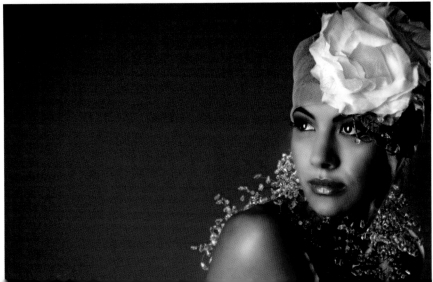

PLATE 79 (ABOVE). PHOTOGRAPH BY RICK AND DEBORAH FERRO.

PLATE 80 (RIGHT). PHOTOGRAPH BY CHERIE STEINBERG COTE.

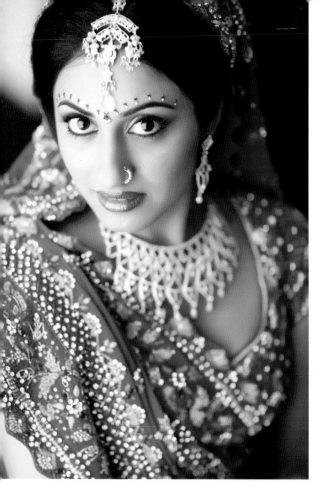

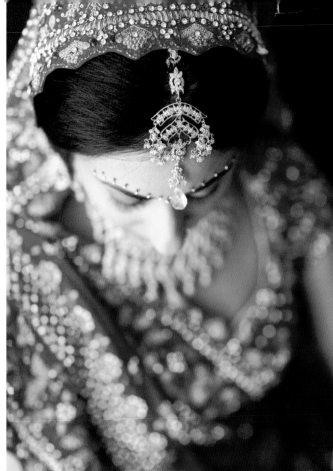

PLATE 81 (FAR LEFT).
PHOTOGRAPH
BY REGETI'S
PHOTOGRAPHY.

PLATE 82 (LEFT).
PHOTOGRAPH
BY REGETI'S
PHOTOGRAPHY.

PLATE 83 (BELOW).
PHOTOGRAPH BY
CHERIE STEINBERG
COTE.

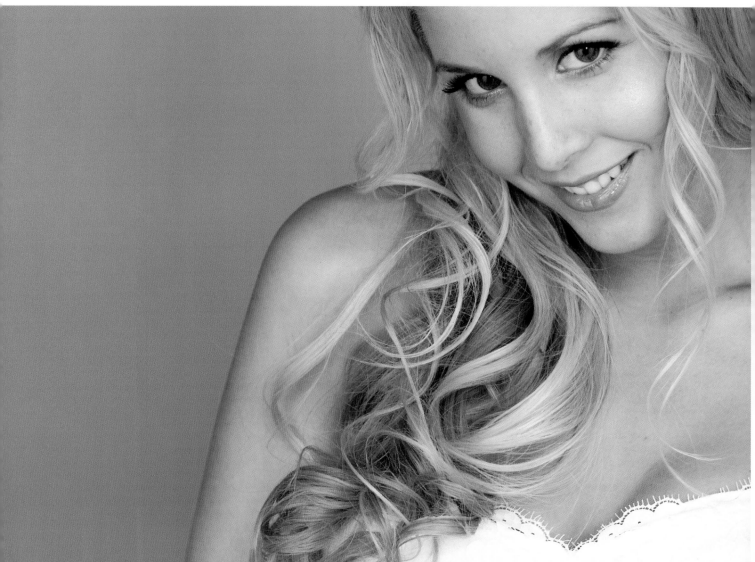

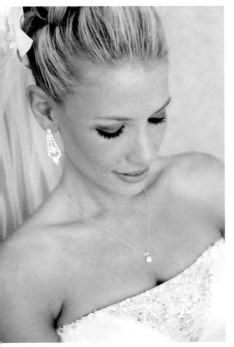

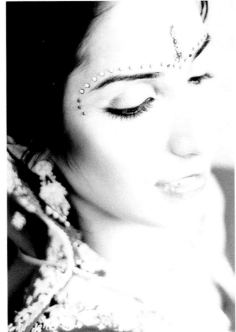

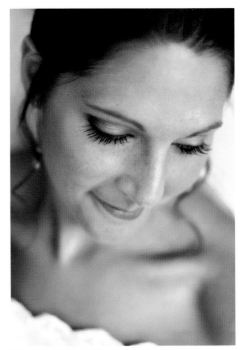

PLATE 84. PHOTOGRAPH BY TRACY DORR.

PLATE 85. PHOTOGRAPH BY TRACY DORR.

PLATE 86. PHOTOGRAPH BY TRACY DORR.

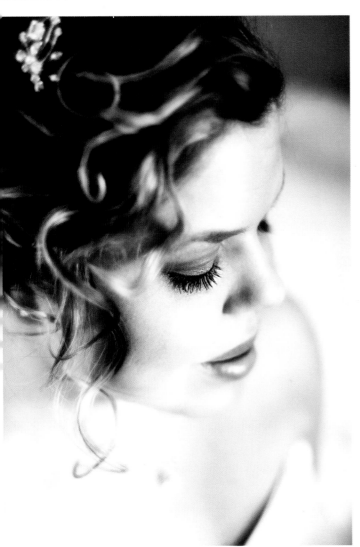

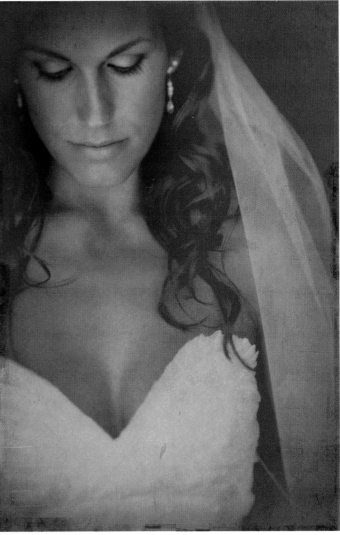

PLATE 87. PHOTOGRAPH BY TRACY DORR.

PLATE 88. PHOTOGRAPH BY JEFFREY AND JULIA WOODS.

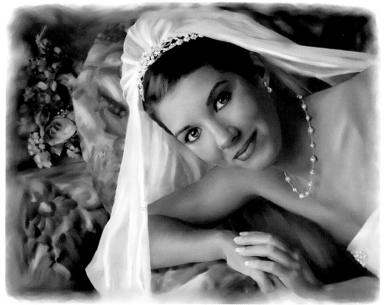

PLATE 89. PHOTOGRAPH BY RICK AND DEBORAH FERRO.

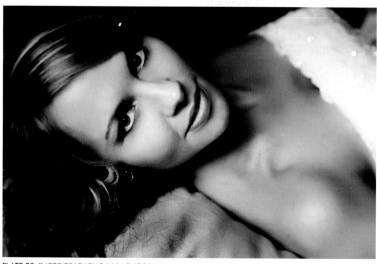

PLATE 90. PHOTOGRAPH BY DAWN SHIELDS.

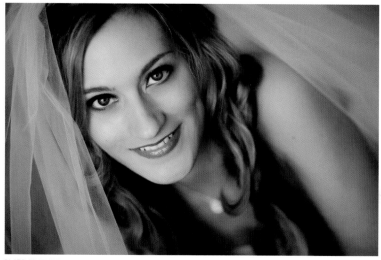

PLATE 91. PHOTOGRAPH BY DAWN SHIELDS.

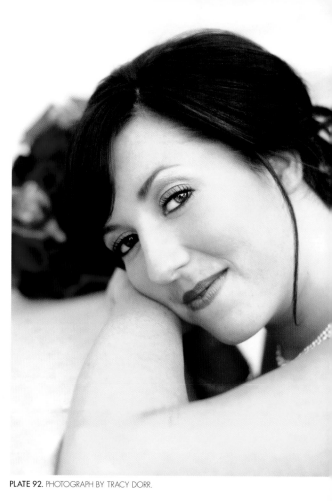

PLATE 92. PHOTOGRAPH BY TRACY DORR.

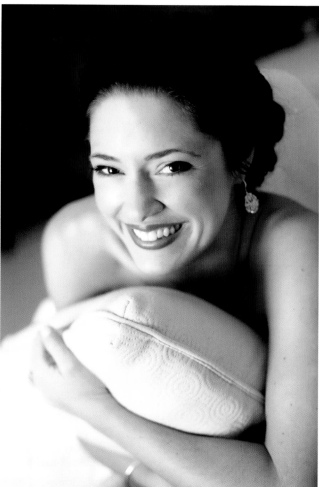

PLATE 93. PHOTOGRAPH BY TRACY DORR.

"Most people want their eyes to look as large as possible. By turning the face toward the main light and bringing the subject's gaze back to the camera, the pupil shifts more toward the corner of the eye opening and gives the eye more impact as well as a larger appearance."[4]—*Jeff Smith*

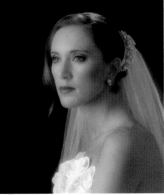

PLATE 95. PHOTOGRAPH BY RICK FERRO.

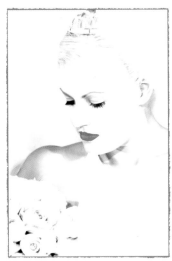

PLATE 96. PHOTOGRAPH BY JEFF AND KATHLEEN HAWKINS.

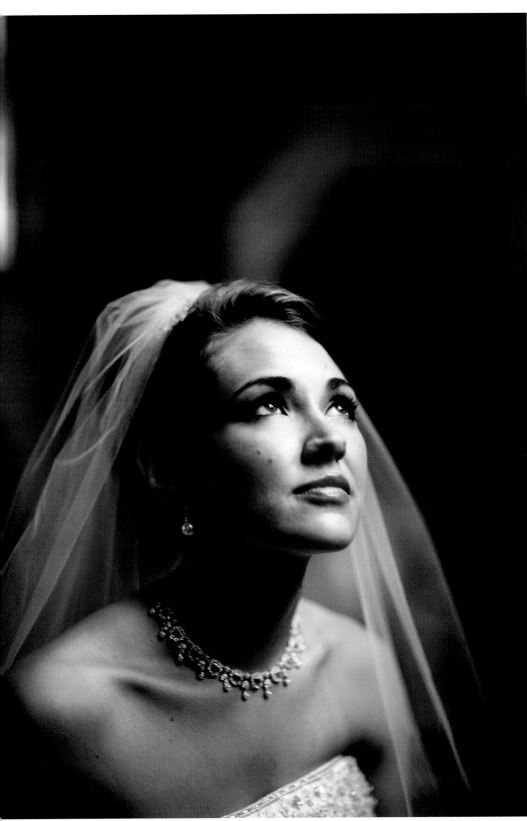

PLATE 94. PHOTOGRAPH BY DAWN SHIELDS.

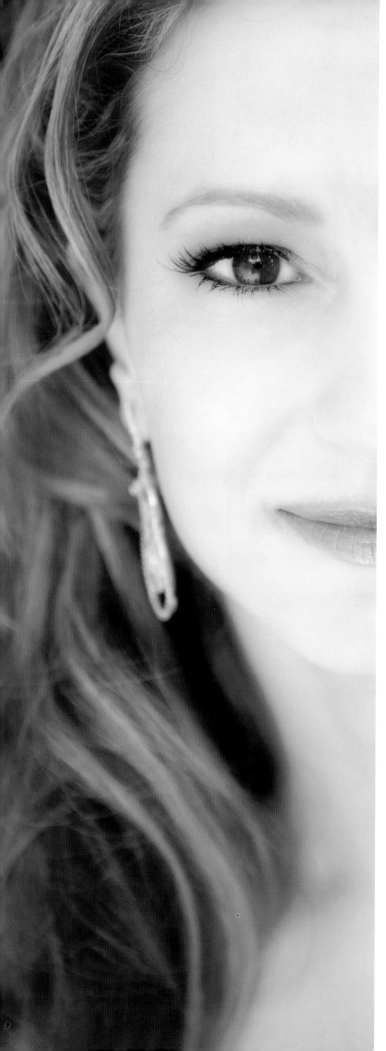

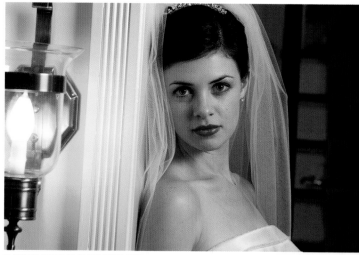

PLATE 97. PHOTOGRAPH BY DOUG BOX.

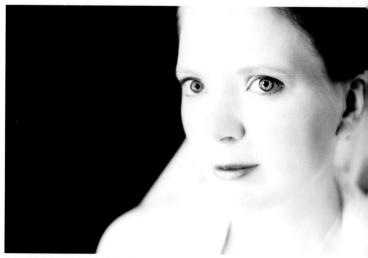

PLATE 98. PHOTOGRAPH BY TRACY DORR.

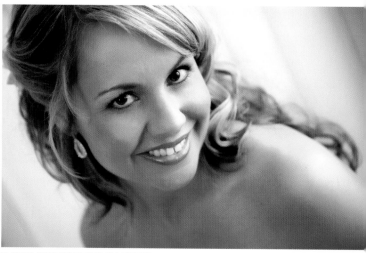

PLATE 99. PHOTOGRAPH BY DAWN SHIELDS.

PLATE 100 (LEFT). PHOTOGRAPH BY DAMON TUCCI.

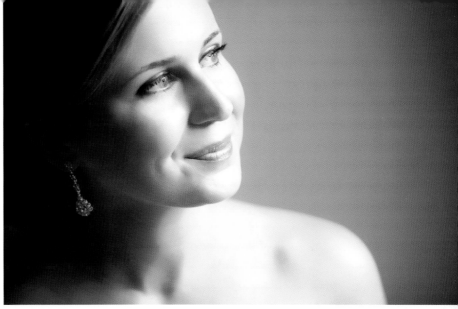

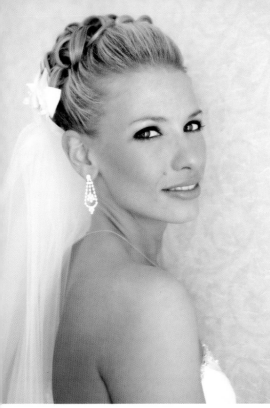

PLATE 101. PHOTOGRAPH BY TRACY DORR.

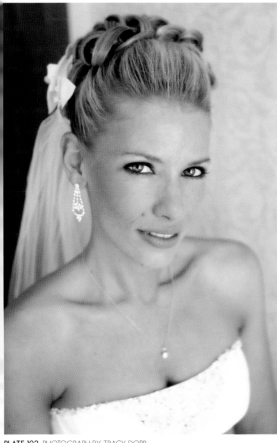

PLATE 102. PHOTOGRAPH BY TRACY DORR.

PLATE 103. PHOTOGRAPH BY DAWN SHIELDS.

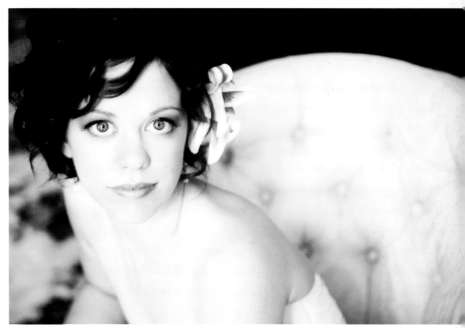

PLATE 104 PHOTOGRAPH BY DAWN SHIELDS.

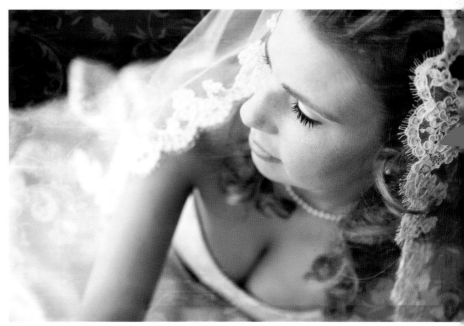

PLATE 105. PHOTOGRAPH BY DAWN SHIELDS.

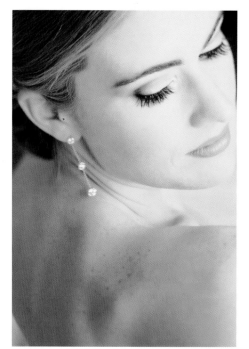

PLATE 106. PHOTOGRAPH BY JEFFREY AND JULIA WOODS.

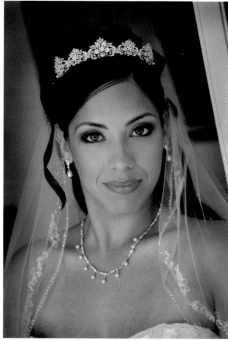

PLATE 107. PHOTOGRAPH BY DAMON TUCCI.

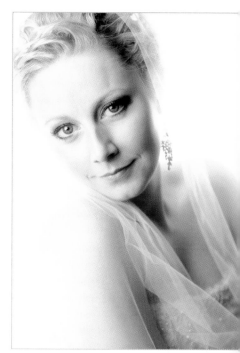

PLATE 108. PHOTOGRAPH BY JEFFREY AND JULIA WOODS.

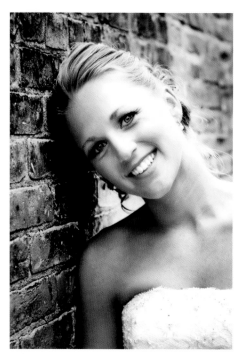

PLATE 109. PHOTOGRAPH BY TRACY DORR.

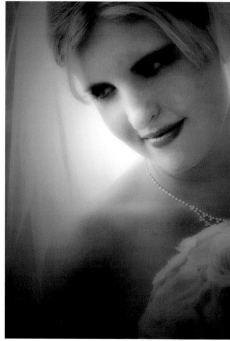

PLATE 110. PHOTOGRAPH BY JEFF AND KATHLEEN HAWKINS.

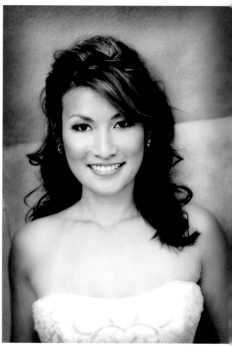

PLATE 111. PHOTOGRAPH BY DAMON TUCCI.

"Ask yourself what it is about a scene that draws your interest, and determine whether surrounding elements support or detract from the subject's magnetism. This process will help you decide what to include and, more importantly, what not to include."[5]—*Marcus Bell*

PLATE 112 (LEFT). PHOTOGRAPH BY DAWN SHIELDS.

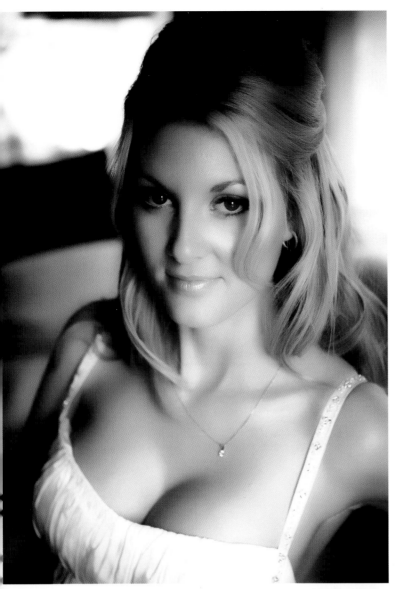

"I tell them, 'You might see me doing things and wonder, **what the heck is he doing?**' Sometimes an experimental shot works and sometimes it doesn't, but I like to constantly challenge myself to come up with new ideas. If I don't, it gets boring."[6]—*Riccis Valladares*

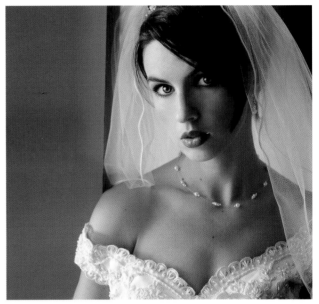

PLATE 113. PHOTOGRAPH BY RICK AND DEBORAH FERRO.

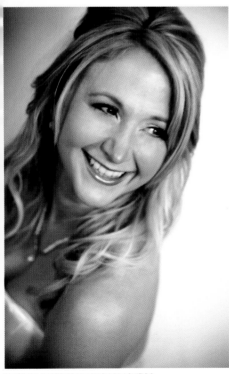

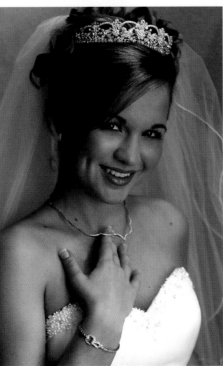

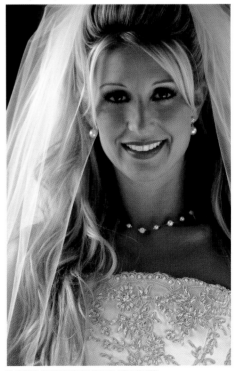

PLATE 114. PHOTOGRAPH BY DAWN SHIELDS.　　PLATE 115. PHOTOGRAPH BY RICK AND DEBORAH FERRO.　　PLATE 116. PHOTOGRAPH BY DAMON TUCCI.

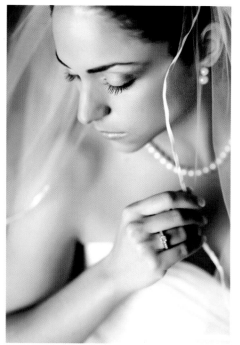

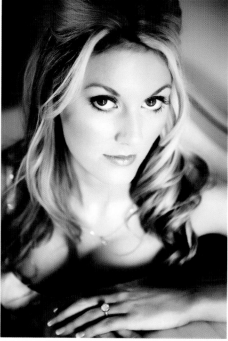

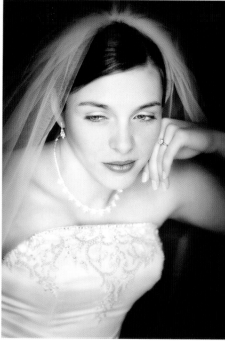

PLATE 117. PHOTOGRAPH BY REGETI'S PHOTOGRAPHY.

PLATE 118. PHOTOGRAPH BY DAWN SHIELDS.

PLATE 119. PHOTOGRAPH BY TRACY DORR.

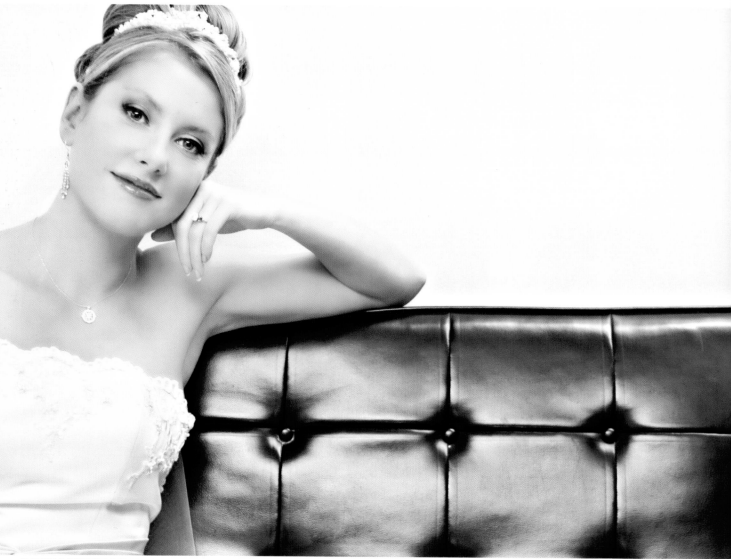

PLATE 120. PHOTOGRAPH BY TRACY DORR.

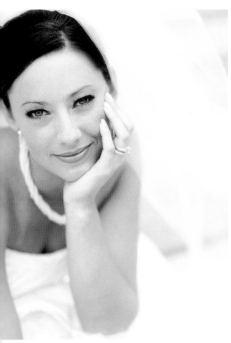

PLATE 121. PHOTOGRAPH BY JEFFREY AND JULIA WOODS.

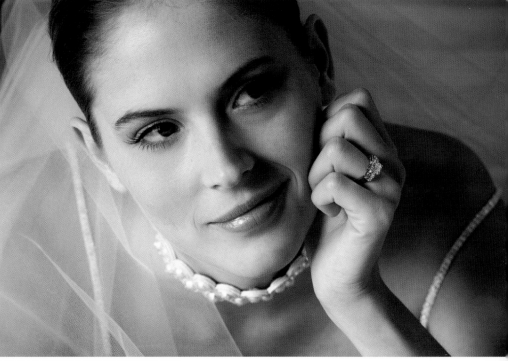

PLATE 124. PHOTOGRAPH BY CHERIE STEINBERG COTE.

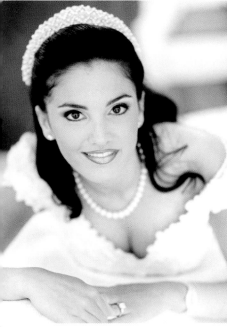

PLATE 122. PHOTOGRAPH BY JEFF AND KATHLEEN HAWKINS.

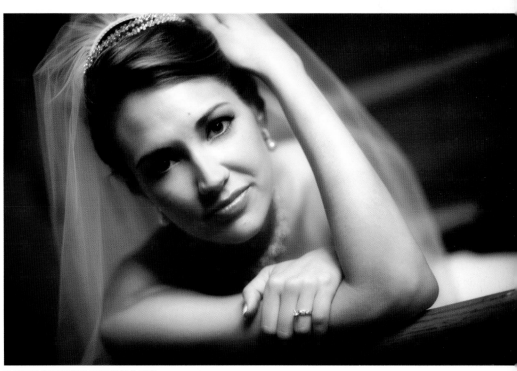

PLATE 125. PHOTOGRAPH BY DAWN SHIELDS.

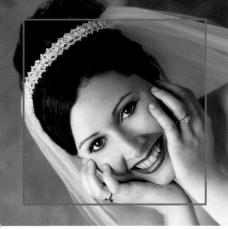

PLATE 123. PHOTOGRAPH BY RICK AND DEBORAH FERRO.

"The hands are best viewed at an angle to the camera. When possible, care should be taken to photograph the side of the hand, which gracefully continues the line of the arm."[7]—*Doug Box*

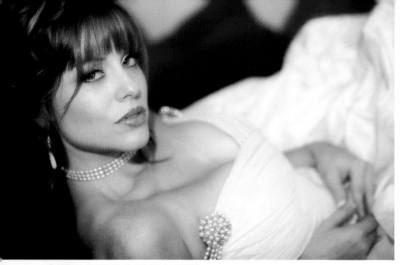

PLATE 126. PHOTOGRAPH BY DAWN SHIELDS.

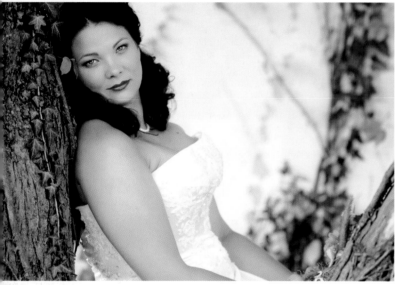

PLATE 127. PHOTOGRAPH BY REGETI'S PHOTOGRAPHY.

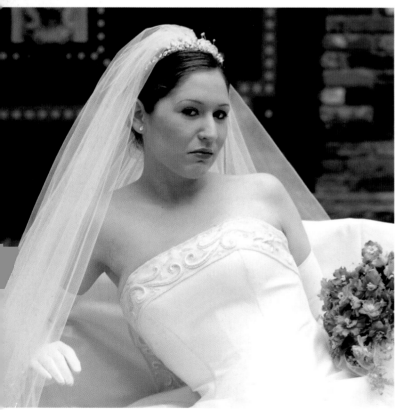

PLATE 128. PHOTOGRAPH BY RICK AND DEBORAH FERRO.

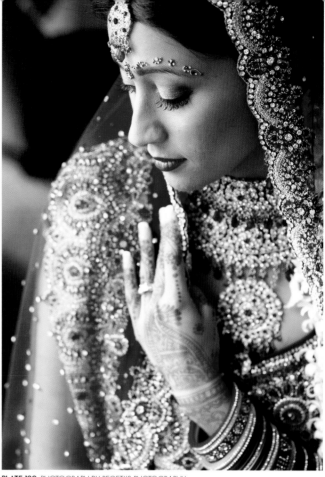

PLATE 129. PHOTOGRAPH BY REGETI'S PHOTOGRAPHY.

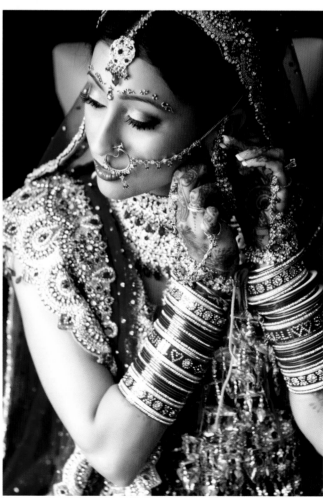

PLATE 130. PHOTOGRAPH BY REGETI'S PHOTOGRAPHY.

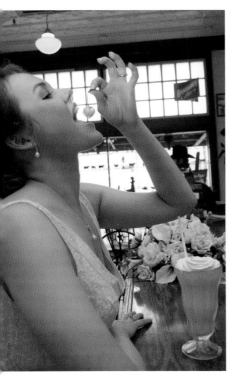

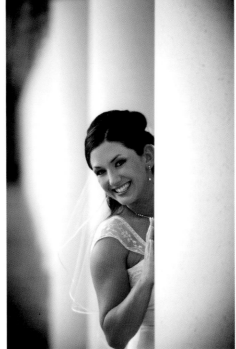

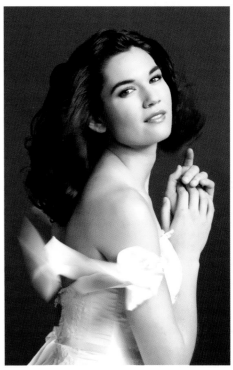

PLATE 131. PHOTOGRAPH BY MARK CHEN.

PLATE 132. PHOTOGRAPH BY JEFF SMITH.

PLATE 133. PHOTOGRAPH BY MARC WEISBERG.

PLATE 134. PHOTOGRAPH BY KEVIN JAIRAJ.

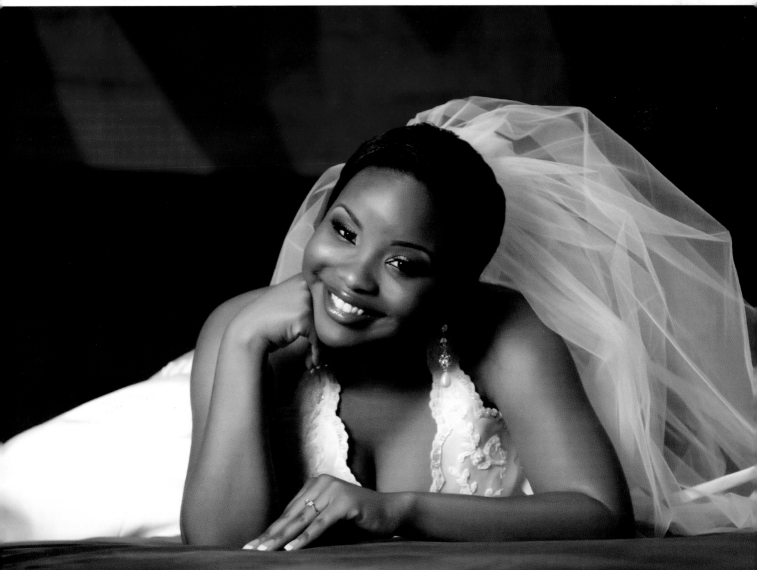

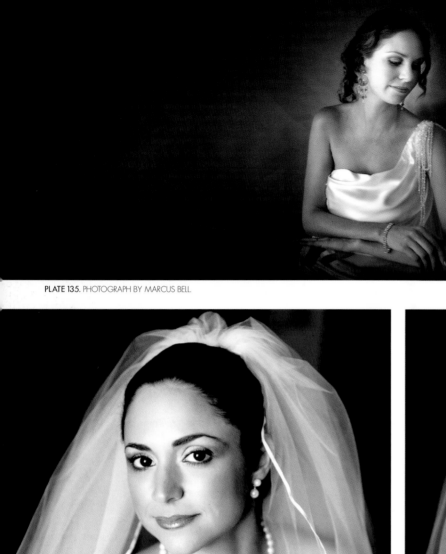

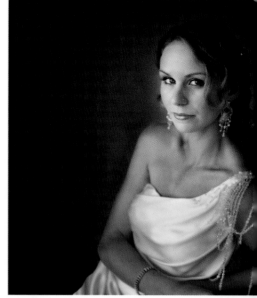

PLATE 135. PHOTOGRAPH BY MARCUS BELL.

PLATE 136. PHOTOGRAPH BY MARCUS BELL.

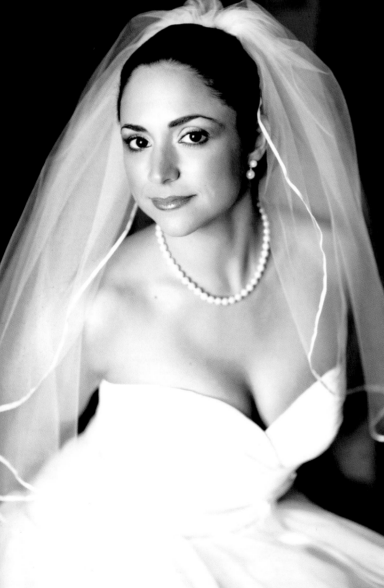

PLATE 137. PHOTOGRAPH BY REGETI'S PHOTOGRAPHY.

PLATE 138. PHOTOGRAPH BY REGETI'S PHOTOGRAPHY.

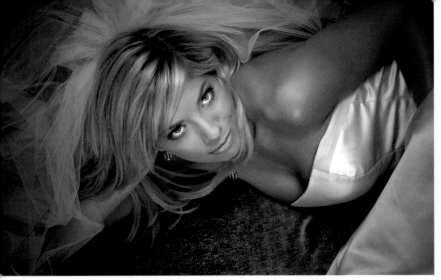

PLATE 139. PHOTOGRAPH BY CHERIE STEINBERG COTE.

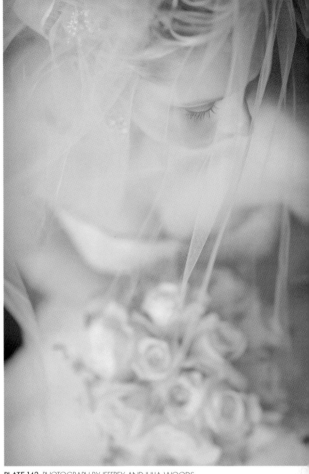

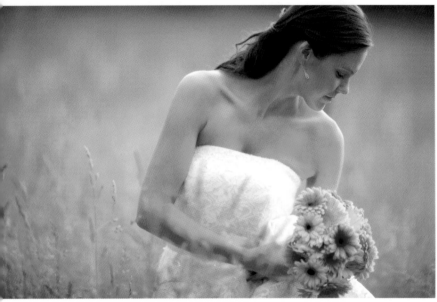

PLATE 142. PHOTOGRAPH BY JEFFREY AND JULIA WOODS.

LATE 140. PHOTOGRAPH BY JEFFREY AND JULIA WOODS.

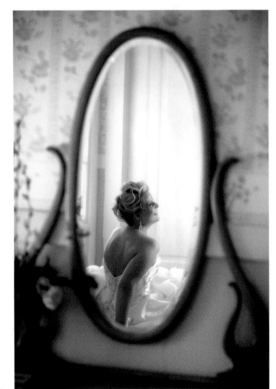

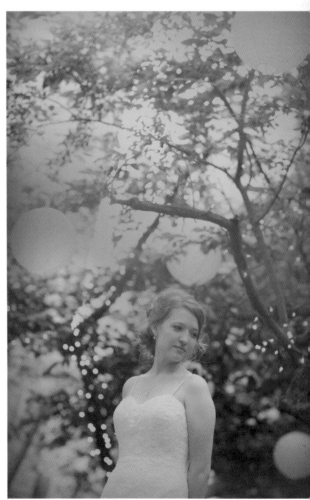

PLATE 141. PHOTOGRAPH BY DAWN SHIELDS.

PLATE 143. PHOTOGRAPH BY JEFFREY AND JULIA WOODS.

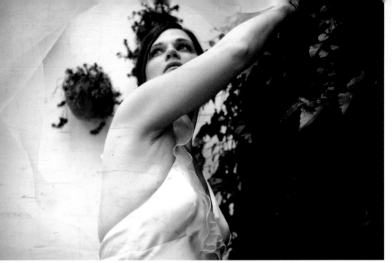

PLATE 144. PHOTOGRAPH BY DAVE AND QUIN CHEUNG.

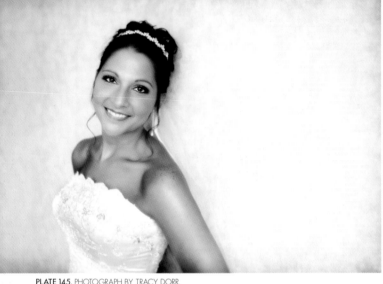

PLATE 145. PHOTOGRAPH BY TRACY DORR.

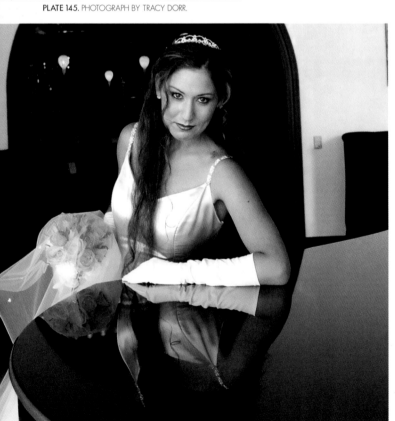

PLATE 146. PHOTOGRAPH BY RICK AND DEBORAH FERRO.

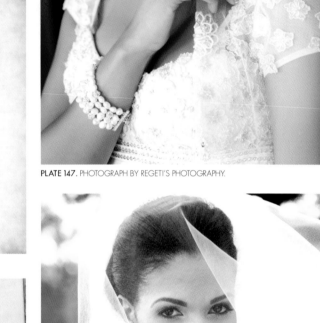

PLATE 147. PHOTOGRAPH BY REGETI'S PHOTOGRAPHY.

PLATE 148. PHOTOGRAPH BY REGETI'S PHOTOGRAPHY.

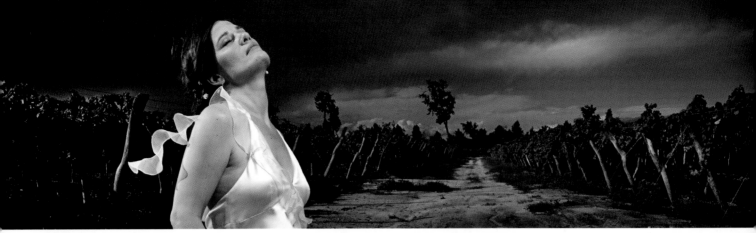

PLATE 149. PHOTOGRAPH BY DAVE AND QUIN CHEUNG.

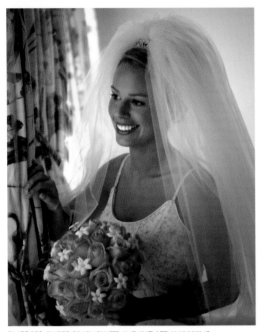

PLATE 150. PHOTOGRAPH BY JEFF AND KATHLEEN HAWKINS.

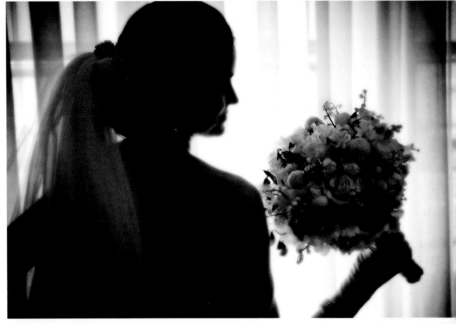

PLATE 151. PHOTOGRAPH BY JEFF AND KATHLEEN HAWKINS.

PLATE 152. PHOTOGRAPH BY RICK AND DEBORAH FERRO.

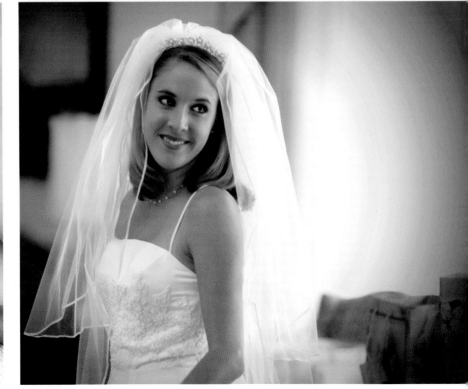

PLATE 153. PHOTOGRAPH BY JEFF AND KATHLEEN HAWKINS.

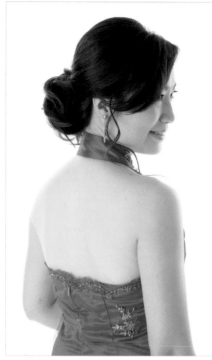

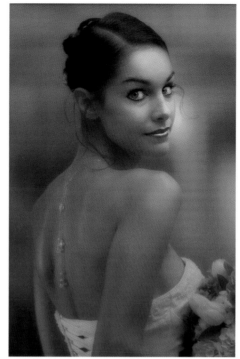

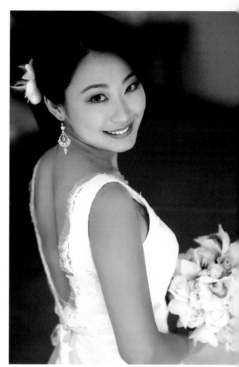

PLATE 154. PHOTOGRAPH BY MARK CHEN.

PLATE 155. PHOTOGRAPH BY MARK CHEN.

PLATE 156. PHOTOGRAPH BY REGETI'S PHOTOGRAPHY.

PLATE 157. PHOTOGRAPH BY HUY NGUYEN.

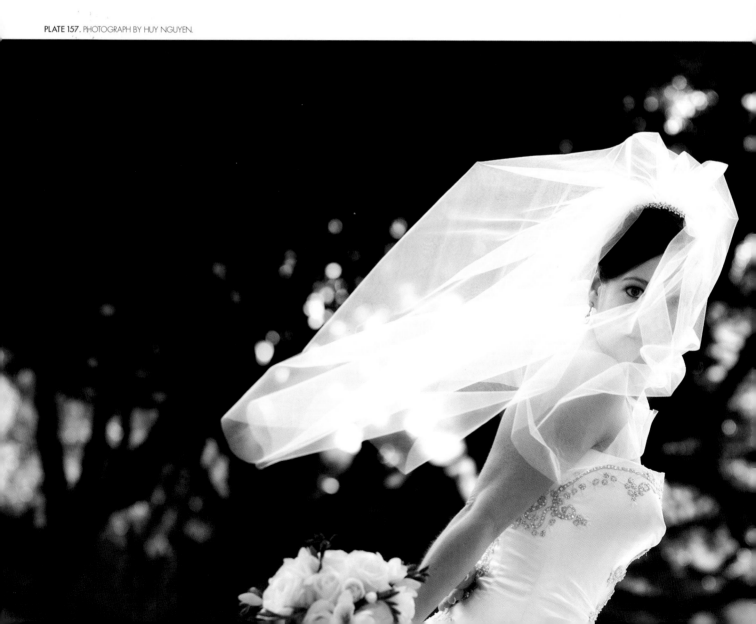

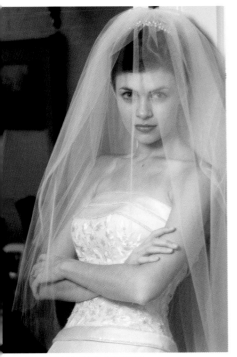

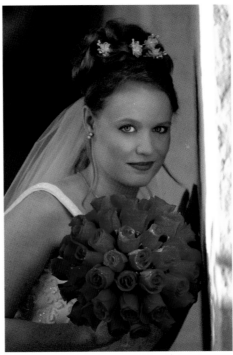

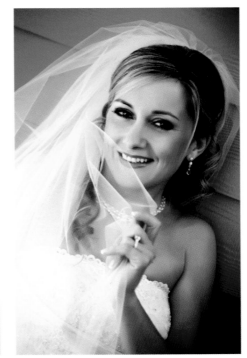

PLATE 158. PHOTOGRAPH BY DOUG BOX.

PLATE 159. PHOTOGRAPH BY JEFF AND KATHLEEN HAWKINS.

PLATE 160. PHOTOGRAPH BY JEFF AND KATHLEEN HAWKINS.

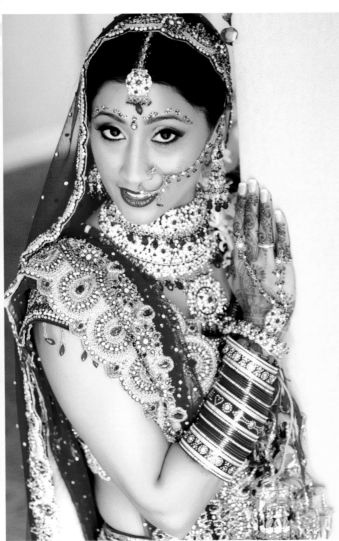

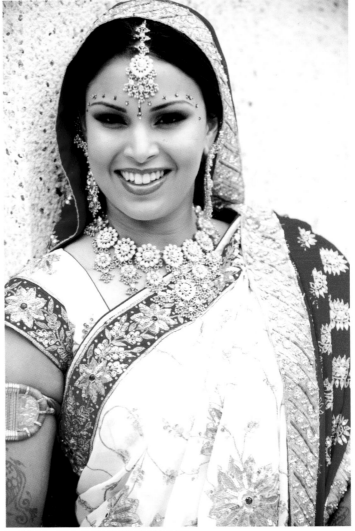

PLATE 161. PHOTOGRAPH BY REGETI'S PHOTOGRAPHY.

PLATE 162. PHOTOGRAPH BY REGETI'S PHOTOGRAPHY.

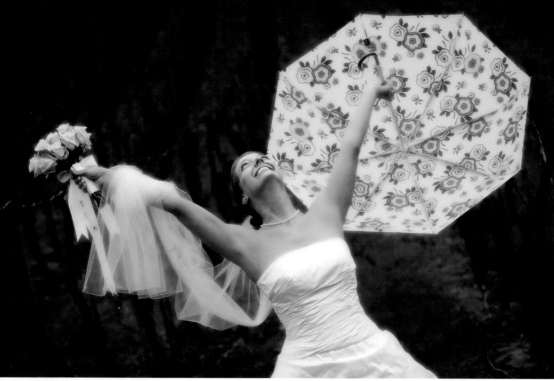

PLATE 163. PHOTOGRAPH BY KEVIN KUBOTA.

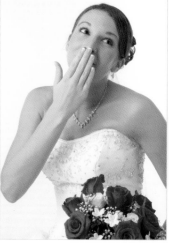

PLATE 165. PHOTOGRAPH BY MARK CHEN.

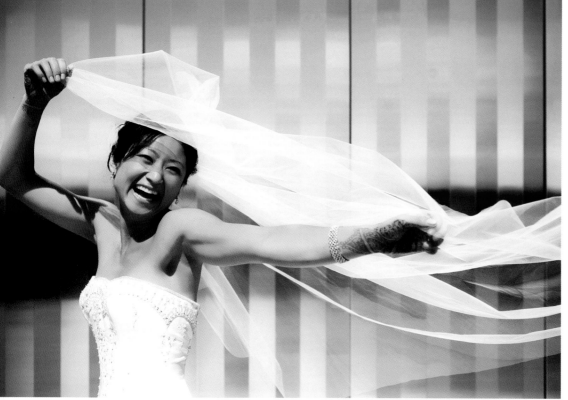

PLATE 164. PHOTOGRAPH BY DAWN SHIELDS.

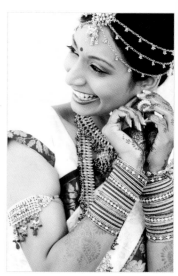

PLATE 166. PHOTOGRAPH BY REGETI'S PHOTOGRAPHY.

"When an image is created at the exact height of the subject's emotion, there is a certain level of vulnerability. That moment is as far as you can get from the stale smiles and deer-in-the-headlights looks you often find in formal photographs. In a moment of purity, you are able to catch the truth about all they are feeling; you are actually making a study of the human condition."[8]—*Tracy Dorr*

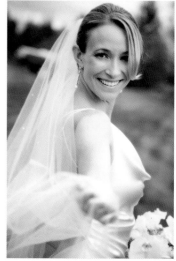

PLATE 167. PHOTOGRAPH BY KEVIN KUBOTA.

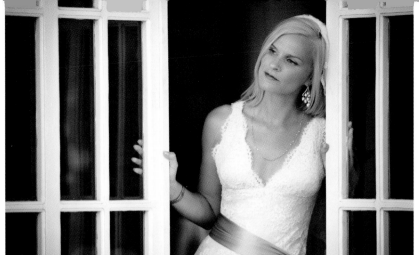

PLATE 168. PHOTOGRAPH BY KEVIN KUBOTA.

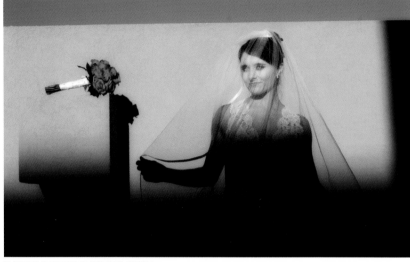

PLATE 169. PHOTOGRAPH BY HUY NGUYEN.

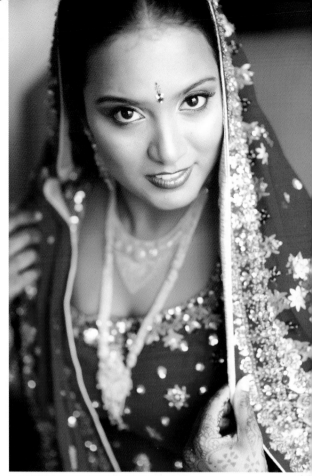

PLATE 171. PHOTOGRAPH BY REGETI'S PHOTOGRAPHY.

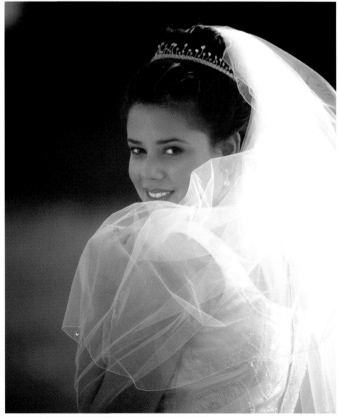

PLATE 170. PHOTOGRAPH BY JEFF AND KATHLEEN HAWKINS.

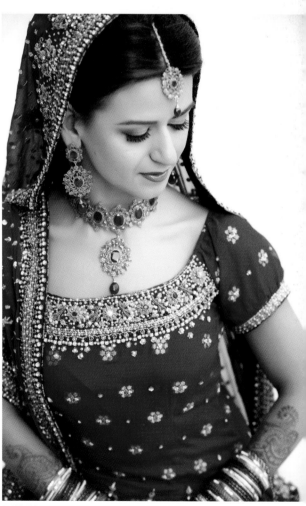

PLATE 172. PHOTOGRAPH BY REGETI'S PHOTOGRAPHY.

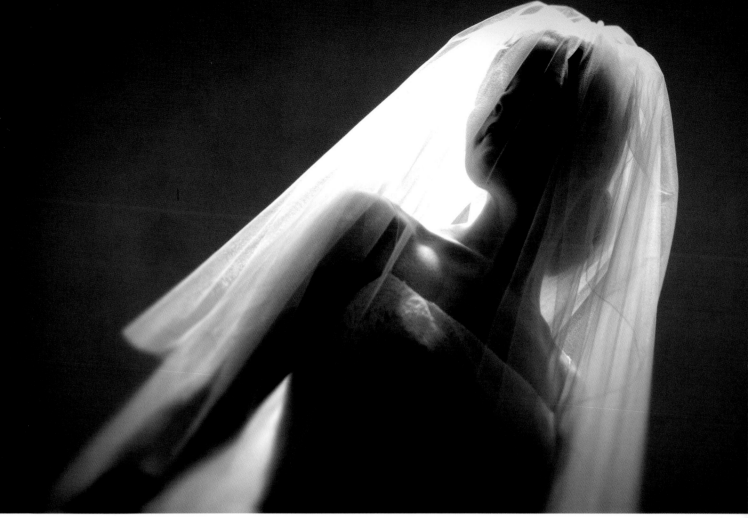

PLATE 173. PHOTOGRAPH BY HUY NGUYEN.

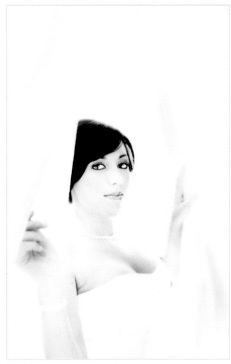

PLATE 174. PHOTOGRAPH BY TRACY DORR.

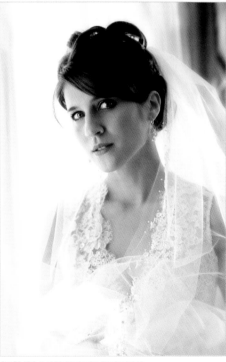

PLATE 175. PHOTOGRAPH BY TRACY DORR.

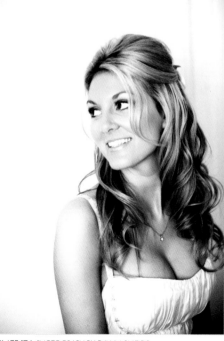

PLATE 176. PHOTOGRAPH BY DAWN SHIELDS.

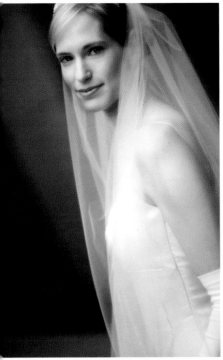

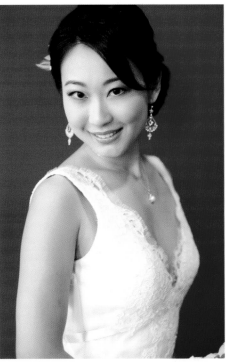

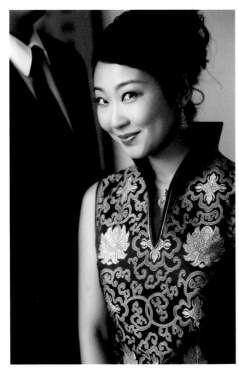

LATE 177. PHOTOGRAPH BY JEFFREY AND JULIA WOODS.

PLATE 178. PHOTOGRAPH BY REGETI'S PHOTOGRAPHY.

PLATE 179. PHOTOGRAPH BY REGETI'S PHOTOGRAPHY.

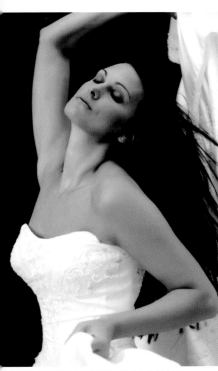

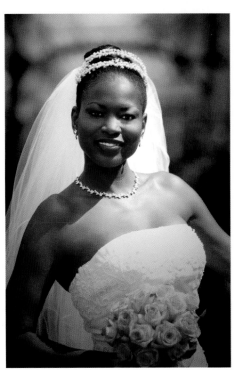

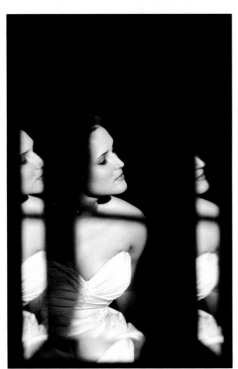

PLATE 180. PHOTOGRAPH BY REGETI'S PHOTOGRAPHY.

PLATE 181. PHOTOGRAPH BY JEFF AND KATHLEEN HAWKINS.

PLATE 182. PHOTOGRAPH BY HUY NGUYEN.

"The size of the bustline is determined by the appearance of cleavage. Cleavage is nothing but a shadow. Turn the subject toward the shadow side of the frame and you will, in turn, increase the apparent size of the bustline."[9]—*Jeff Smith*

"I urge you to pay close attention to the details. Little things like **a not-so-perfect veil** or the stems showing on a bouquet can ruin an otherwise beautiful portrait. They may not seem like much, but the details can make or break your image."[10]—*Rick Ferro*

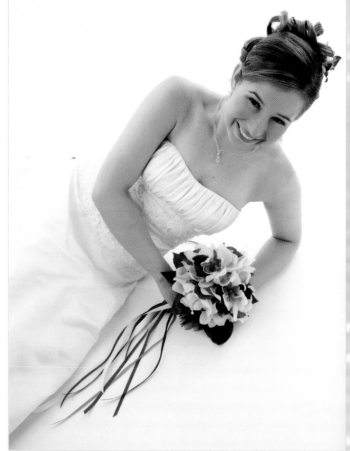

PLATE 185. PHOTOGRAPH BY MARK CHEN.

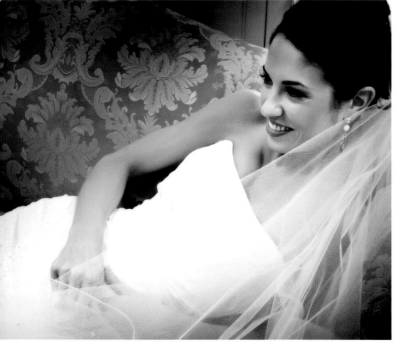

PLATE 183. PHOTOGRAPH BY JEFF AND KATHLEEN HAWKINS.

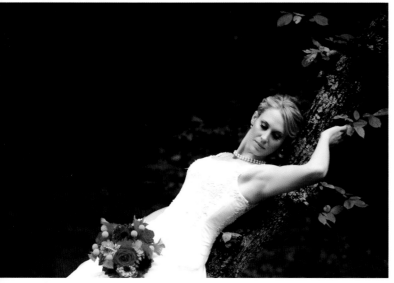

PLATE 184. PHOTOGRAPH BY REGETI'S PHOTOGRAPHY.

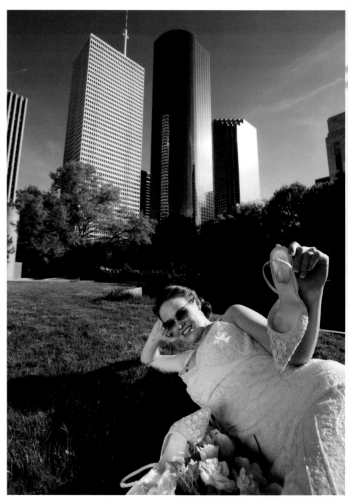

PLATE 186. PHOTOGRAPH BY MARK CHEN.

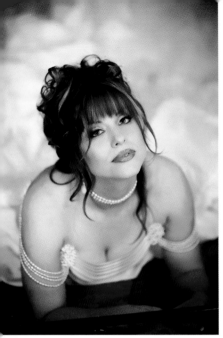

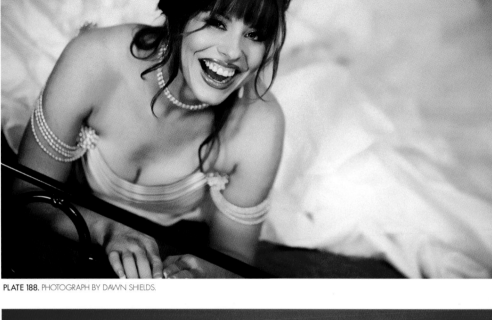

PLATE 187. PHOTOGRAPH BY DAWN SHIELDS.

PLATE 188. PHOTOGRAPH BY DAWN SHIELDS.

"Brides who are into the art of photography [. . .] want to see themselves in those magazine-style images, and that makes my job great, because they have no problem giving me **the time it takes** to create those pictures."[11]—*Dawn Shields*

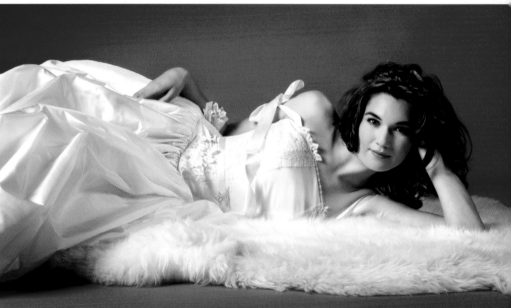

PLATE 189. PHOTOGRAPH BY MARC WEISBERG.

PLATE 190 (RIGHT). PHOTOGRAPH BY DAWN SHIELDS.

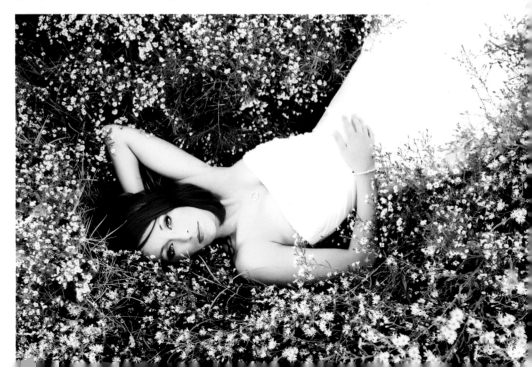

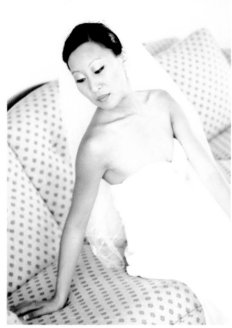

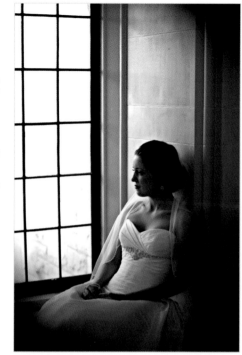

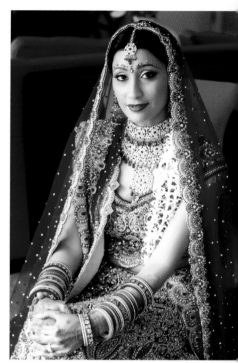

PLATE 191. PHOTOGRAPH BY TRACY DORR.

PLATE 192. PHOTOGRAPH BY TRACY DORR.

PLATE 193. PHOTOGRAPH BY REGETI'S PHOTOGRAPHY.

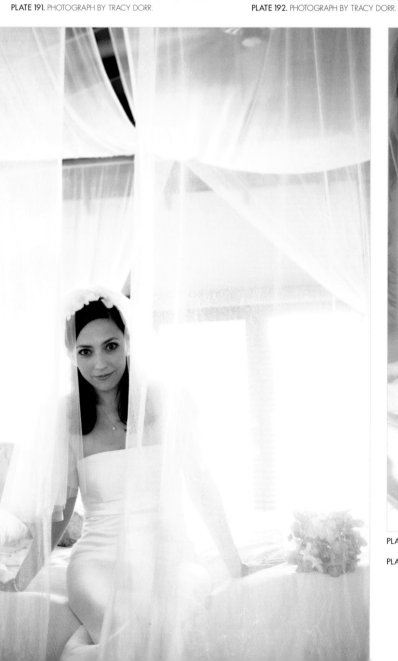

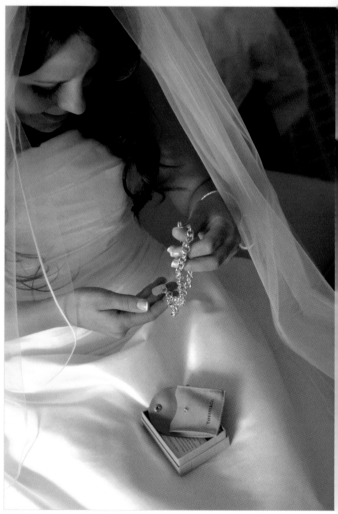

PLATE 194 (LEFT). PHOTOGRAPH BY HUY NGUYEN.

PLATE 195 (ABOVE). PHOTOGRAPH BY DAMON TUCCI.

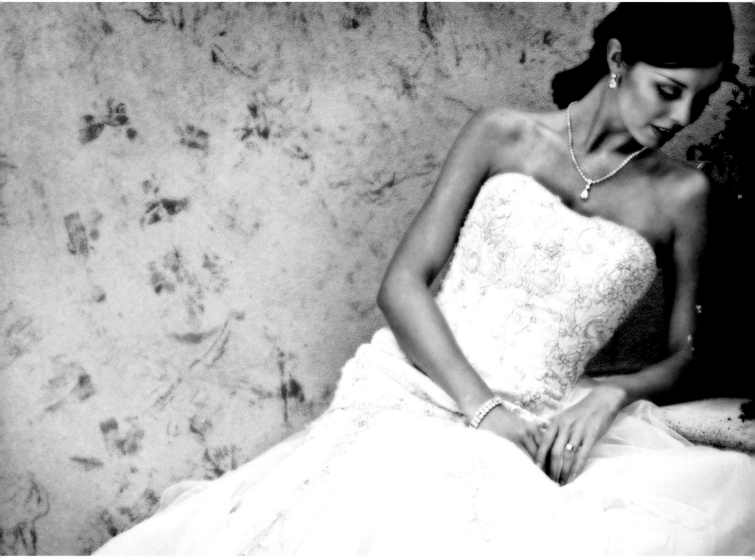

PLATE 196. PHOTOGRAPH BY JEFF AND KATHLEEN HAWKINS.

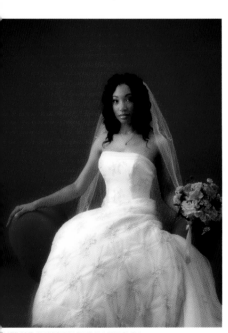

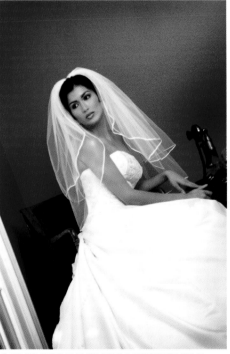

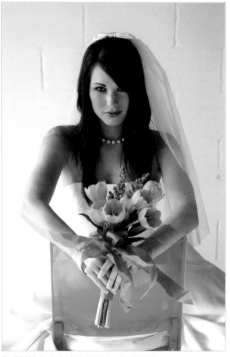

PLATE 197. PHOTOGRAPH BY MARK CHEN.

PLATE 198. PHOTOGRAPH BY JEFF AND KATHLEEN HAWKINS.

PLATE 199. PHOTOGRAPH BY DAMON TUCCI.

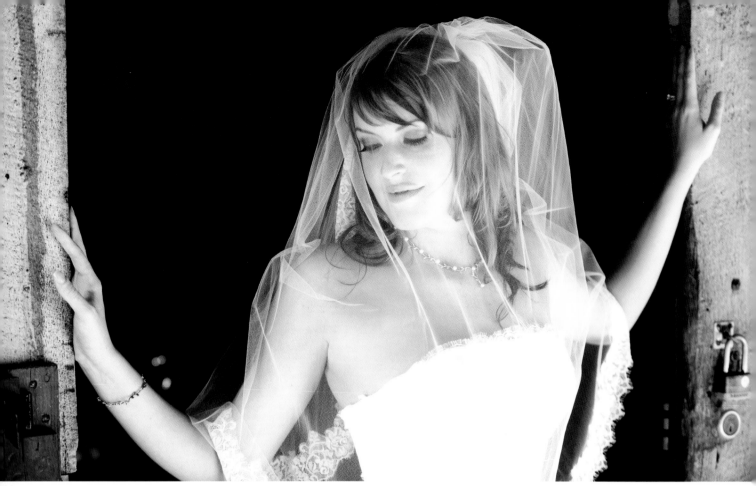

PLATE 200. PHOTOGRAPH BY REGETI'S PHOTOGRAPHY.

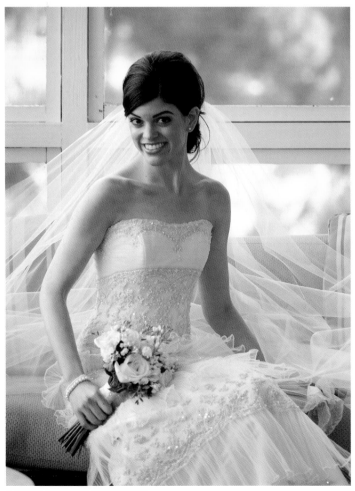

PLATE 201. PHOTOGRAPH BY DOUG BOX.

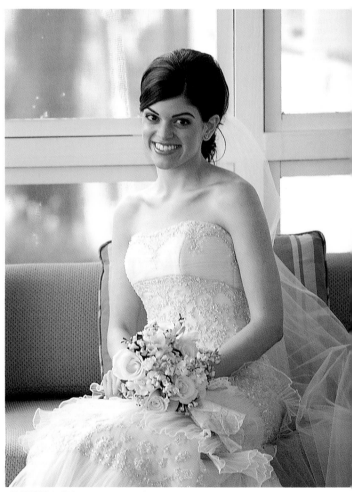

PLATE 202. PHOTOGRAPH BY DOUG BOX.

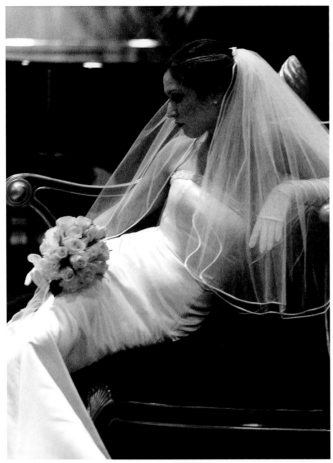

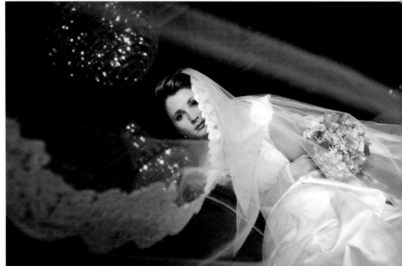

PLATE 205. PHOTOGRAPH BY HUY NGUYEN.

PLATE 203. PHOTOGRAPH BY RICK AND DEBORAH FERRO.

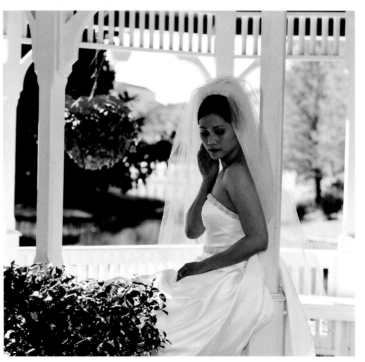

PLATE 206. PHOTOGRAPH BY HUY NGUYEN.

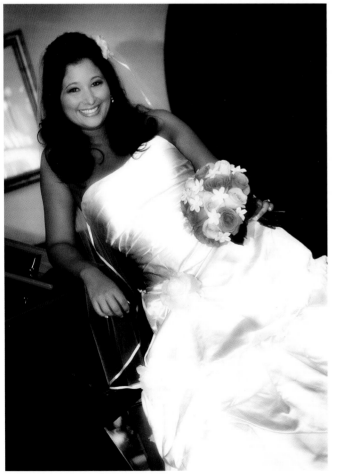

PLATE 204. PHOTOGRAPH BY JEFF AND KATHLEEN HAWKINS.

PLATE 207. PHOTOGRAPH BY RICK AND DEBORAH FERRO.

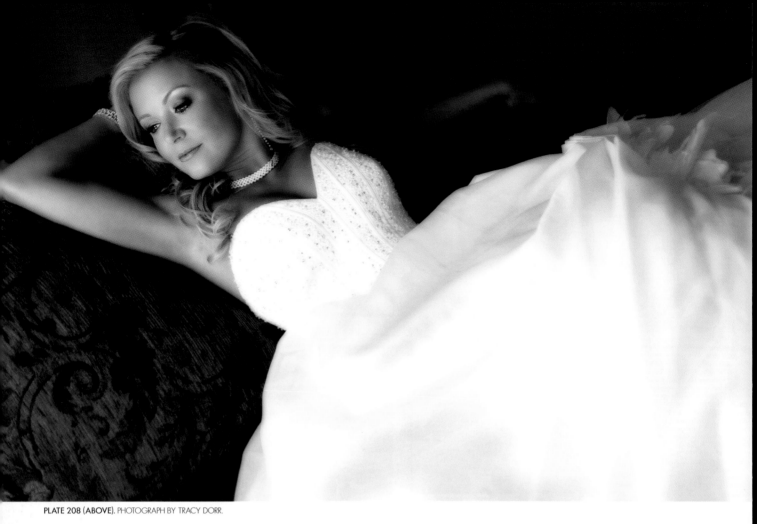

PLATE 208 (ABOVE). PHOTOGRAPH BY TRACY DORR.

PLATE 209 (BELOW). PHOTOGRAPH BY TRACY DORR.

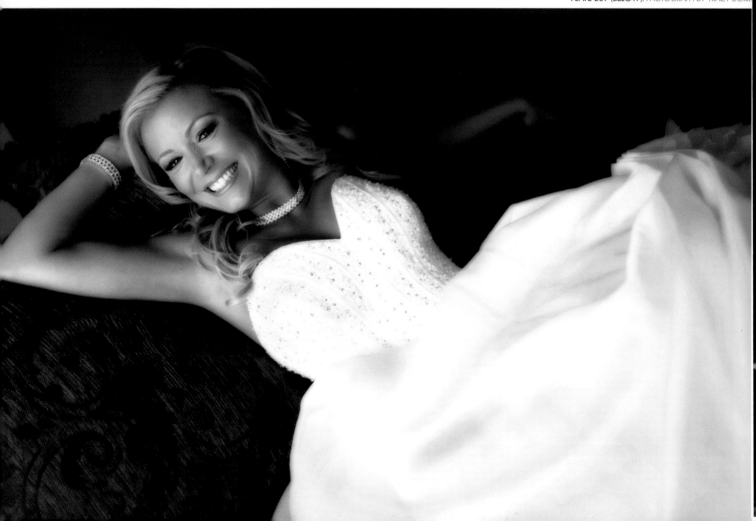

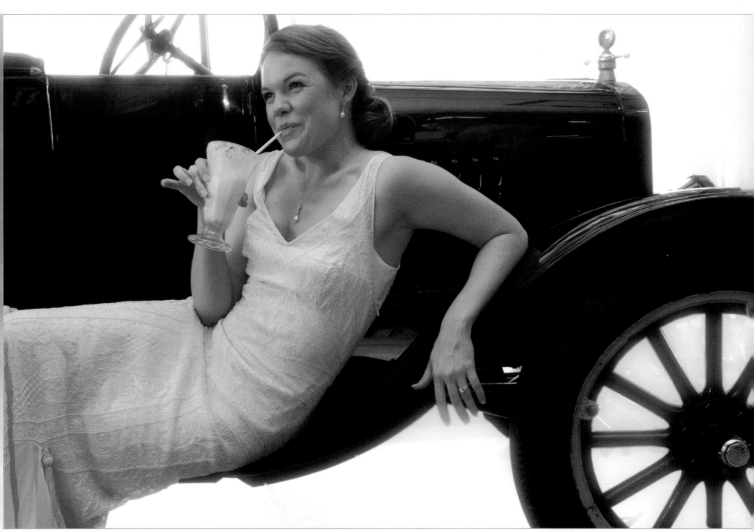

PLATE 210. PHOTOGRAPH BY MARK CHEN.

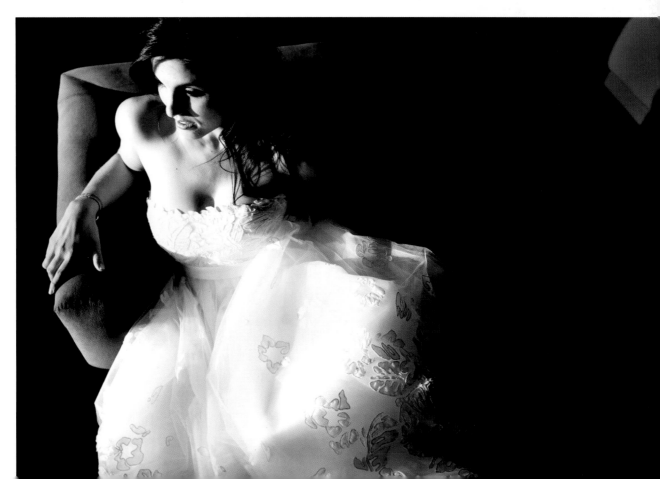

PLATE 211. PHOTOGRAPH
BY HUY NGUYEN

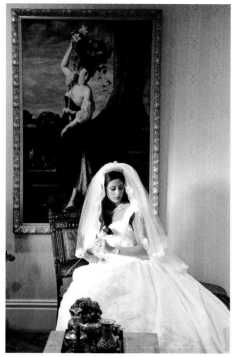

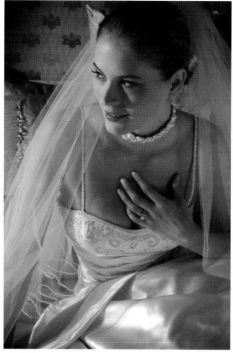

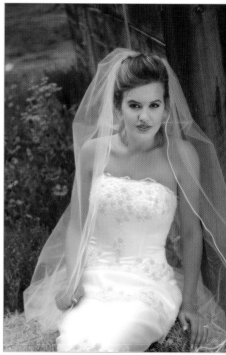

PLATE 212. PHOTOGRAPH BY JEFF AND KATHLEEN HAWKINS.

PLATE 213. PHOTOGRAPH BY CHERIE STEINBERG COTE.

PLATE 214. PHOTOGRAPH BY DAMON TUCCI.

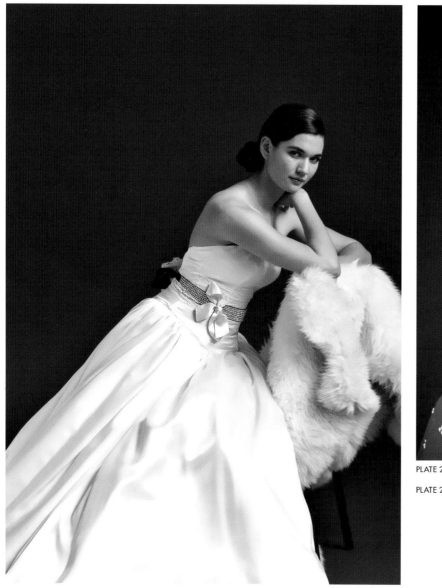

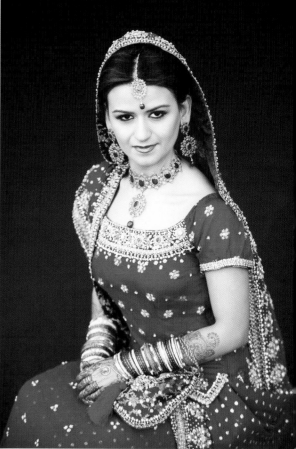

PLATE 215 (LEFT). PHOTOGRAPH BY MARC WEISBERG.

PLATE 216 (ABOVE). PHOTOGRAPH BY REGETI'S PHOTOGRAPHY.

PLATE 217. PHOTOGRAPH BY DAVE AND QUIN CHEUNG.

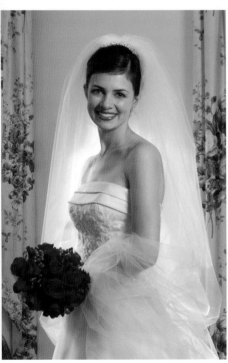

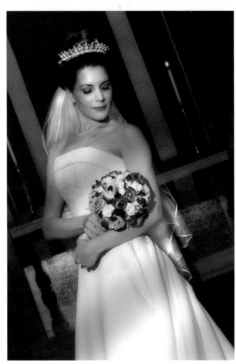

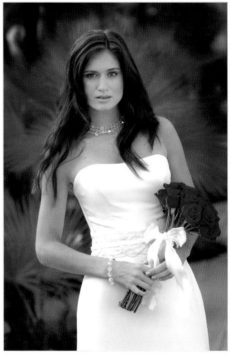

PLATE 218. PHOTOGRAPH BY DOUG BOX.

PLATE 219. PHOTOGRAPH BY JEFF AND KATHLEEN HAWKINS.

PLATE 220. PHOTOGRAPH BY DAMON TUCCI.

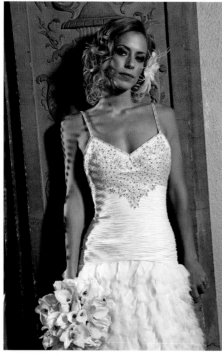

PLATE 221. PHOTOGRAPH BY CHERIE STEINBERG COTE.

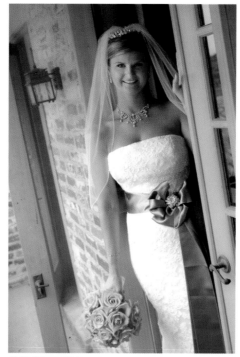

PLATE 222. PHOTOGRAPH BY DAMON TUCCI.

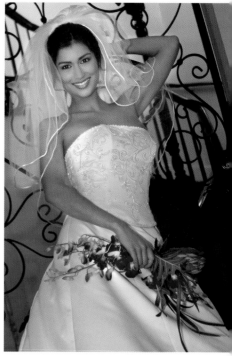

PLATE 223. PHOTOGRAPH BY JEFF AND KATHLEEN HAWKINS.

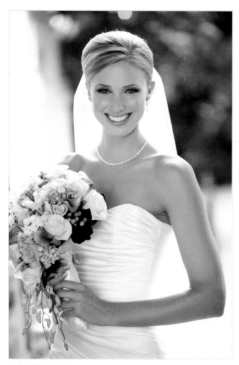

PLATE 224. PHOTOGRAPH BY REGETI'S PHOTOGRAPHY.

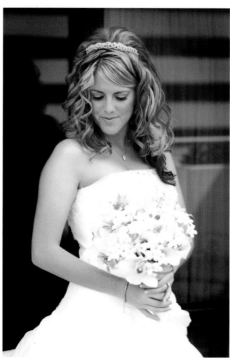

PLATE 225. PHOTOGRAPH BY REGETI'S PHOTOGRAPHY.

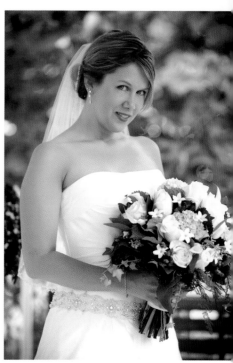

PLATE 226. PHOTOGRAPH BY REGETI'S PHOTOGRAPHY.

"Ten years ago, I looked at wedding photography and said, 'If I'm going to do wedding photography, I need to do **something different** with it.' So I started to do things like cross-processing and infrared. I got really good at those techniques, but the minute I mastered them, I thought, 'Okay, I know how to do this, I don't want to do it anymore.' I always want to move on and learn something new."[12]—*Cherie Steinberg Cote*

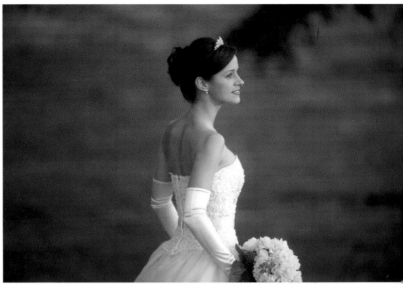

PLATE 229. PHOTOGRAPH BY DOUG BOX.

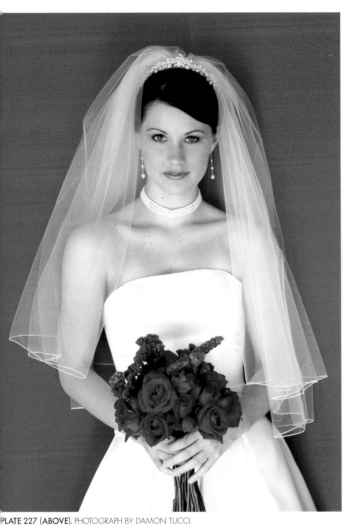

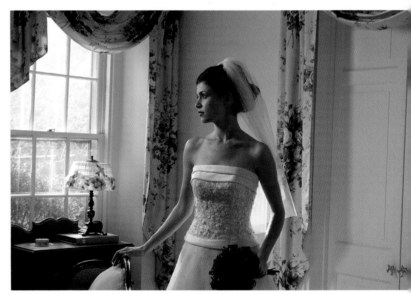

PLATE 227 (ABOVE). PHOTOGRAPH BY DAMON TUCCI.

PLATE 228 (BELOW). PHOTOGRAPH BY HUY NGUYEN

PLATE 230. PHOTOGRAPH BY DOUG BOX.

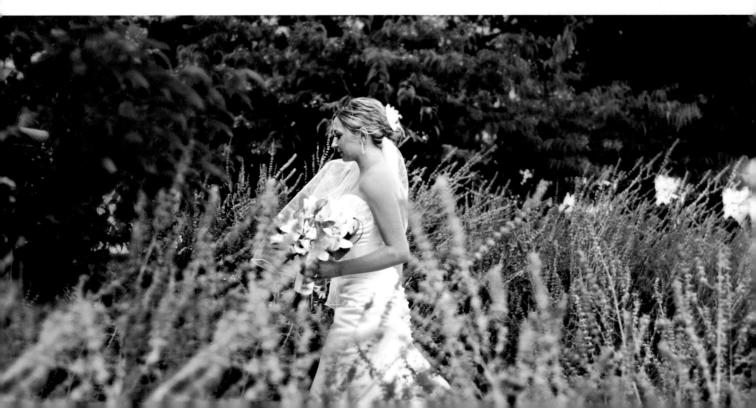

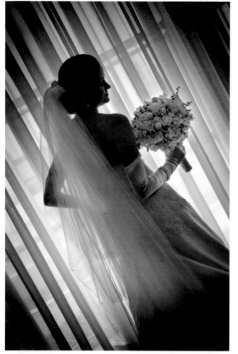

PLATE 231. PHOTOGRAPH BY JEFF AND KATHLEEN HAWKINS.

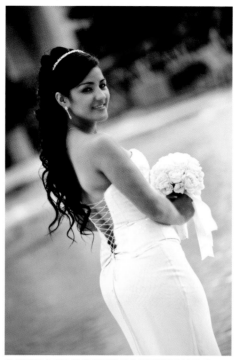

PLATE 232. PHOTOGRAPH BY JEFF AND KATHLEEN HAWKINS.

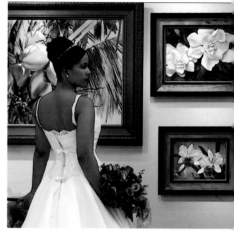

PLATE 233. PHOTOGRAPH BY RICK AND DEBORAH FERRO.

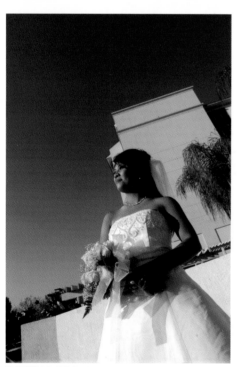

PLATE 234. PHOTOGRAPH BY JEFF AND KATHLEEN HAWKINS.

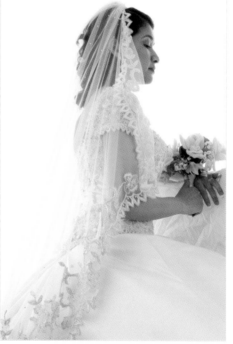

PLATE 235. PHOTOGRAPH BY MARK CHEN.

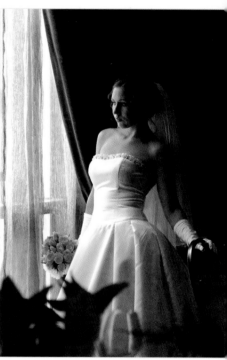

PLATE 236. PHOTOGRAPH BY RICK AND DEBORAH FERRO.

"The bouquet is a special part of the bride's attire and an important prop for your photography. Treat it with care. You may wish to shoot it in different areas—in the bride's hands, cradled in her arms, sitting on a nearby ledge, etc. Be sure the bride holds the bouquet gracefully and naturally."[13]—*Rick Ferro*

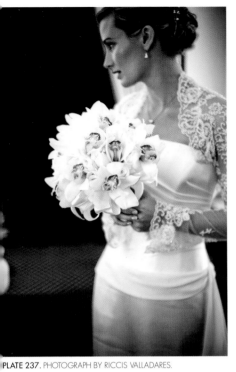

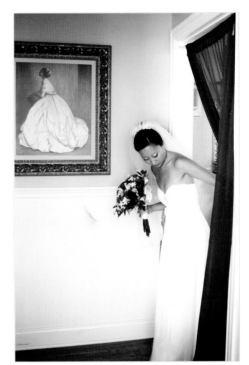

PLATE 237. PHOTOGRAPH BY RICCIS VALLADARES.

PLATE 238. PHOTOGRAPH BY RICCIS VALLADARES.

PLATE 239. PHOTOGRAPH BY TRACY DORR.

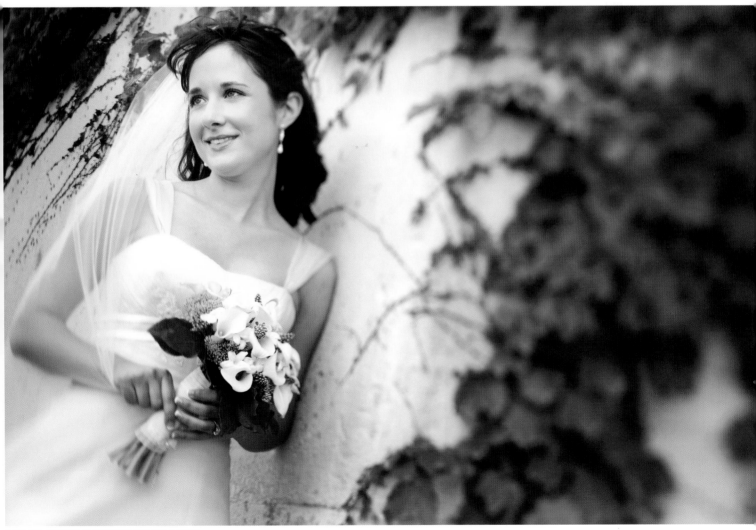

PLATE 240. PHOTOGRAPH BY JEFFREY AND JULIA WOODS.

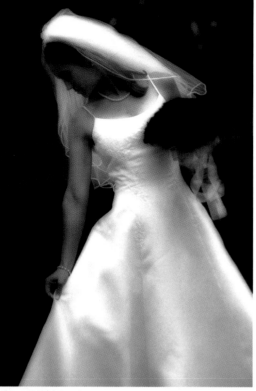

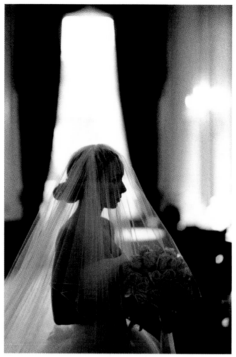

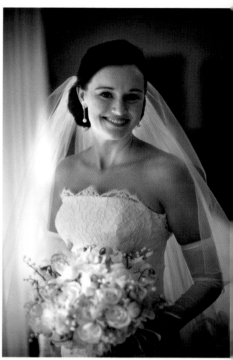

PLATE 241. PHOTOGRAPH BY JEFF AND KATHLEEN HAWKINS.

PLATE 242. PHOTOGRAPH BY JEFF AND KATHLEEN HAWKINS.

PLATE 243. PHOTOGRAPH BY JEFF AND KATHLEEN HAWKINS.

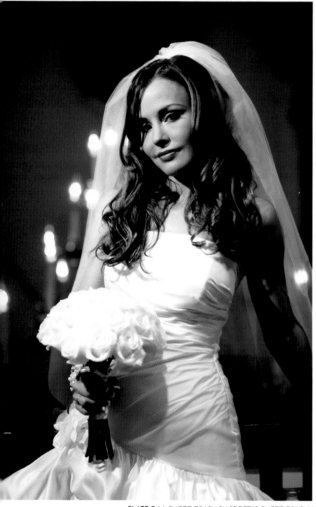

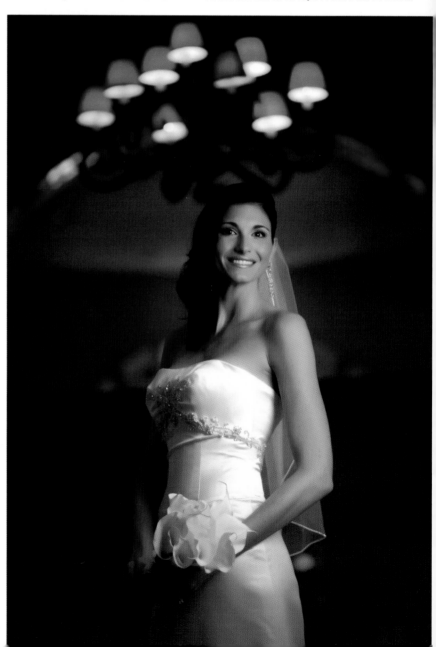

PLATE 244. PHOTOGRAPH BY REGETI'S PHOTOGRAPHY.

PLATE 245. PHOTOGRAPH BY KEVIN JAIRAJ.

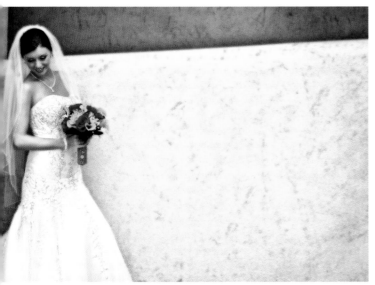

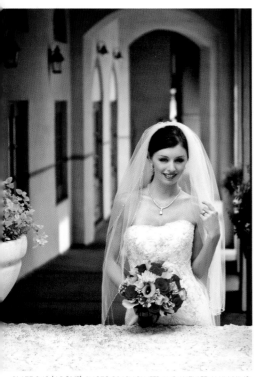

"We are all about real moments, but we also want to capture some stylish fashion images—so we are not embarrassed to say we are posers. Not all of our wedding clients are models; they usually need a little direction."[14]—*Damon Tucci*

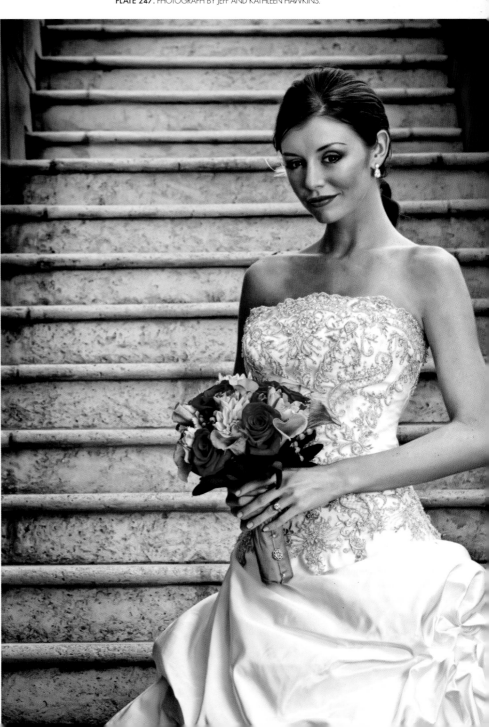

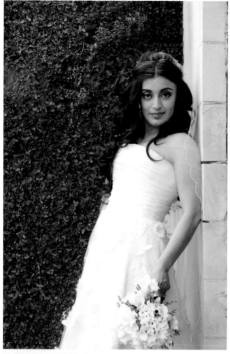

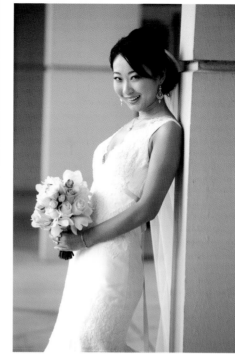

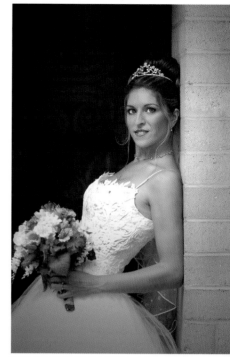

PLATE 250. PHOTOGRAPH BY MARK CHEN.

PLATE 251. PHOTOGRAPH BY REGETI'S PHOTOGRAPHY.

PLATE 252. PHOTOGRAPH BY JEFF AND KATHLEEN HAWKINS.

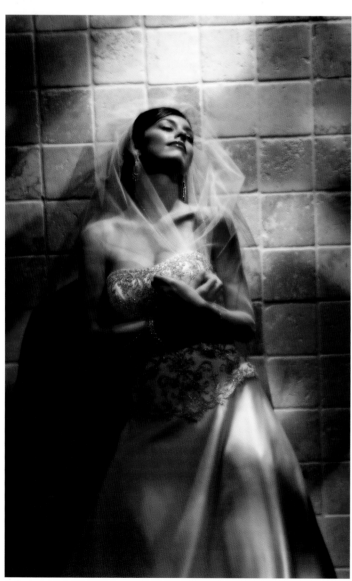

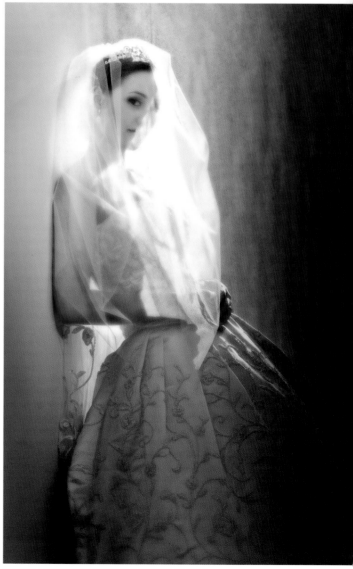

PLATE 253. PHOTOGRAPH BY JEFF AND KATHLEEN HAWKINS.

PLATE 254. PHOTOGRAPH BY JEFF AND KATHLEEN HAWKINS.

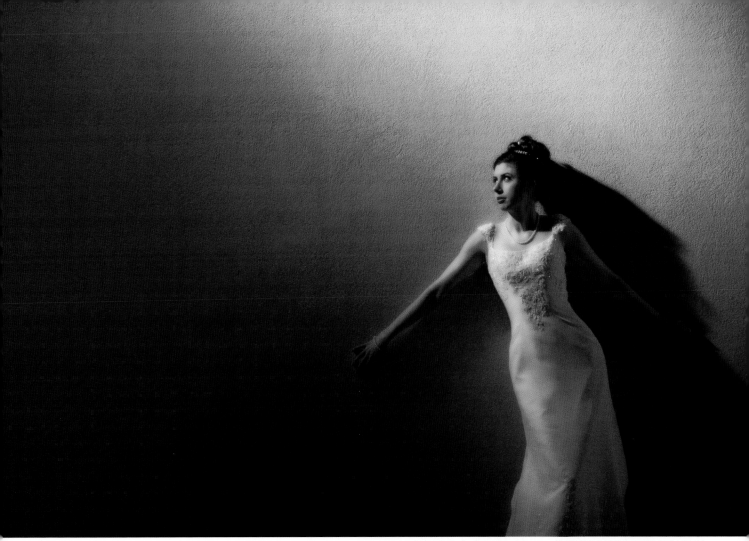

PLATE 255. PHOTOGRAPH BY KEVIN JAIRAJ.

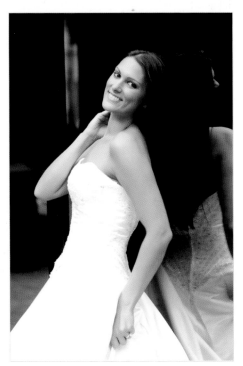

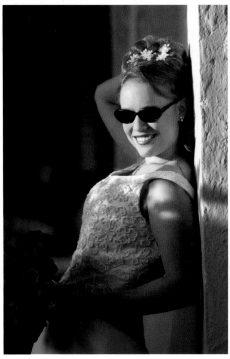

PLATE 256. PHOTOGRAPH BY TRACY DORR.

PLATE 257. PHOTOGRAPH BY REGETI'S PHOTOGRAPHY.

PLATE 258. PHOTOGRAPH BY JEFF AND KATHLEEN HAWKINS.

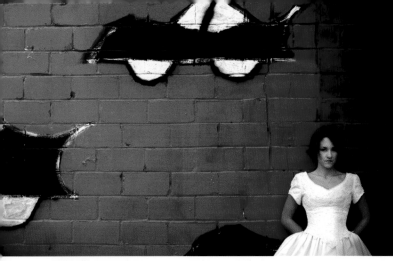

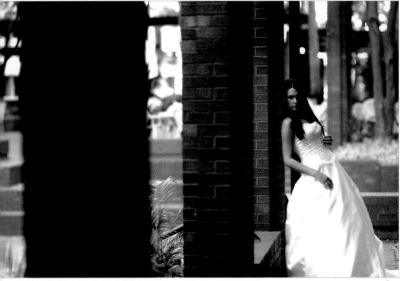

PLATE 259. PHOTOGRAPH BY DAMON TUCCI.

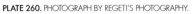

PLATE 260. PHOTOGRAPH BY REGETI'S PHOTOGRAPHY.

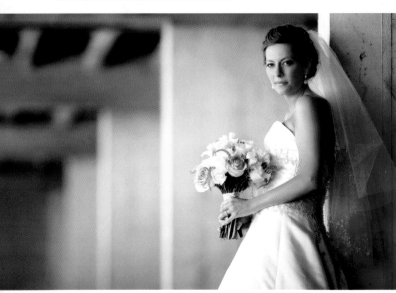

PLATE 261. PHOTOGRAPH BY JEFFREY AND JULIA WOODS.

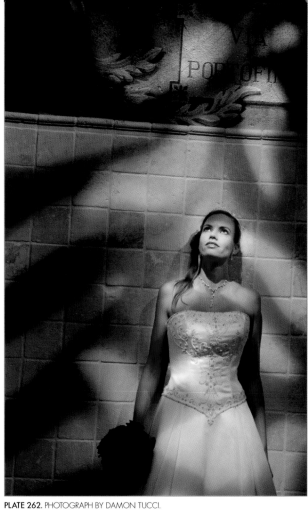

PLATE 262. PHOTOGRAPH BY DAMON TUCCI.

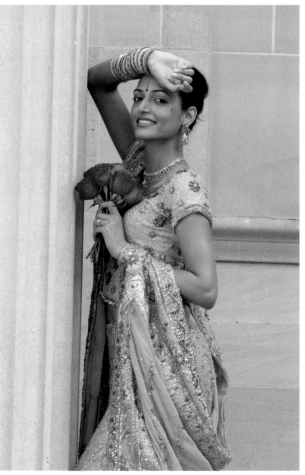

PLATE 263. PHOTOGRAPH BY MARK CHEN.

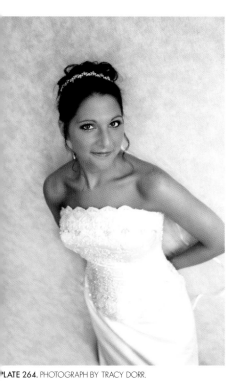

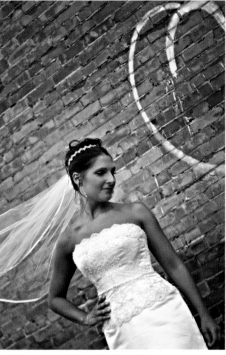

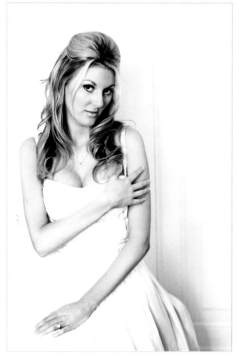

PLATE 264. PHOTOGRAPH BY TRACY DORR.

PLATE 265. PHOTOGRAPH BY TRACY DORR.

PLATE 266. PHOTOGRAPH BY DAWN SHIELDS.

PLATE 267. PHOTOGRAPH BY KEVIN JAIRAJ.

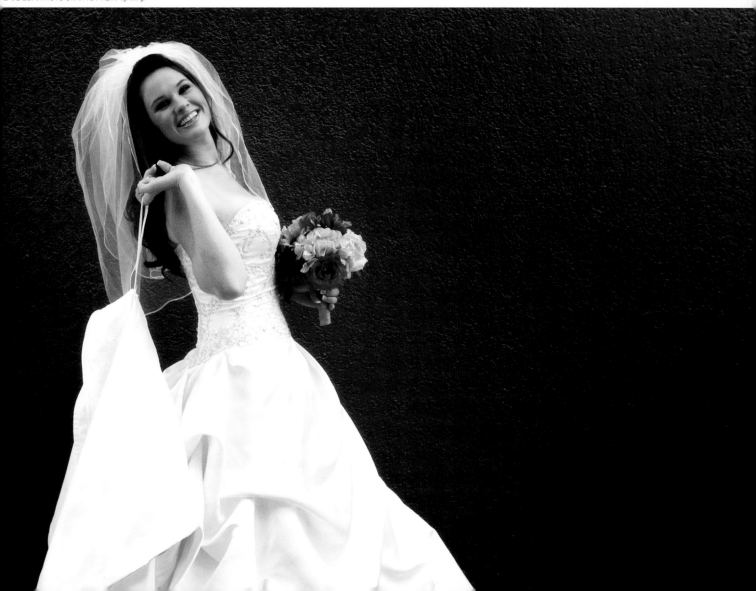

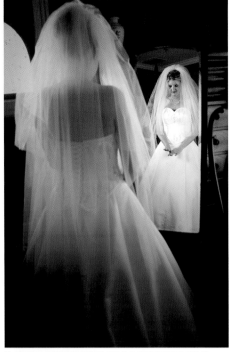

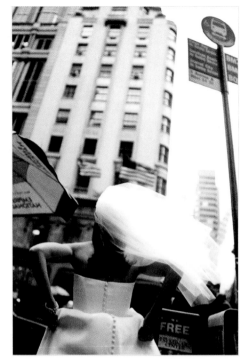

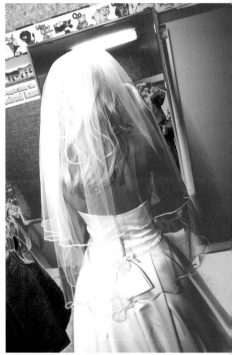

PLATE 268. PHOTOGRAPH BY JEFF AND KATHLEEN HAWKINS.

PLATE 269. PHOTOGRAPH BY JEFF AND KATHLEEN HAWKINS.

PLATE 270. PHOTOGRAPH BY JEFF AND KATHLEEN HAWKINS.

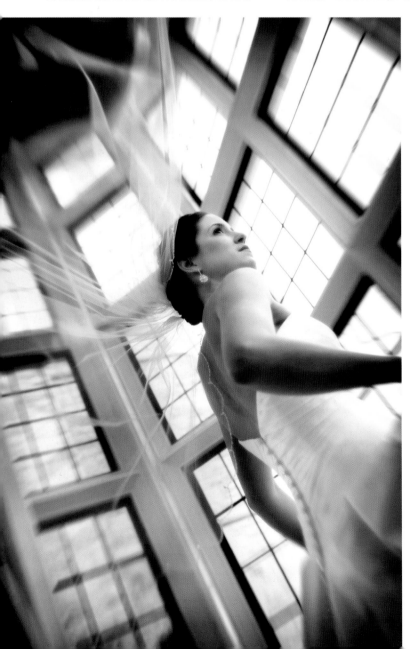

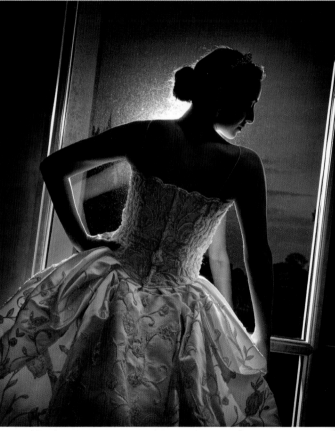

PLATE 271 (LEFT). PHOTOGRAPH BY TRACY DORR.

PLATE 272 (ABOVE). PHOTOGRAPH BY JEFF AND KATHLEEN HAWKINS.

"Technical efficiency can be a very satisfying thing, but the real **spine-tingling**, goose-bumping experiences come from the creation of a really awesome image. To hear our creative voice, we have to silence the technical chatter as much as possible. This comes with experience."[15]—*Kevin Kubota*

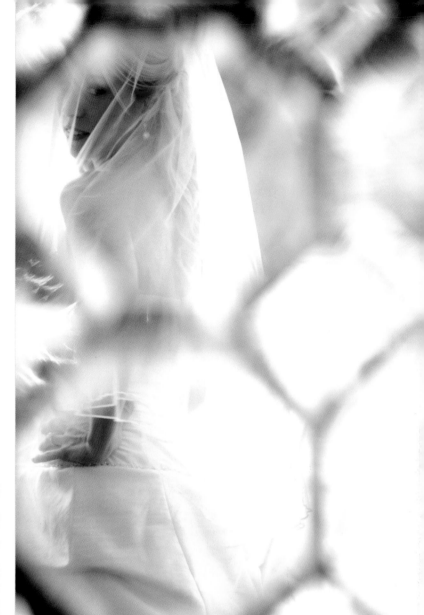

PLATE 273 (BELOW). PHOTOGRAPH BY RICCIS VALLADARES.

PLATE 274 (RIGHT). PHOTOGRAPH BY HUY NGUYEN.

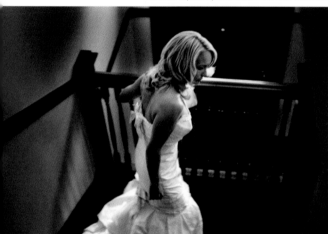

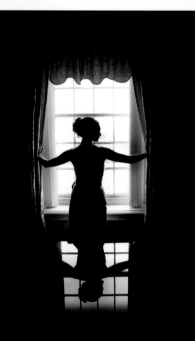

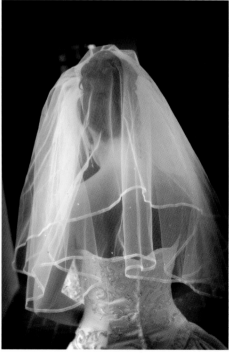

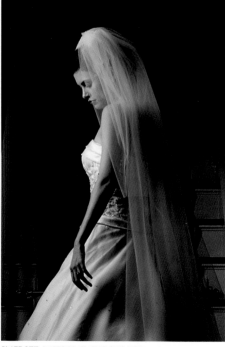

PLATE 275. PHOTOGRAPH BY DAWN SHIELDS.

PLATE 276. PHOTOGRAPH BY DAMON TUCCI.

PLATE 277. PHOTOGRAPH BY DOUG BOX.

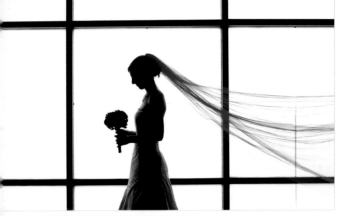

PLATE 278. PHOTOGRAPH BY HUY NGUYEN.

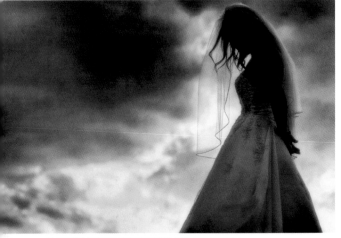

PLATE 279. PHOTOGRAPH BY JEFFREY AND JULIA WOODS.

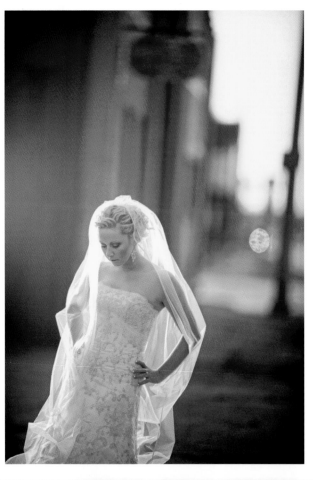

PLATE 280 (LEFT). PHOTOGRAPH BY JEFFREY AND JULIA WOODS.

PLATE 281 (BELOW). PHOTOGRAPH BY HUY NGUYEN.

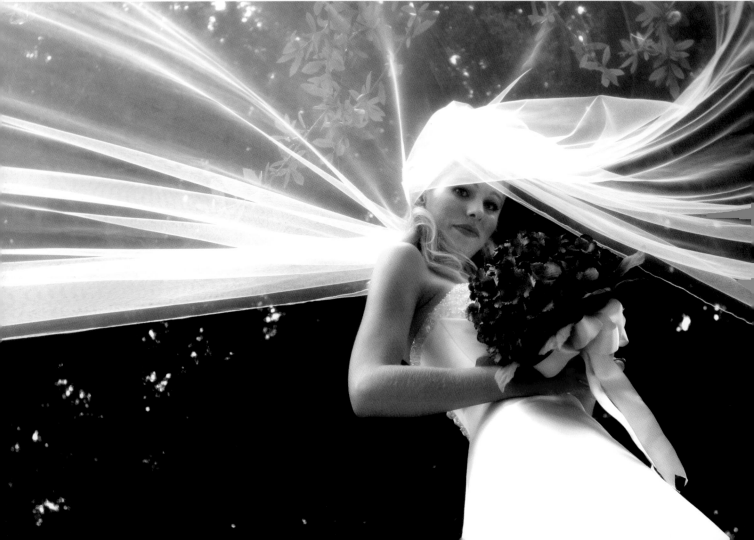

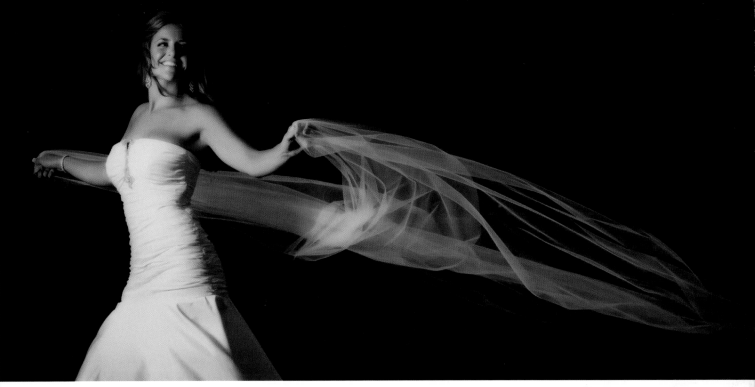

PLATE 282 (ABOVE). PHOTOGRAPH BY KEVIN JAIRAJ.

PLATE 283 (RIGHT). PHOTOGRAPH BY DAVE AND QUIN CHEUNG.

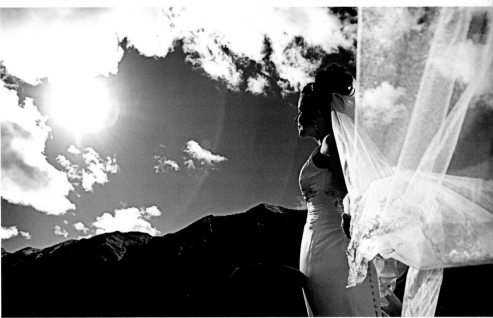

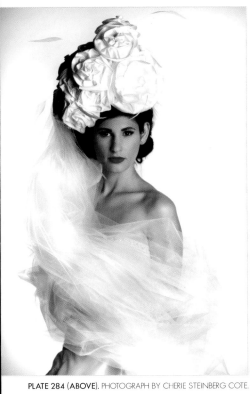

PLATE 284 (ABOVE). PHOTOGRAPH BY CHERIE STEINBERG COTE.

PLATE 285 (RIGHT). PHOTOGRAPH BY DAVE AND QUIN CHEUNG.

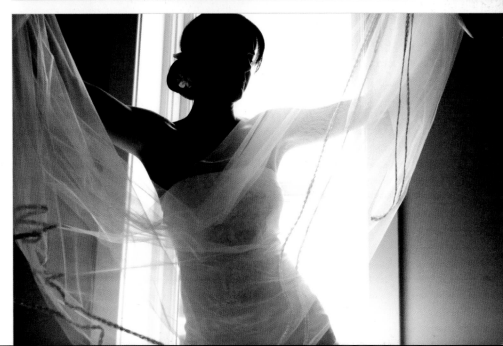

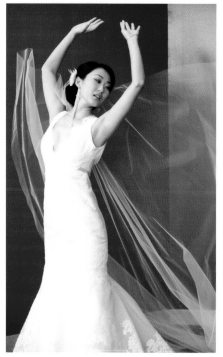

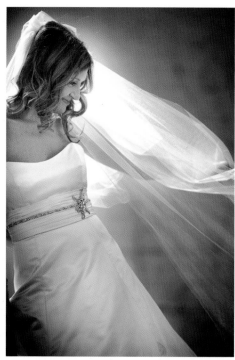

"'Shift your weight' is a key phrase that can really help flatter the subject in their photos. Some people have a difficult time learning to **shift their weight** away from the camera, and it may take some practice. [The engagement session] allows some time for this, so you don't have to slow down the portraits on the wedding day."[16]—*Kathleen Hawkins*

PLATE 286. PHOTOGRAPH BY REGETI'S PHOTOGRAPHY.

PLATE 287. PHOTOGRAPH BY JEFFREY AND JULIA WOODS.

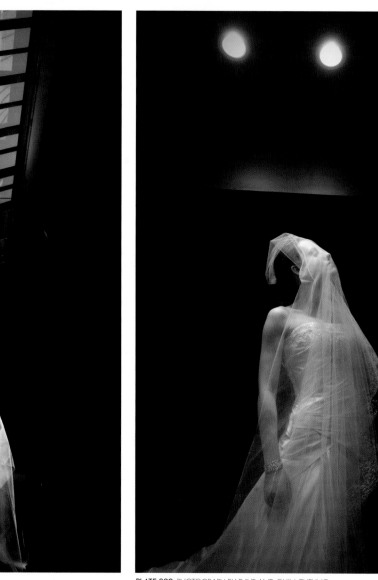

PLATE 288. PHOTOGRAPH BY DAVE AND QUIN CHEUNG.

PLATE 289. PHOTOGRAPH BY DAVE AND QUIN CHEUNG.

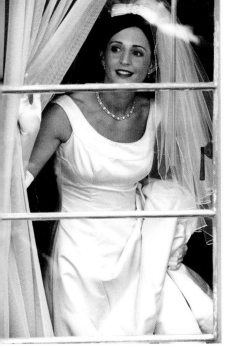

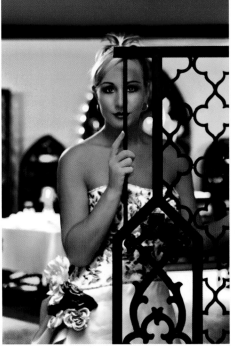

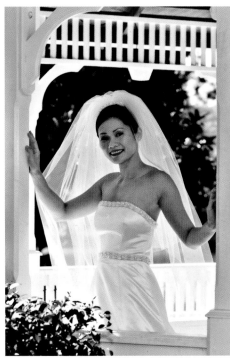

PLATE 290. PHOTOGRAPH BY JEFF AND KATHLEEN HAWKINS. PLATE 291. PHOTOGRAPH BY RICK AND DEBORAH FERRO. PLATE 292. PHOTOGRAPH BY RICK AND DEBORAH FERRO.

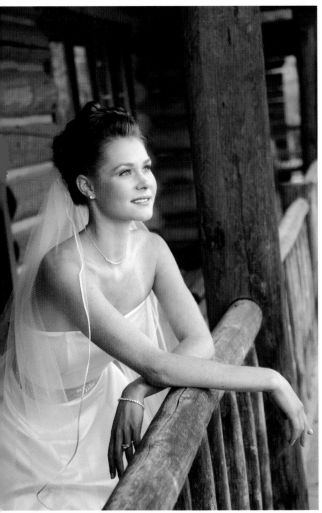

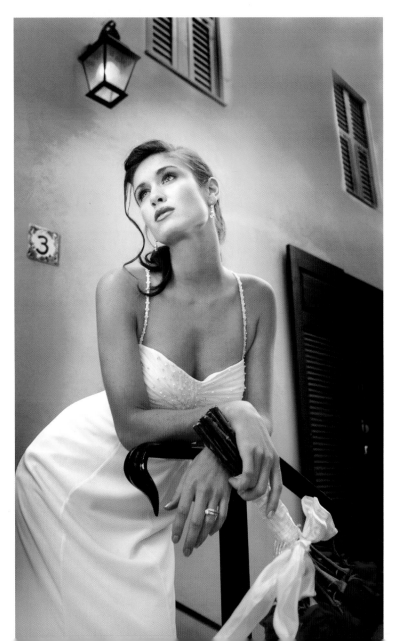

PLATE 293 (ABOVE). PHOTOGRAPH BY DAMON TUCCI.

PLATE 294 (RIGHT). PHOTOGRAPH BY DAMON TUCCI.

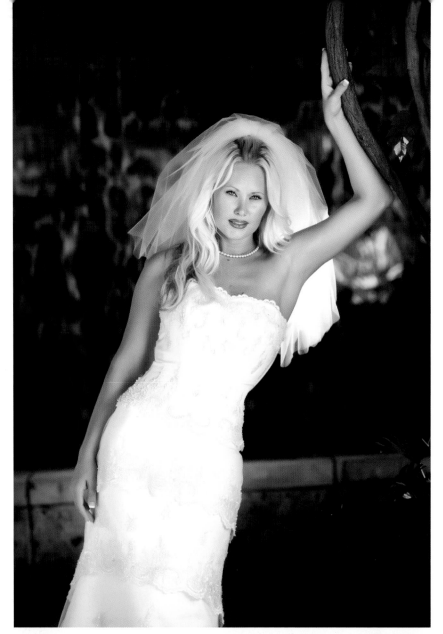

"I like to put a little 'dance' in my poses—a sense of swing or movement that makes the photograph a **more vivid** and natural portrait. After all, if you are looking for elegance in your images, why would you want poses that just make your subjects look stiff?"[17]—*Rick Ferro*

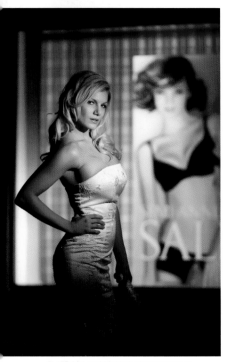

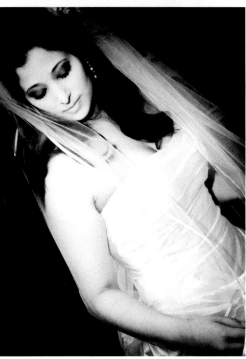

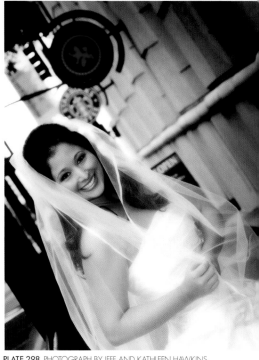

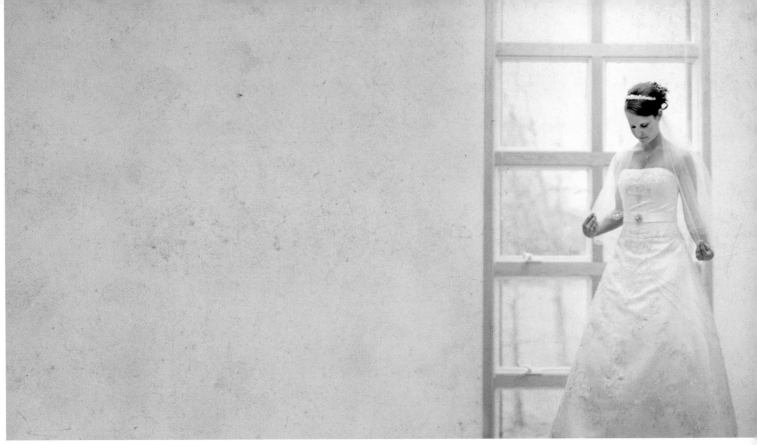

PLATE 299. PHOTOGRAPH BY JEFFREY AND JULIA WOODS.

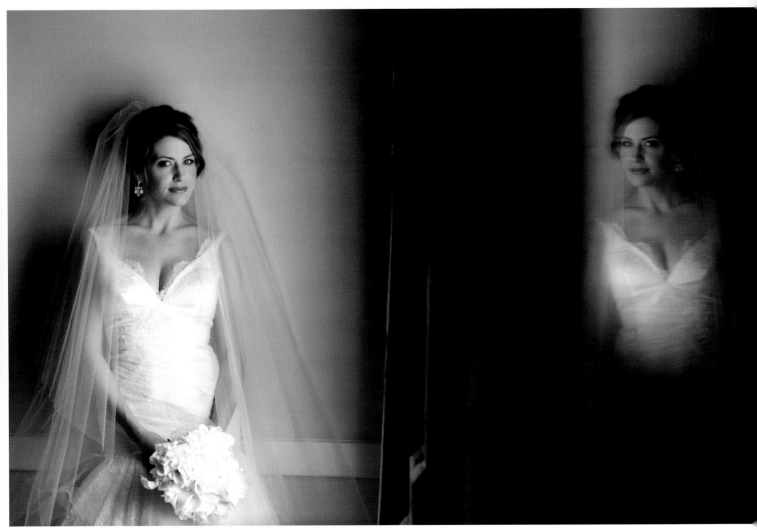

PLATE 300. PHOTOGRAPH BY HUY NGUYEN.

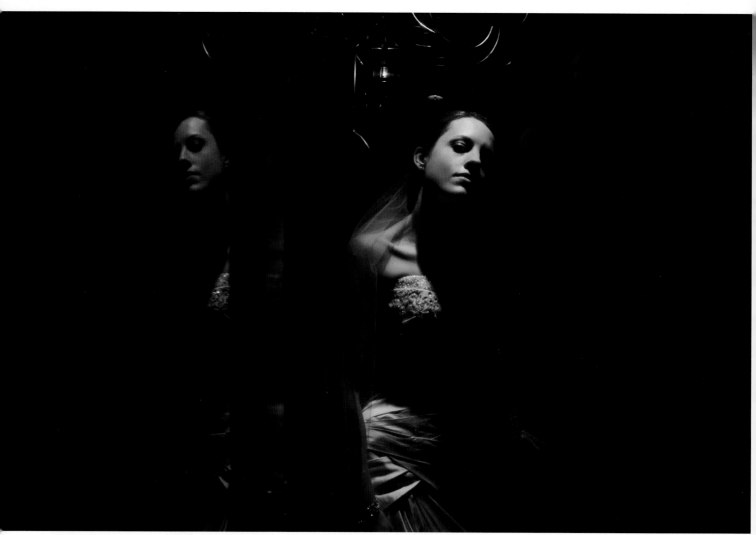

PLATE 301. PHOTOGRAPH BY DAVE AND QUIN CHEUNG.

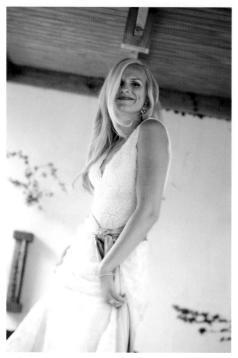

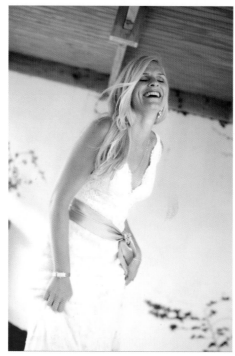

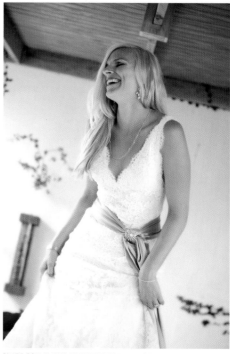

PLATE 302. PHOTOGRAPH BY KEVIN KUBOTA.

PLATE 303. PHOTOGRAPH BY KEVIN KUBOTA.

PLATE 304. PHOTOGRAPH BY KEVIN KUBOTA.

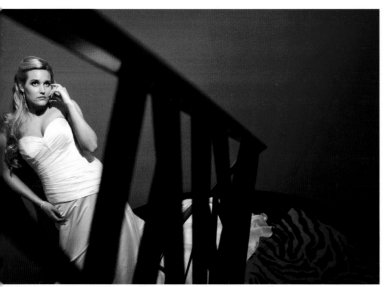

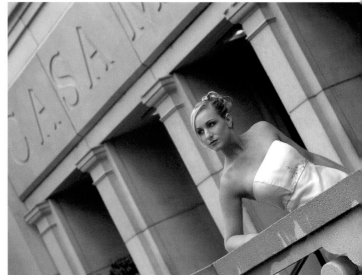

PLATE 305. PHOTOGRAPH BY HUY NGUYEN.

PLATE 306. PHOTOGRAPH BY RICK AND DEBORAH FERRO.

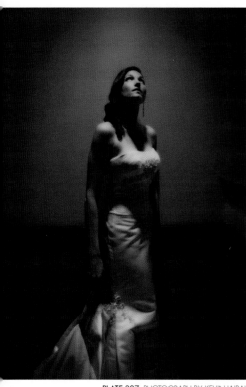

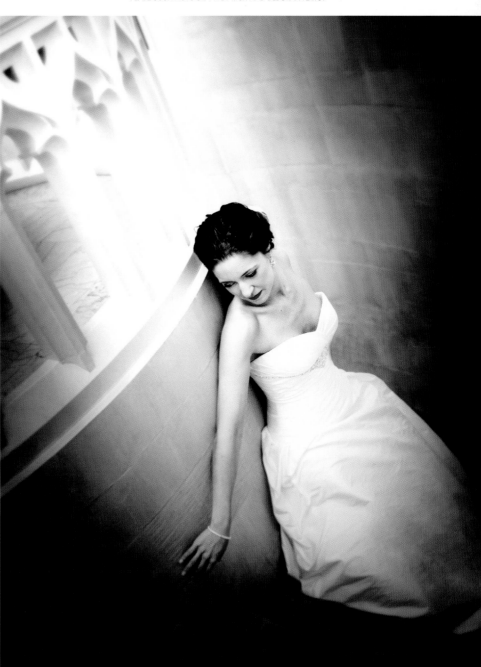

PLATE 307. PHOTOGRAPH BY KEVIN JAIRAJ.

PLATE 308 (RIGHT). PHOTOGRAPH BY TRACY DORR.

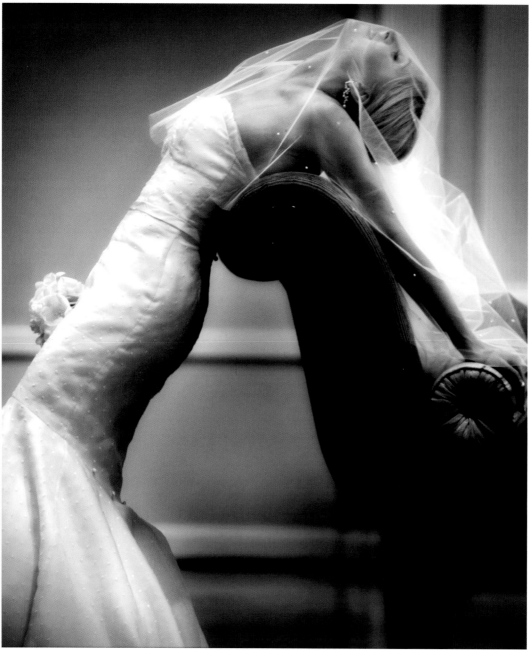

"A wedding is an uncontrolled situation. Sometime you hit **home runs**, sometimes you strike out. But if I only shot what I knew I could get, it would be boring. We all make mistakes, but hopefully they are outweighed by our successes."[18]—*Huy Nguyen*

PLATE 309. PHOTOGRAPH BY HUY NGUYEN.

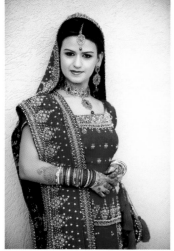

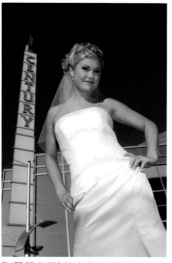

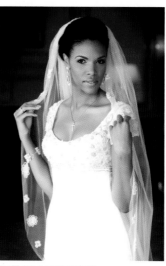

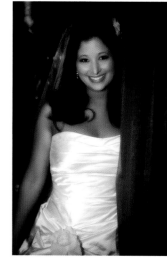

PLATE 310. PHOTOGRAPH BY REGETI'S PHOTOGRAPHY.

PLATE 311. PHOTOGRAPH BY DAMON TUCCI.

PLATE 312. PHOTOGRAPH BY REGETI'S PHOTOGRAPHY.

PLATE 313. PHOTOGRAPH BY JEFF AND KATHLEEN HAWKINS.

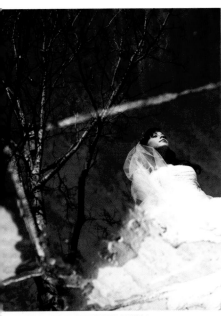

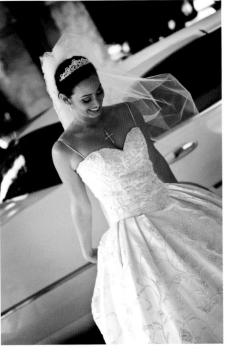

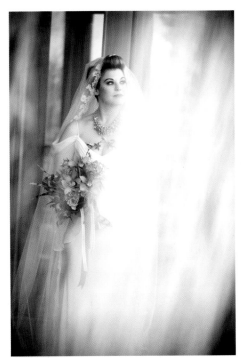

PLATE 314. PHOTOGRAPH BY HUY NGUYEN. PLATE 315. PHOTOGRAPH BY JEFF AND KATHLEEN HAWKINS. PLATE 316. PHOTOGRAPH BY KEVIN KUBOTA.

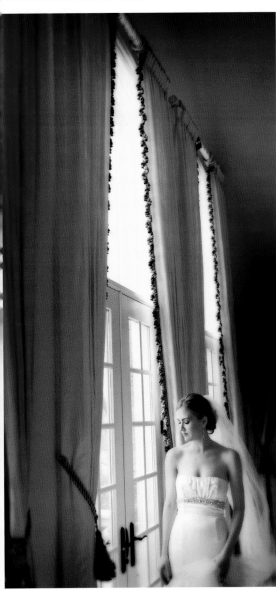

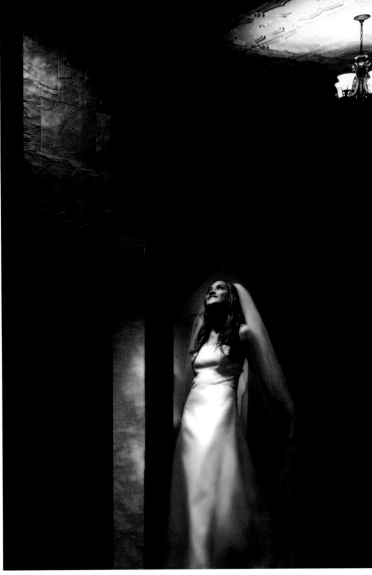

PLATE 317. PHOTOGRAPH BY JEFFREY AND JULIA WOODS. PLATE 318. PHOTOGRAPH BY DAWN SHIELDS.

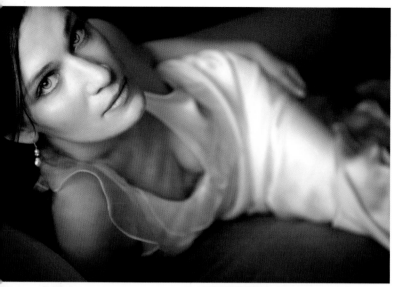

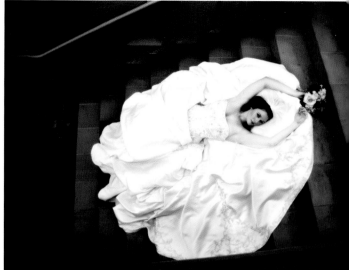

PLATE 319. PHOTOGRAPH BY DAVE AND QUIN CHEUNG.

PLATE 320. PHOTOGRAPH BY KEVIN JAIRAJ.

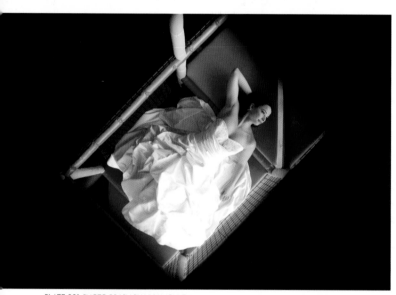

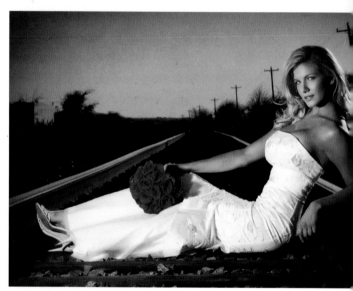

PLATE 321. PHOTOGRAPH BY HUY NGUYEN.

PLATE 322. PHOTOGRAPH BY KEVIN JAIRAJ.

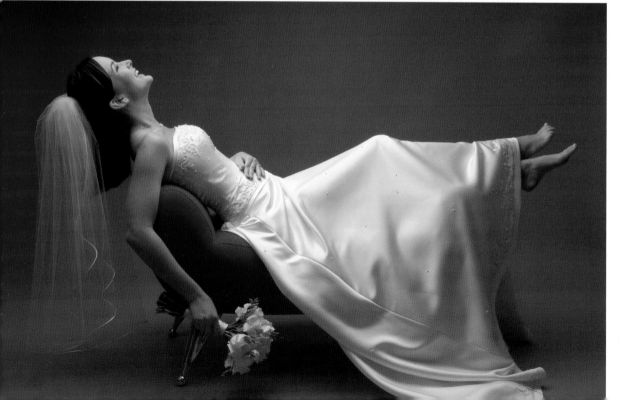

PLATE 323. PHOTOGRAPH BY MARK CHEN.

PLATE 324 (BELOW). PHOTOGRAPH BY MARK CHEN.

PLATE 325 (RIGHT). PHOTOGRAPH BY RICK AND DEBORAH FERRO.

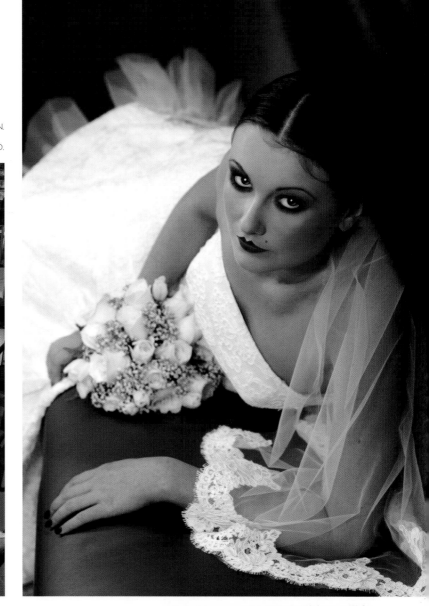

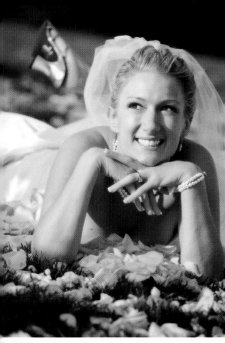

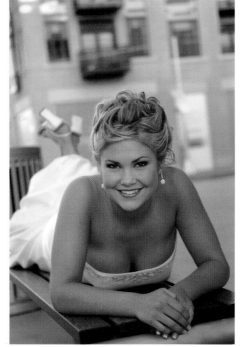

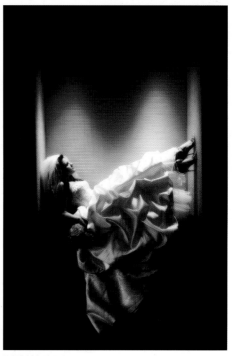

PLATE 326. PHOTOGRAPH BY KEVIN KUBOTA.

PLATE 327. PHOTOGRAPH BY DAMON TUCCI.

PLATE 328. PHOTOGRAPH BY KEVIN JAIRAJ.

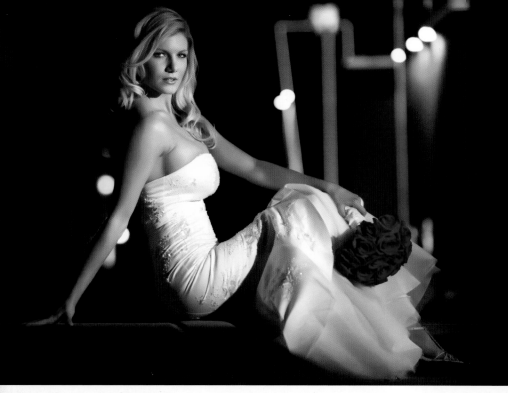

"We spend fifteen to twenty minutes doing a mini photo shoot with the bride alone [before the ceremony]. We are mindful not to get her dress dirty and usually ask the **maid of honor** to help with the train. We also carry a sheet to lay down under the dress. If you don't have a sheet, you can usually score some towels, tablecloths, or sheets from the venue."[19]—*Damon Tucci*

PLATE 329. PHOTOGRAPH BY KEVIN JAIRAJ.

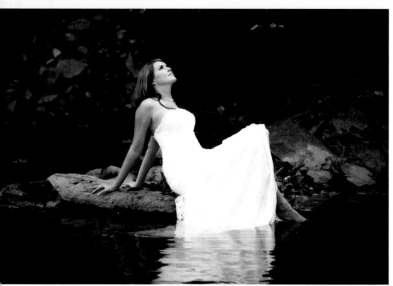

PLATE 330. PHOTOGRAPH BY REGETI'S PHOTOGRAPHY.

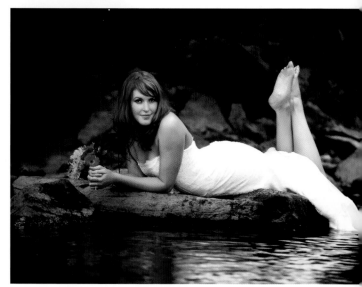

PLATE 331. PHOTOGRAPH BY REGETI'S PHOTOGRAPHY.

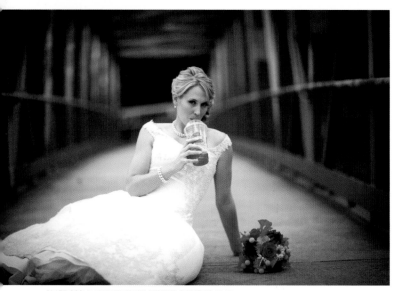

PLATE 332. PHOTOGRAPH BY REGETI'S PHOTOGRAPHY.

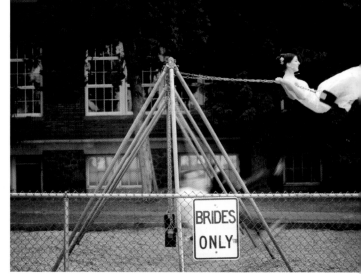

PLATE 333. PHOTOGRAPH BY KEVIN KUBOTA.

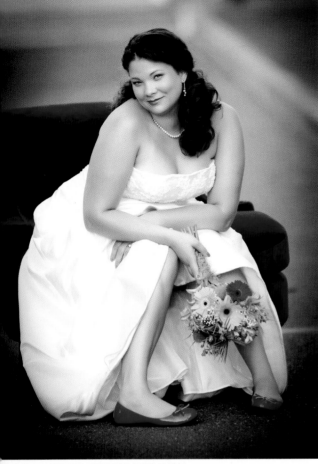

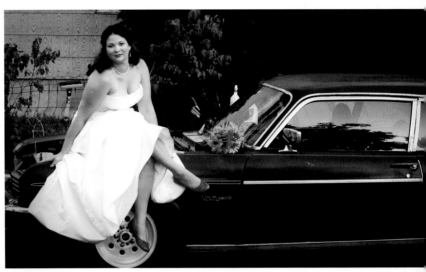

PLATE 336. PHOTOGRAPH BY REGETI'S PHOTOGRAPHY.

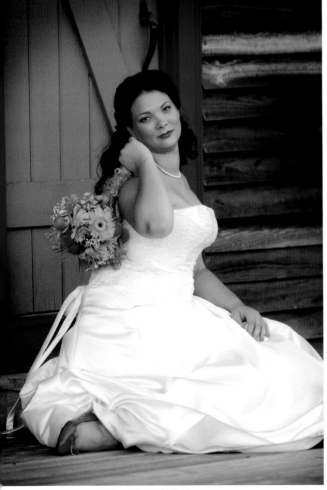

PLATE 334. PHOTOGRAPH BY REGETI'S PHOTOGRAPHY.

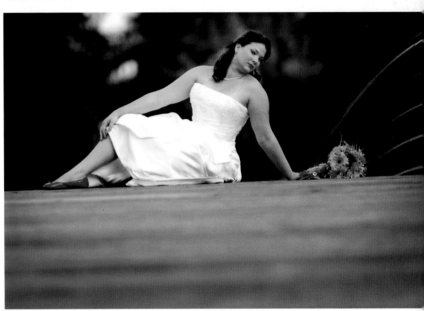

PLATE 337. PHOTOGRAPH BY REGETI'S PHOTOGRAPHY.

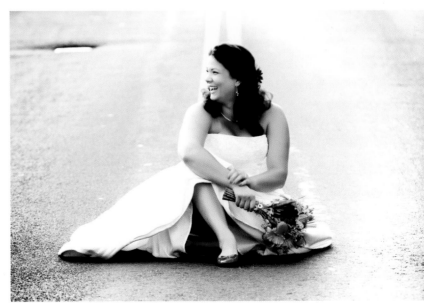

PLATE 335. PHOTOGRAPH BY REGETI'S PHOTOGRAPHY.

PLATE 338. PHOTOGRAPH BY REGETI'S PHOTOGRAPHY.

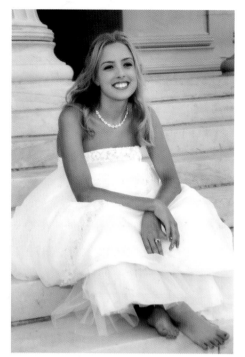

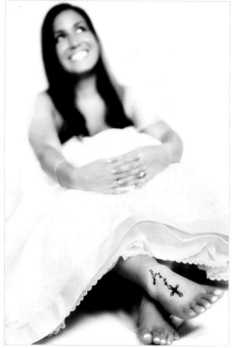

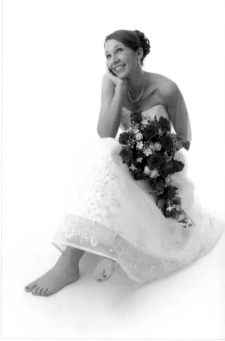

PLATE 339. PHOTOGRAPH BY TRACY DORR.

PLATE 340. PHOTOGRAPH BY TRACY DORR.

PLATE 341. PHOTOGRAPH BY MARK CHEN.

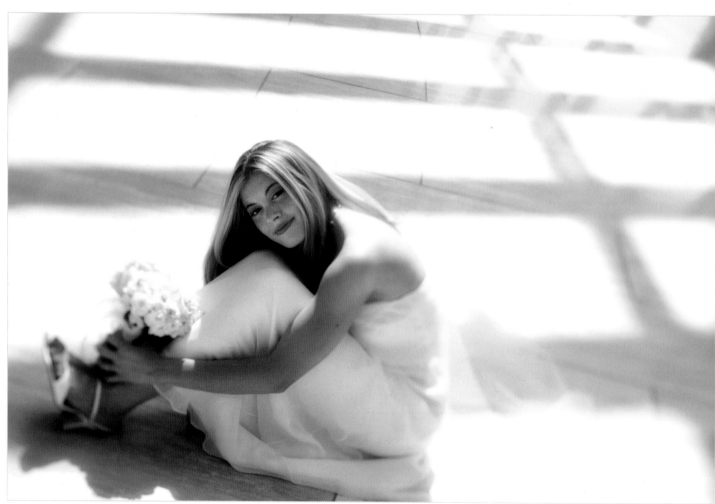

PLATE 342. PHOTOGRAPH BY HUY NGUYEN.

"Be confident when instructing [subjects] on poses you are looking for. **Your confidence** will assure them that they are in good hands and encourage them to put their trust in you."[20]—*Rick Ferro*

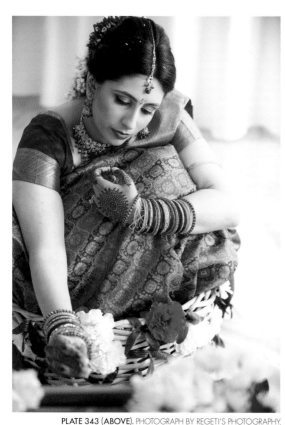

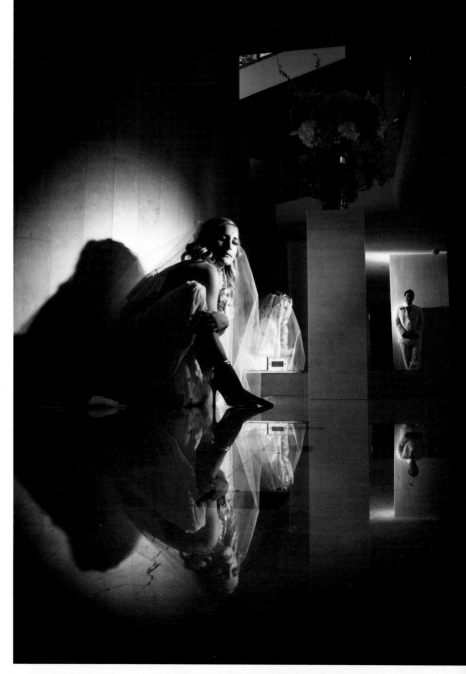

PLATE 343 (ABOVE). PHOTOGRAPH BY REGETI'S PHOTOGRAPHY.

PLATE 344 (RIGHT). PHOTOGRAPH BY DAVE AND QUIN CHEUNG.

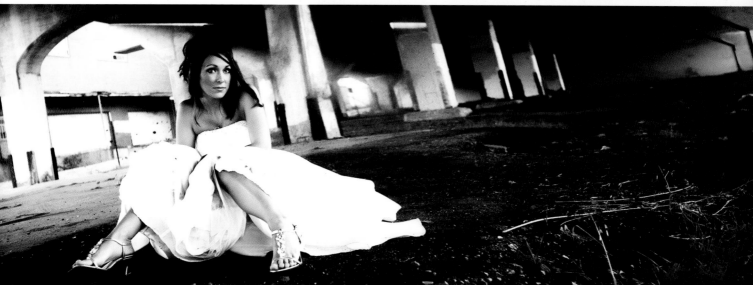

PLATE 345. PHOTOGRAPH BY DAWN SHIELDS.

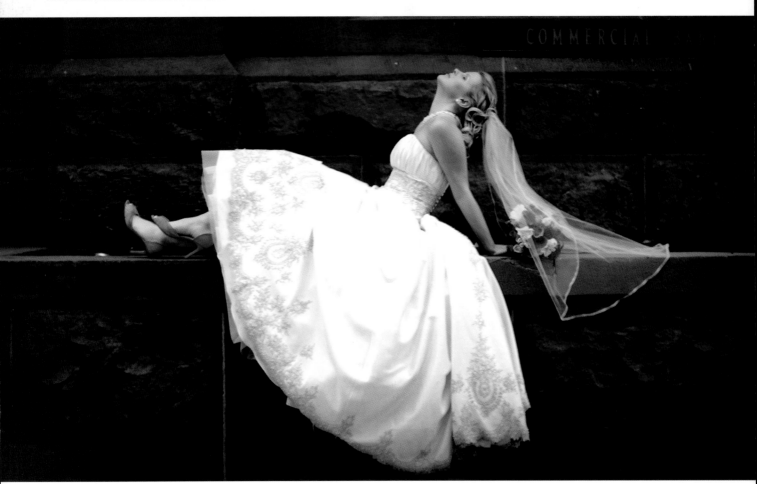

PLATE 346. PHOTOGRAPH BY REGETI'S PHOTOGRAPHY.

PLATE 347. PHOTOGRAPH BY REGETI'S PHOTOGRAPHY.

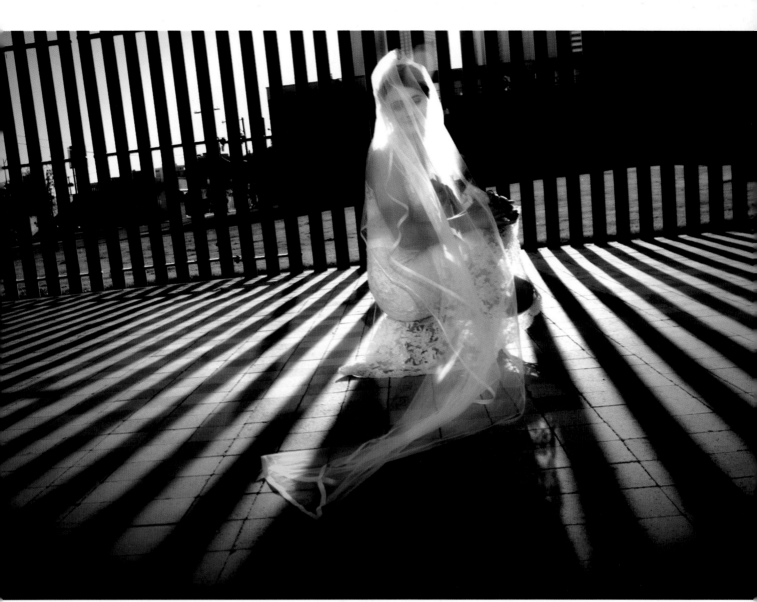

PLATE 348. PHOTOGRAPH BY HUY NGUYEN.

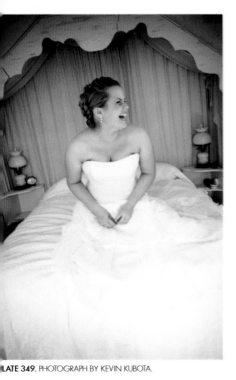

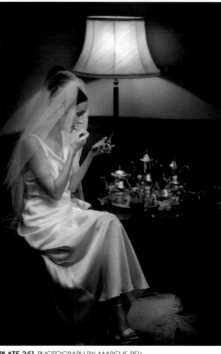

PLATE 349. PHOTOGRAPH BY KEVIN KUBOTA.

PLATE 350. PHOTOGRAPH BY REGETI'S PHOTOGRAPHY.

PLATE 351. PHOTOGRAPH BY MARCUS BELL.

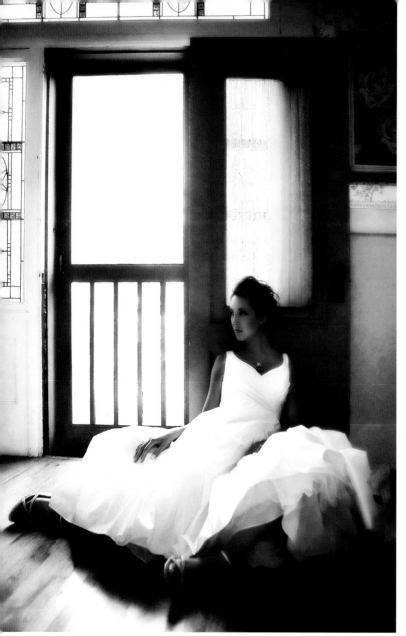

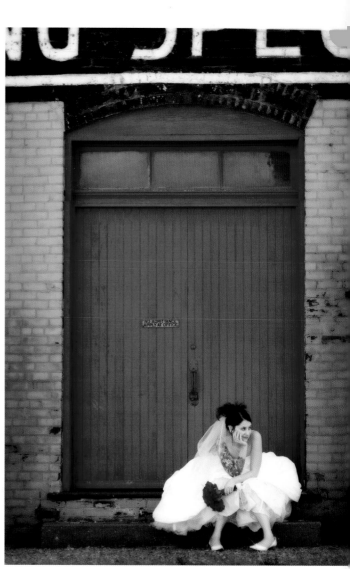

PLATE 352. PHOTOGRAPH BY DAWN SHIELDS.

PLATE 353. PHOTOGRAPH BY JEFFREY AND JULIA WOODS.

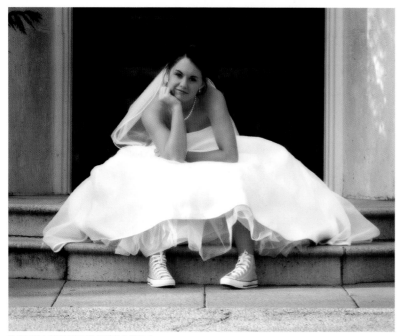

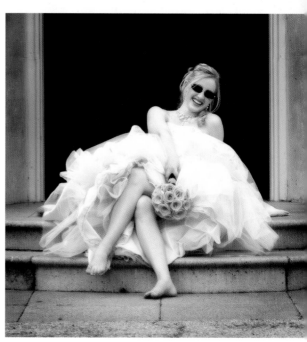

PLATE 354. PHOTOGRAPH BY KEVIN JAIRAJ.

PLATE 355. PHOTOGRAPH BY KEVIN JAIRAJ.

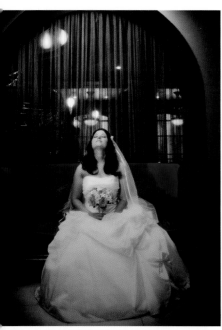

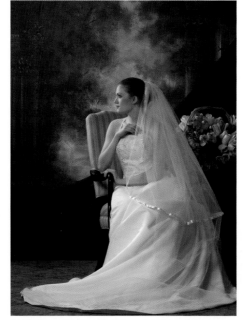

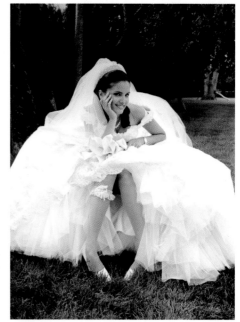

ATE 356. PHOTOGRAPH BY JEFF AND KATHLEEN HAWKINS.　　PLATE 357. PHOTOGRAPH BY RICK AND DEBORAH FERRO.　　PLATE 358. PHOTOGRAPH BY JEFF AND KATHLEEN HAWKINS.

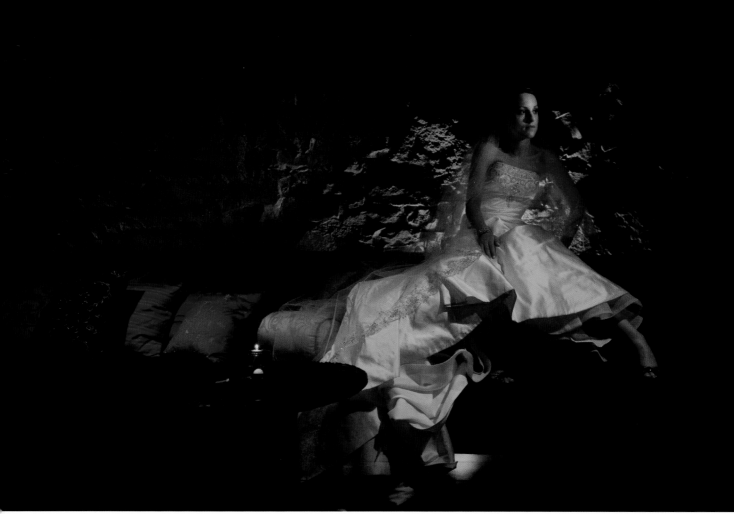

ATE 359 PHOTOGRAPH BY DAVE AND QUIN CHEUNG.

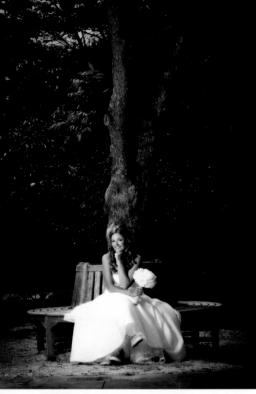

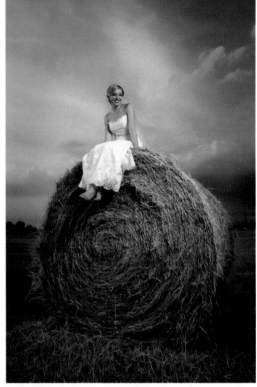

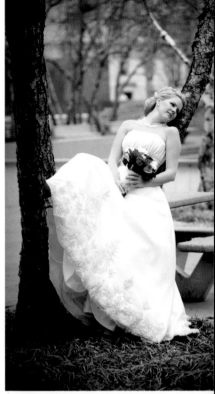

PLATE 360. PHOTOGRAPH BY KEVIN JAIRAJ.

PLATE 361. PHOTOGRAPH BY KEVIN JAIRAJ.

PLATE 362. PHOTOGRAPH BY REGETI'S PHOTOGRAPHY.

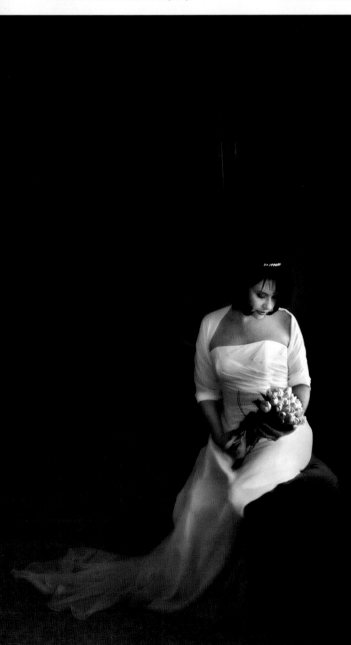

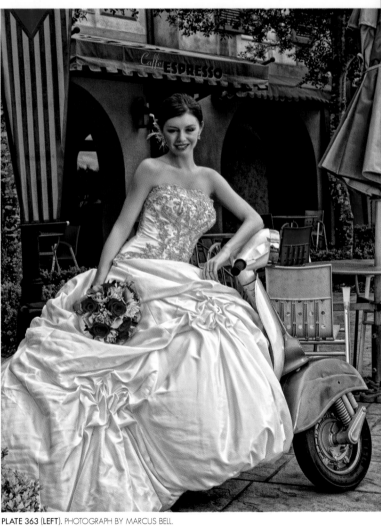

PLATE 363 (LEFT). PHOTOGRAPH BY MARCUS BELL.

PLATE 364 (ABOVE). PHOTOGRAPH BY JEFF AND KATHLEEN HAWKINS.

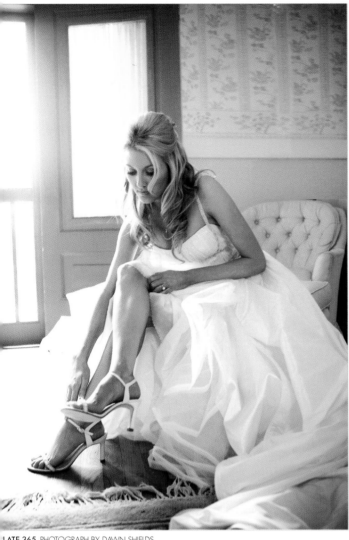

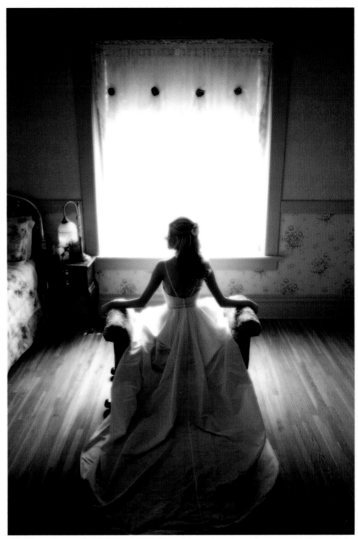

PLATE 365. PHOTOGRAPH BY DAWN SHIELDS.

PLATE 366. PHOTOGRAPH BY DAWN SHIELDS.

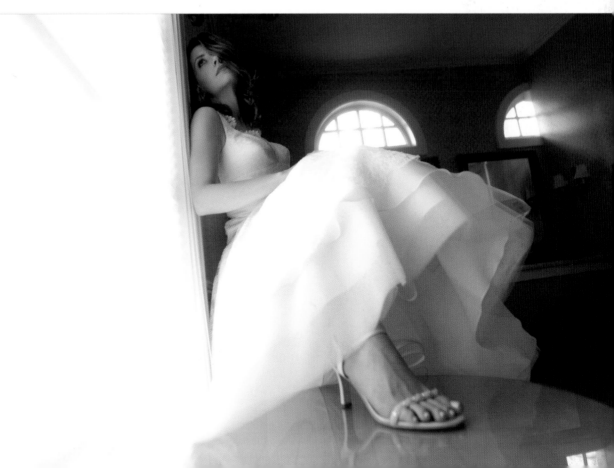

PLATE 367.
PHOTOGRAPH BY
HUY NGUYEN.

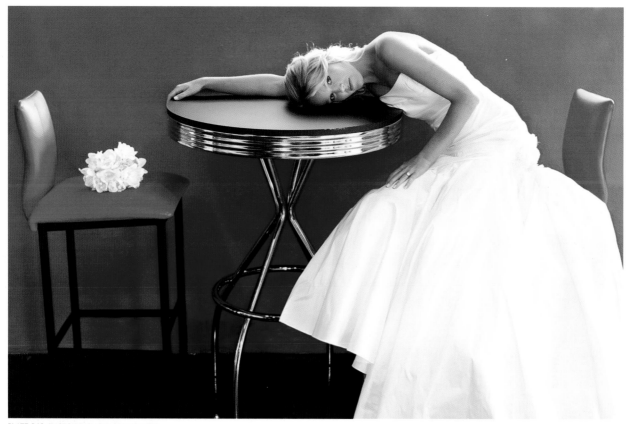

PLATE 368. PHOTOGRAPH BY HUY NGUYEN.

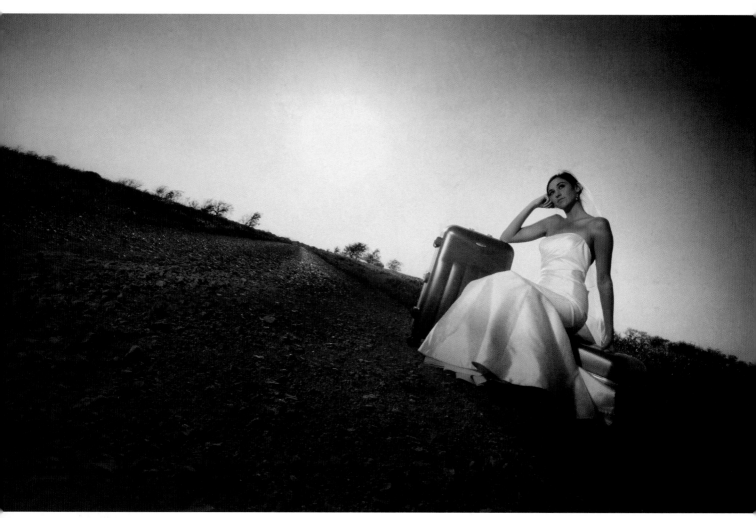

PLATE 369. PHOTOGRAPH BY KEVIN JAIRAJ.

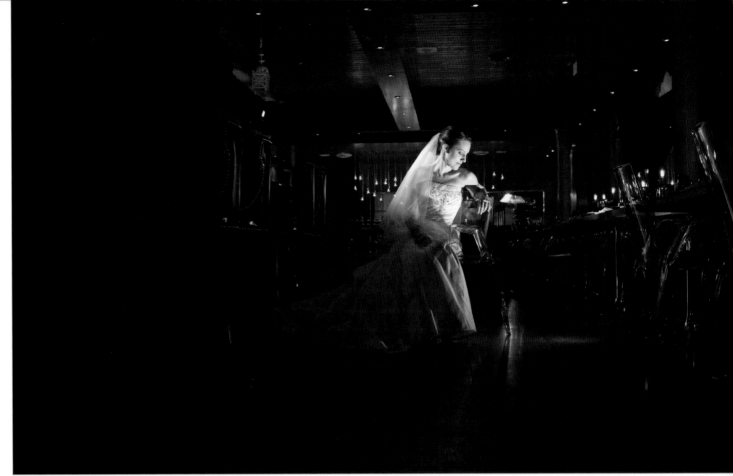

PLATE 370. PHOTOGRAPH BY DAVE AND QUIN CHEUNG.

PLATE 371 (BELOW). PHOTOGRAPH BY MARCUS BELL.

PLATE 372 (BELOW). PHOTOGRAPH BY RICK AND DEBORAH FERRO.

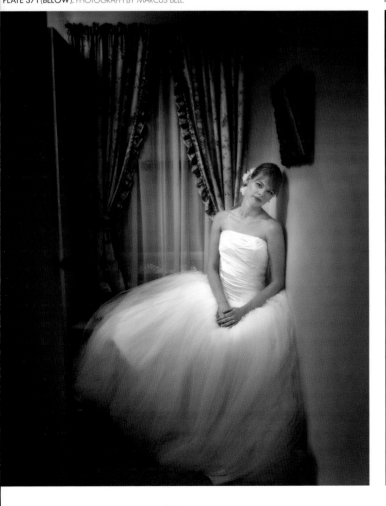

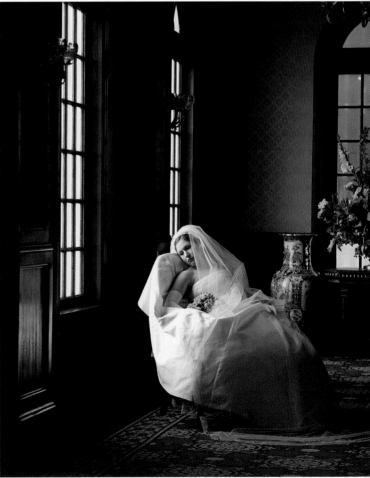

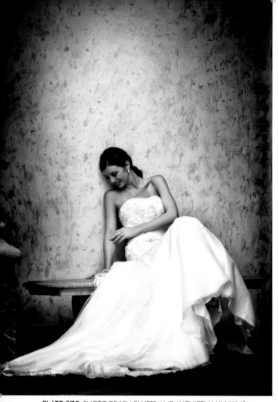

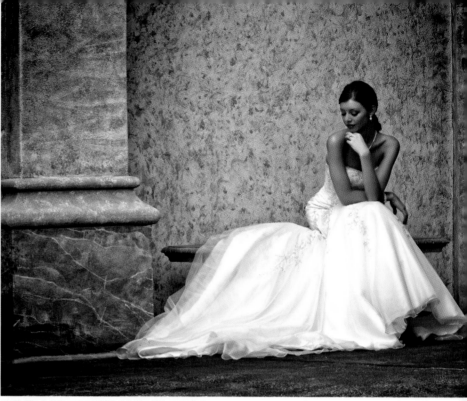

PLATE 373. PHOTOGRAPH BY JEFF AND KATHLEEN HAWKINS.

PLATE 374. PHOTOGRAPH BY JEFF AND KATHLEEN HAWKINS.

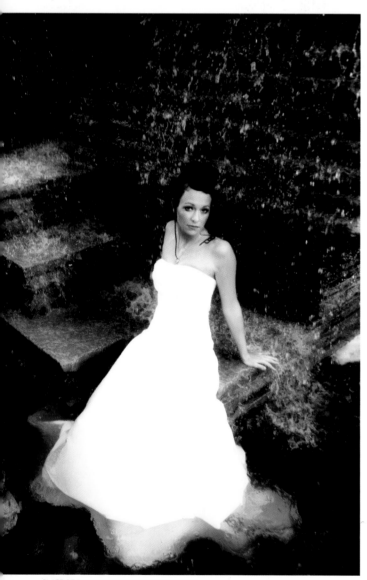

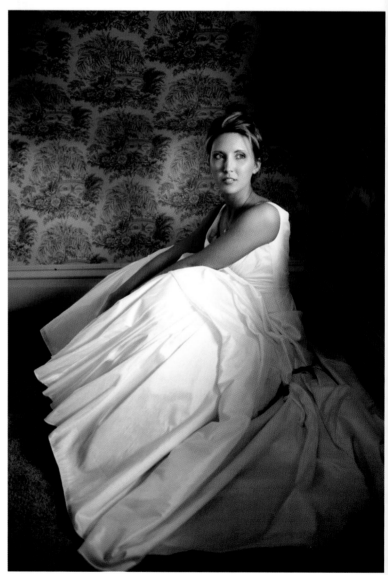

PLATE 375. PHOTOGRAPH BY DAWN SHIELDS.

PLATE 376. PHOTOGRAPH BY DAWN SHIELDS.

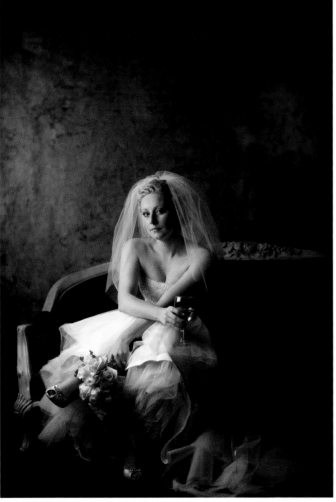

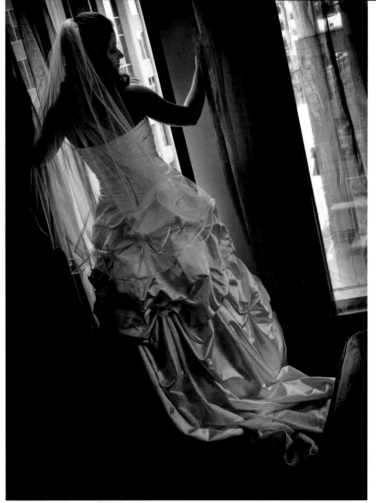

PLATE 377. PHOTOGRAPH BY JEFFREY AND JULIA WOODS.

PLATE 378. PHOTOGRAPH BY JEFF AND KATHLEEN HAWKINS.

PLATE 379 (BELOW). PHOTOGRAPH BY KEVIN JAIRAJ.

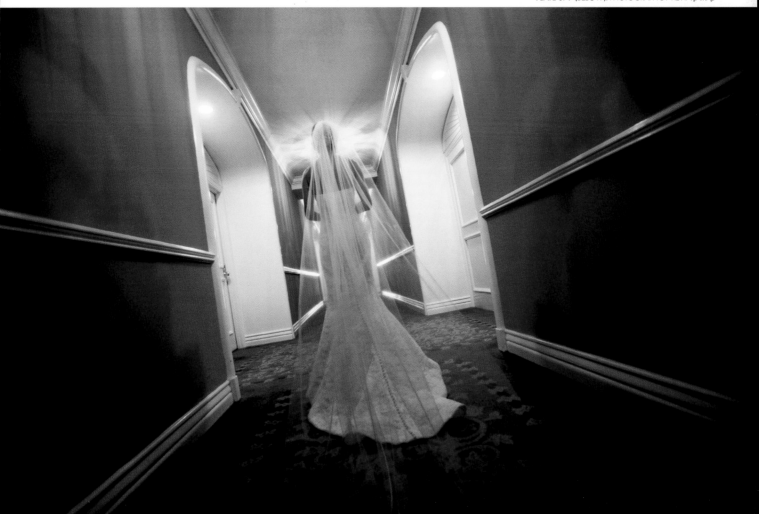

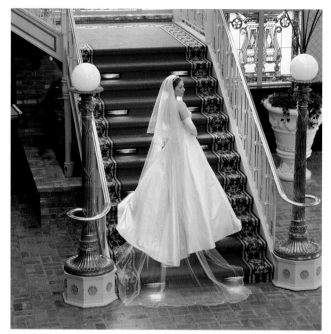

PLATE 380. PHOTOGRAPH BY RICK AND DEBORAH FERRO.

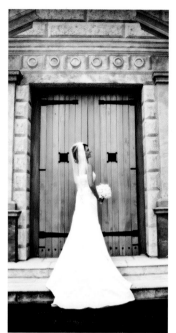

PLATE 381. PHOTOGRAPH BY
JEFF AND KATHLEEN HAWKINS.

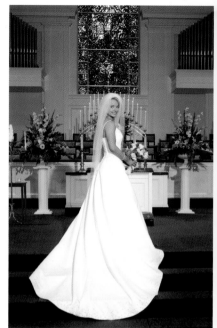

PLATE 382. PHOTOGRAPH BY
JEFF AND KATHLEEN HAWKINS.

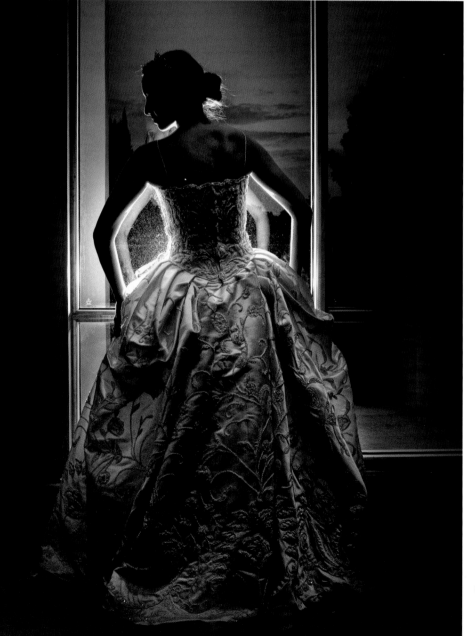

"It's important that we are on the same page and they know where I'm coming from. If they see me as the hired help or just some photographer guy, they're not going to let me do what I do. We need to develop a relationship where they are **totally at ease** with me. If we cannot achieve that, then I'm not going to be able to capture the best images I can. That's 80 percent of the hard work. After that, it's all about having fun."[21]—*Riccis Valladares*

PLATE 383. PHOTOGRAPH BY JEFF AND KATHLEEN HAWKINS.

"Once in a while, you'll have clients with brilliant ideas and good taste. They will devote extra resources to make their wedding special. When you **see these things**, shoot them. Make it a continuation of a creative process. The clients will be happy that their efforts were documented, and your album will look great."[22]—*Mark Chen*

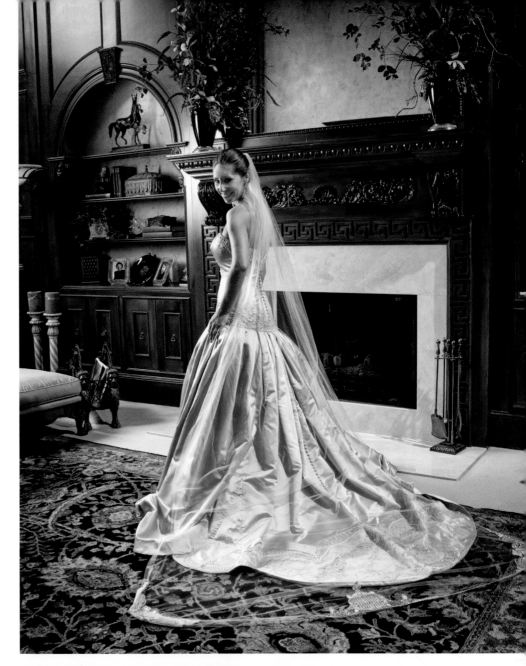

PLATE 384 (RIGHT). PHOTOGRAPH BY JEFF AND KATHLEEN HAWKINS.

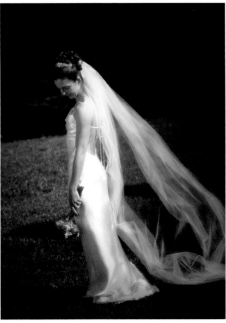

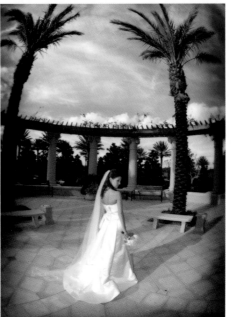

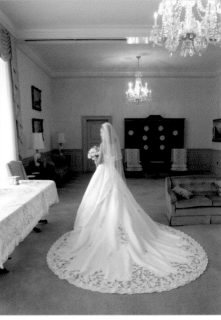

PLATE 385. PHOTOGRAPH BY JEFF AND KATHLEEN HAWKINS.

PLATE 386. PHOTOGRAPH BY DAMON TUCCI.

PLATE 387. PHOTOGRAPH BY JEFF AND KATHLEEN HAWKINS.

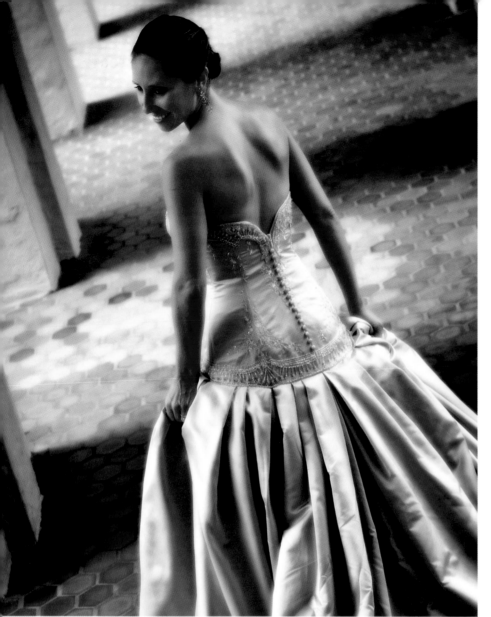

"I don't accept every client. It is important our styles and personalities mesh. Recently, I had a woman tell me that the photography wasn't very important to her. I knew that **wasn't going to work**, so I told her we just weren't a good match."[23]—*Kevin Jairaj*

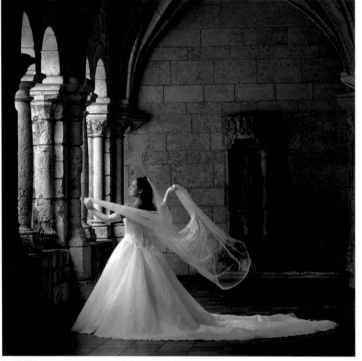

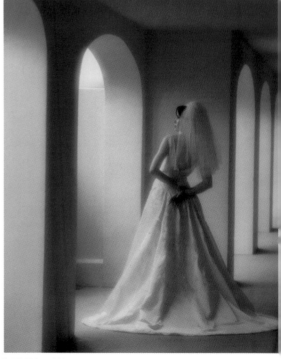

"When shooting the bride's portrait, it is important to keep in mind her personality and **the image she has worked to create**. Your aim is to provide her with one of the most beautiful photographs she will ever see of herself, a lasting reminder of youth, beauty, and love."[24]—*Marcus Bell*

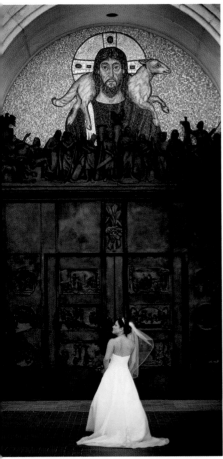

PLATE 391. PHOTOGRAPH BY JEFF AND KATHLEEN HAWKINS.

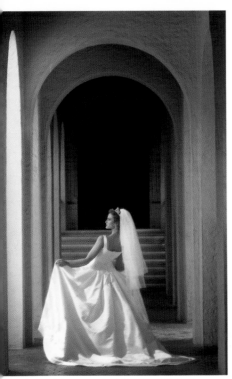

PLATE 392. PHOTOGRAPH BY RICK AND DEBORAH FERRO.

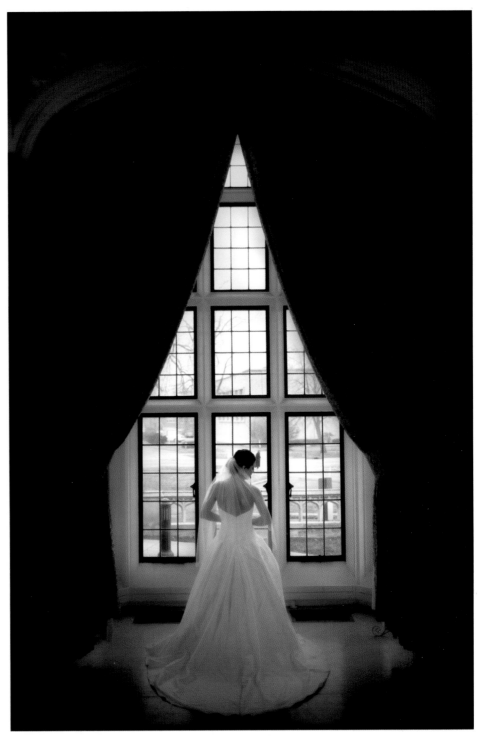

PLATE 393. PHOTOGRAPH BY TRACY DORR.

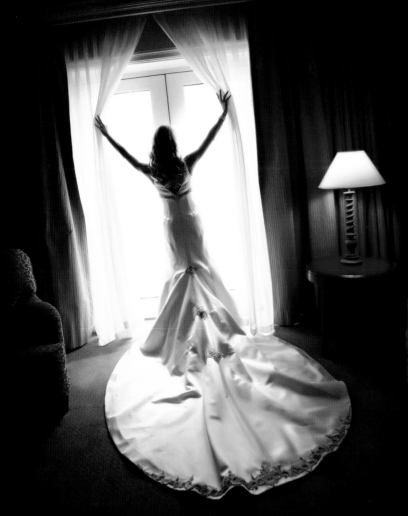

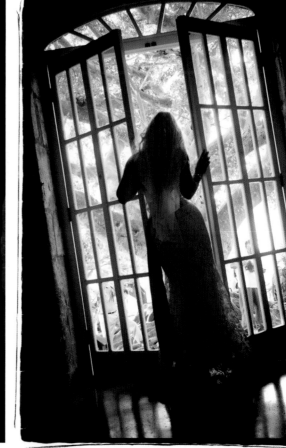

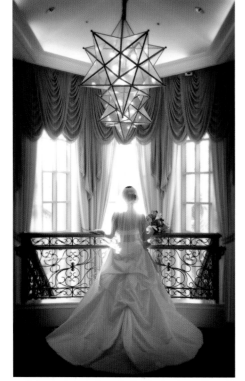

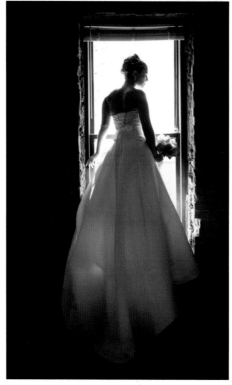

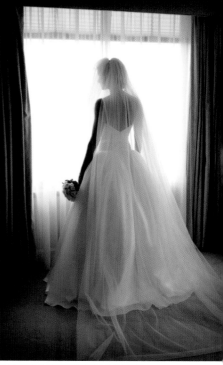

PLATE 396. PHOTOGRAPH BY DAMON TUCCI.

PLATE 397. PHOTOGRAPH BY HUY NGUYEN.

PLATE 398. PHOTOGRAPH BY MARCUS BELL.

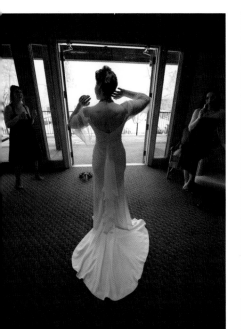

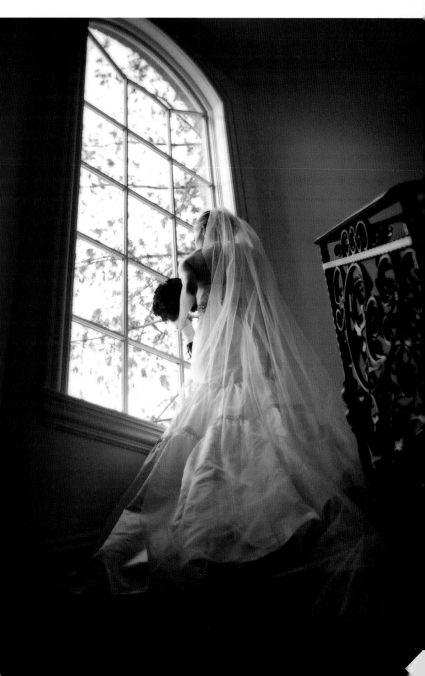

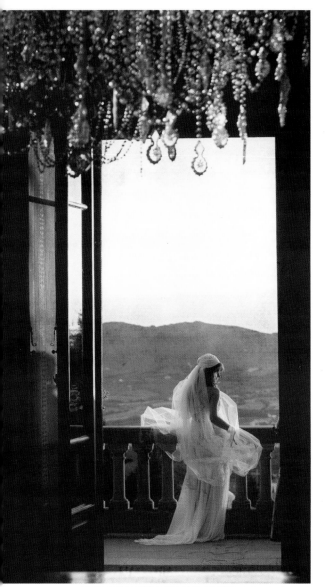

"In the art production phase, we can create more mood than in the straight photo. This makes it much easier to sell. Clients see **a great photo** and get connected to it immediately. Then they can't leave without buying it."[25]—*Jeffrey and Julia Woods*

PLATE 399. PHOTOGRAPH BY KEVIN KUBOTA.

PLATE 400. PHOTOGRAPH BY DAMON TUCCI.

PLATE 401 (ABOVE). PHOTOGRAPH BY JEFFREY AND JULIA WOODS.

PLATE 402 (RIGHT). PHOTOGRAPH BY JEFFREY AND JULIA WOODS.

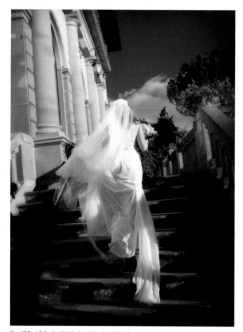

PLATE 403. PHOTOGRAPH BY JEFFREY AND JULIA WOODS.

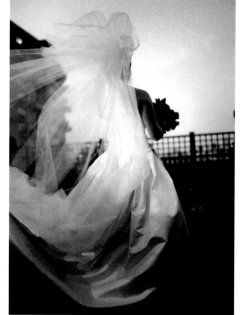

PLATE 404. PHOTOGRAPH BY JEFF AND KATHLEEN HAWKINS.

PLATE 405. PHOTOGRAPH BY KEVIN KUBOTA.

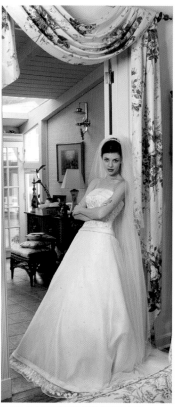

PLATE 406. PHOTOGRAPH BY DOUG BOX.

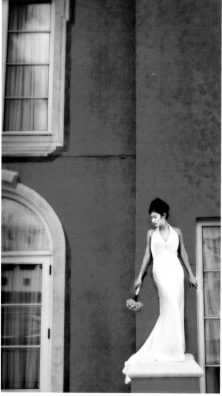

PLATE 407. PHOTOGRAPH BY DAMON TUCCI.

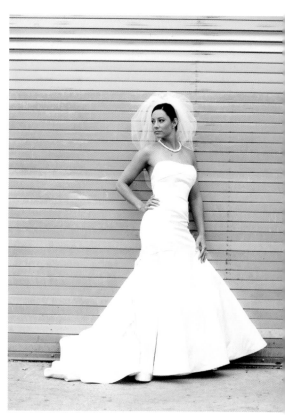

PLATE 408. PHOTOGRAPH BY JEFFREY AND JULIA WOODS.

"A good pose starts with a strong foundation. When posing your subject, you must pay attention to the feet—whether or not you plan to include them within the photographic frame. I have the person stand with their **weight on their back foot** (the one farthest from the camera). This lowers the back shoulder and shifts the line of the hips, giving some flow to the body and creating a more dynamic, appealing line."[26]—*Doug Box*

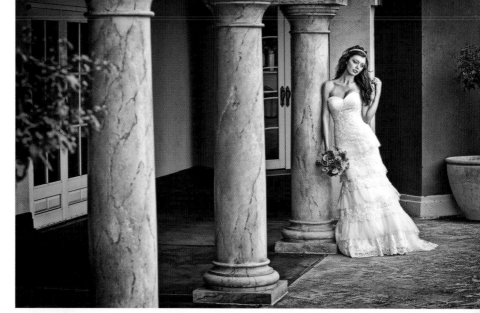

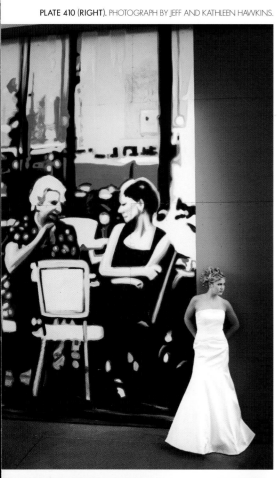

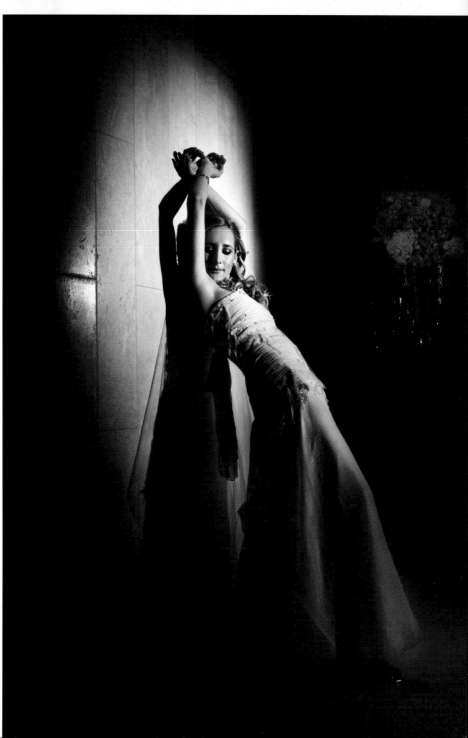

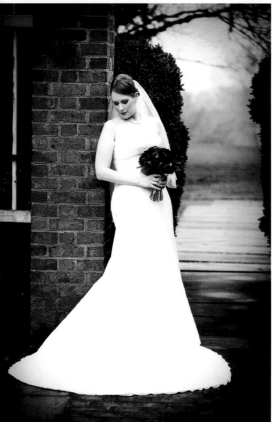

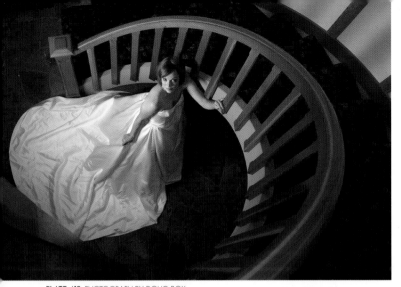

PLATE 413. PHOTOGRAPH BY DOUG BOX.

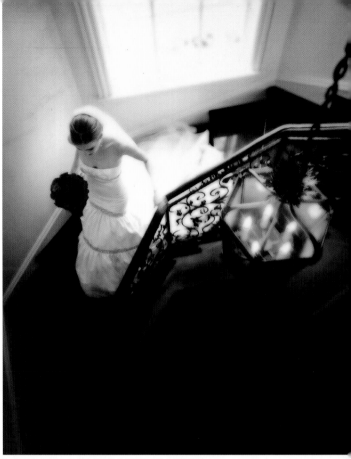

PLATE 416. PHOTOGRAPH BY JEFF AND KATHLEEN HAWKINS.

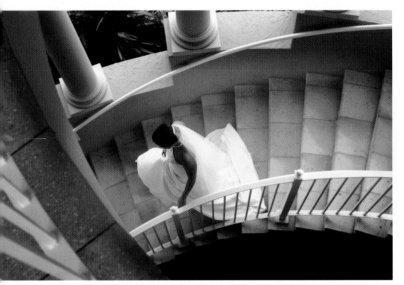

PLATE 414. PHOTOGRAPH BY JEFF AND KATHLEEN HAWKINS.

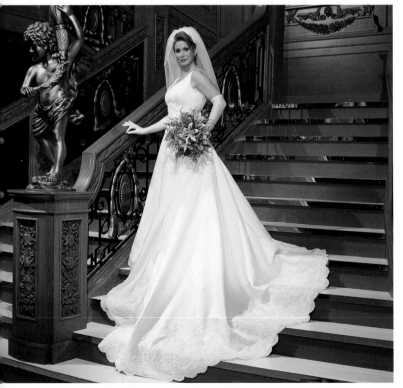

PLATE 415. PHOTOGRAPH BY RICK AND DEBORAH FERRO.

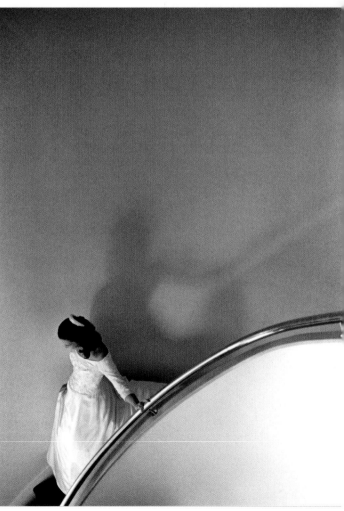

PLATE 417. PHOTOGRAPH BY JEFF AND KATHLEEN HAWKINS.

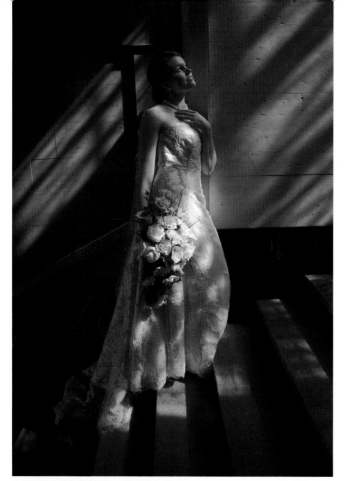

PLATE 418. PHOTOGRAPH BY MARK CHEN.

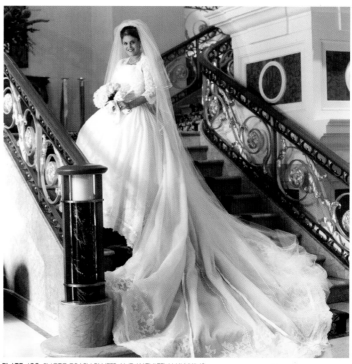

PLATE 420. PHOTOGRAPH BY JEFF AND KATHLEEN HAWKINS.

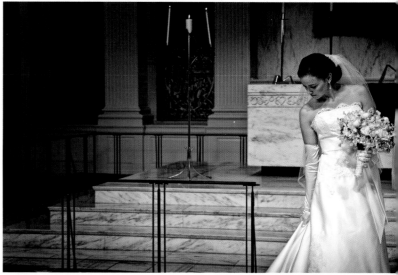

PLATE 421. PHOTOGRAPH BY JEFF AND KATHLEEN HAWKINS.

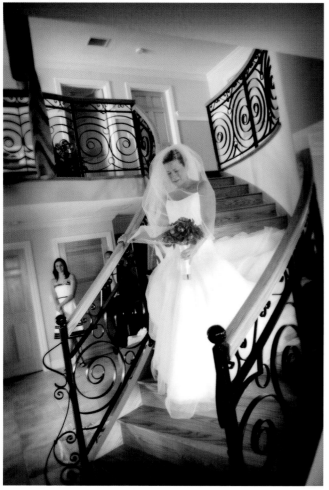

PLATE 419. PHOTOGRAPH BY DAMON TUCCI.

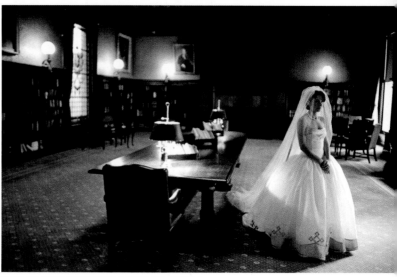

PLATE 422. PHOTOGRAPH BY JEFF AND KATHLEEN HAWKINS.

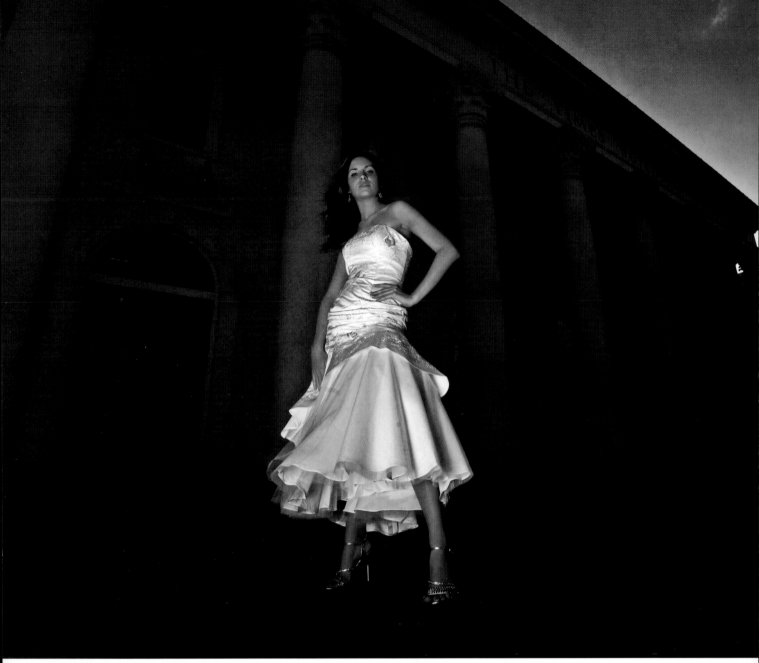

PLATE 423 (LEFT). PHOTOGRAPH BY KEVIN JAIRAJ.

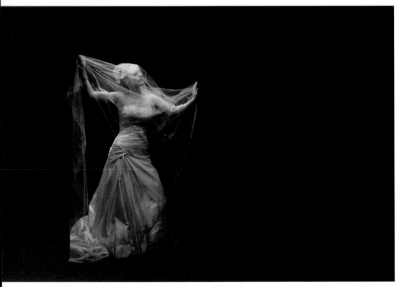

PLATE 424. PHOTOGRAPH BY DAVE AND QUIN CHEUNG.

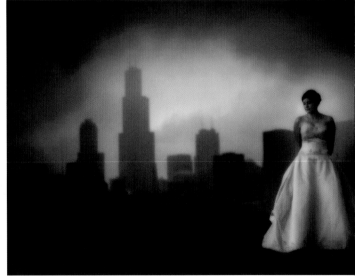

PLATE 425. PHOTOGRAPH BY JEFFREY AND JULIA WOODS.

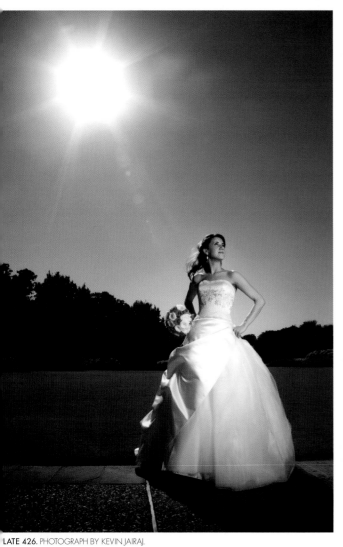

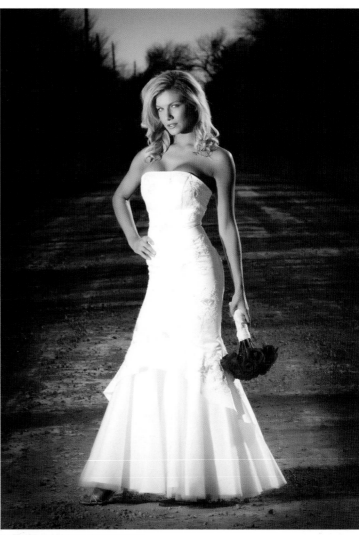

LATE 426. PHOTOGRAPH BY KEVIN JAIRAJ.

PLATE 427. PHOTOGRAPH BY KEVIN JAIRAJ.

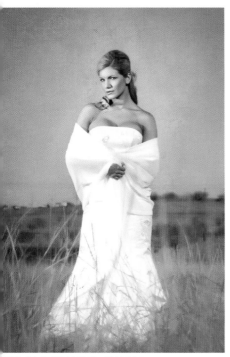

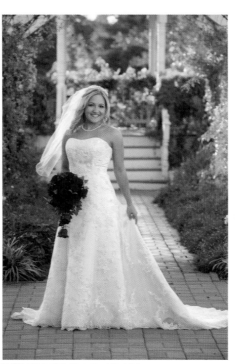

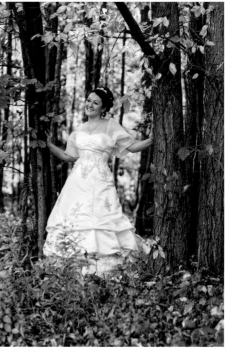

PLATE 428. PHOTOGRAPH BY KEVIN JAIRAJ.

PLATE 429. PHOTOGRAPH BY DOUG BOX.

PLATE 430. PHOTOGRAPH BY TRACY DORR.

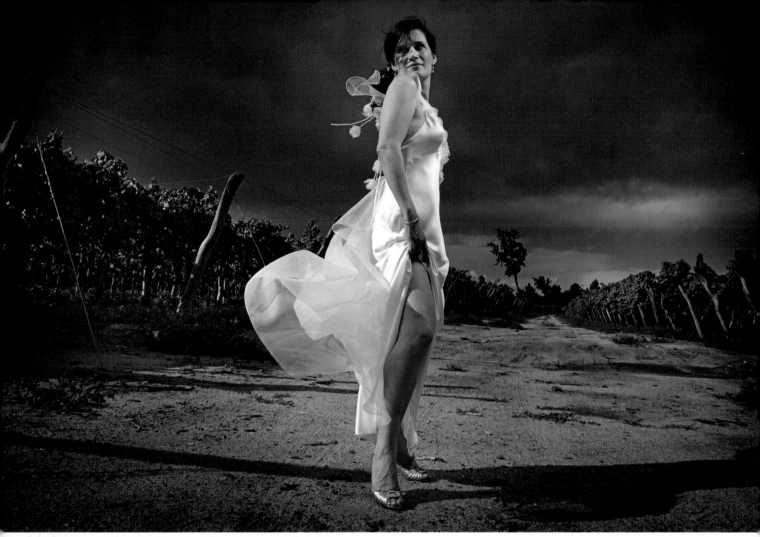

PLATE 431. PHOTOGRAPH BY DAVE AND QUIN CHEUNG.

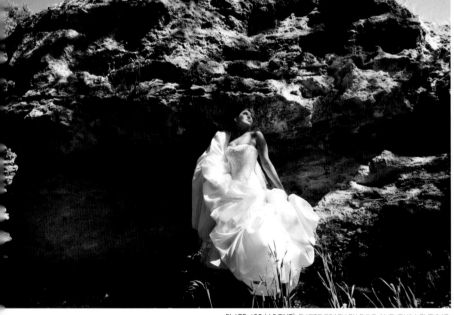

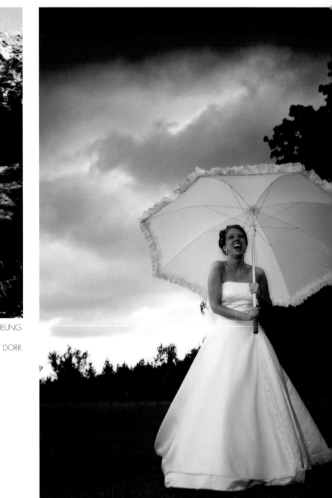

PLATE 432 (ABOVE). PHOTOGRAPH BY DAVE AND QUIN CHEUNG.

PLATE 433 (RIGHT). PHOTOGRAPH BY TRACY DORR.

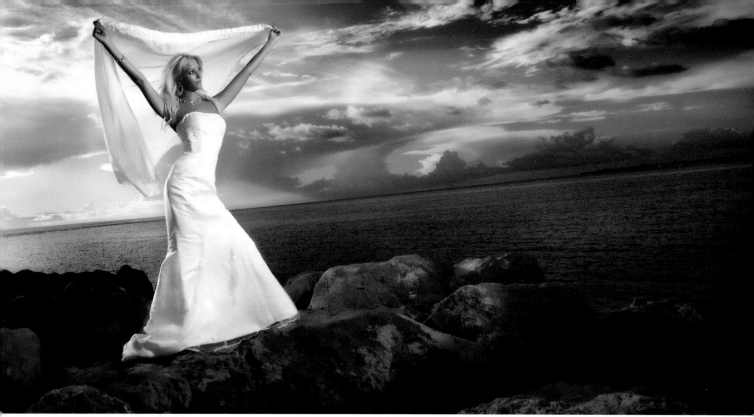

PLATE 434. PHOTOGRAPH BY KEVIN JAIRAJ.

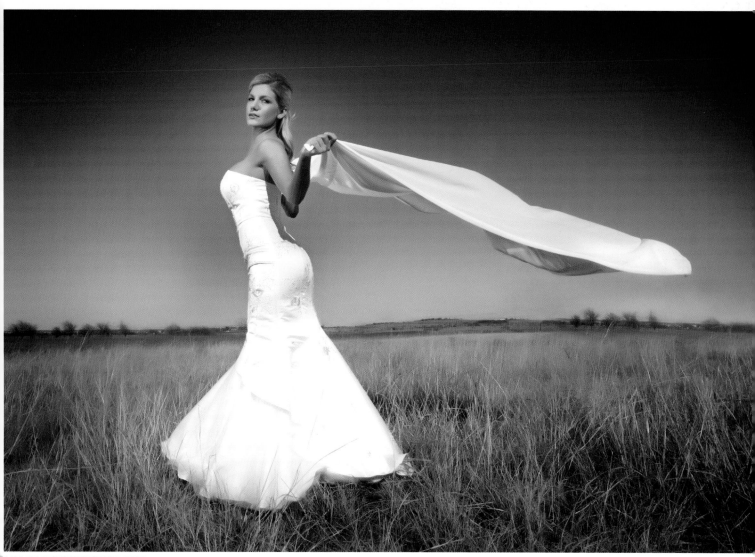

PLATE 435. PHOTOGRAPH BY KEVIN JAIRAJ.

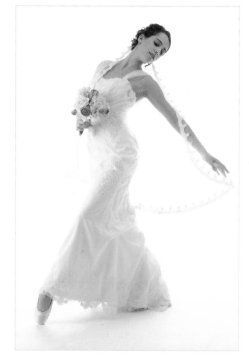

PLATE 436. PHOTOGRAPH BY MARK CHEN.

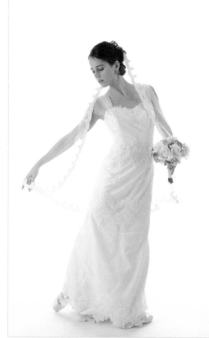

PLATE 437. PHOTOGRAPH BY MARK CHEN.

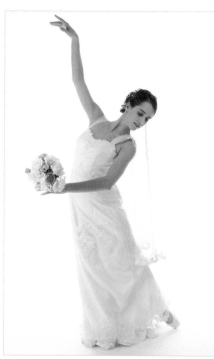

PLATE 438. PHOTOGRAPH BY MARK CHEN.

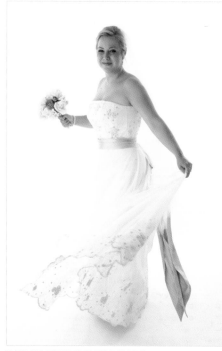

PLATE 439. PHOTOGRAPH BY MARK CHEN.

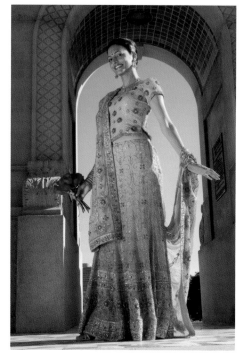

PLATE 440. PHOTOGRAPH BY MARK CHEN.

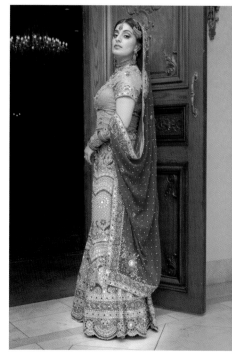

PLATE 441. PHOTOGRAPH BY MARK CHEN.

"Never take things at face value. Make yourself responsible for adapting a good idea to fit your needs. The most unhappy and unsuccessful people in any profession, and in life in general, are the ones who consistently look at new ideas and say that they won't work. The **happy and truly successful people** in the world look at new ideas and think, 'It could work—and I think I can make it even better.'"[27]—*Jeff Smith*

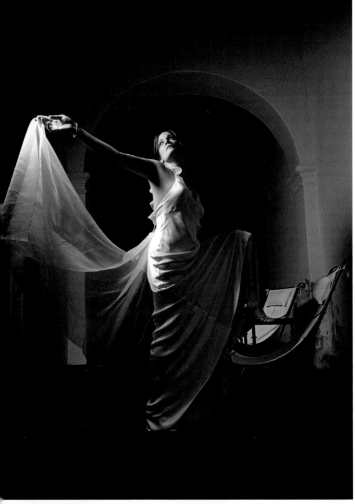

PLATE 442. PHOTOGRAPH BY DAVE AND QUIN CHEUNG.

"Photography before the ceremony is a lot of fun. Photography after the ceremony is a task. Between the ceremony and the reception, people are always looking at their watches. What time is the reception? When do we need to get out of the church? If I can avoid that, their whole experience with me will be really free and fun."[28]—*Dawn Shields*

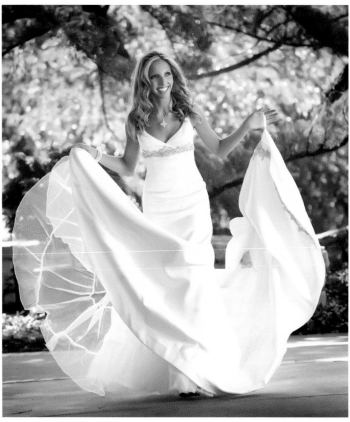

PLATE 444. PHOTOGRAPH BY KEVIN JAIRAJ.

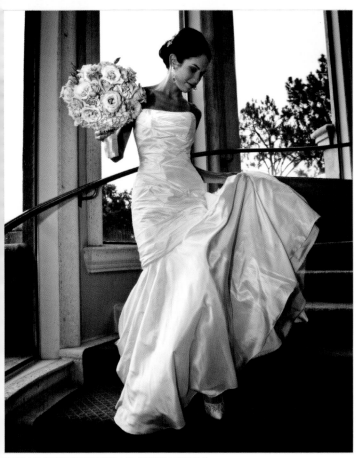

PLATE 443. PHOTOGRAPH BY JEFF AND KATHLEEN HAWKINS.

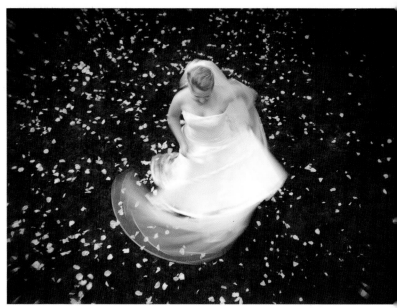

PLATE 445. PHOTOGRAPH BY KEVIN KUBOTA.

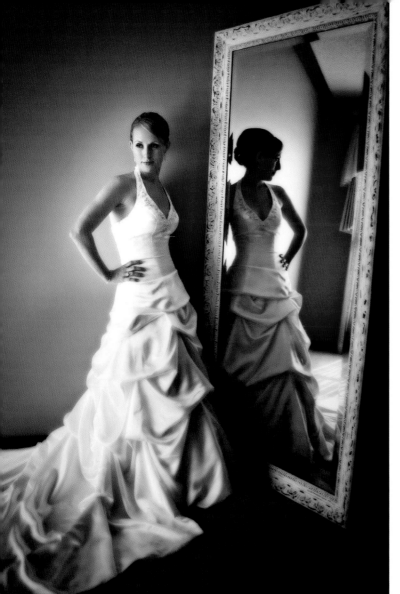

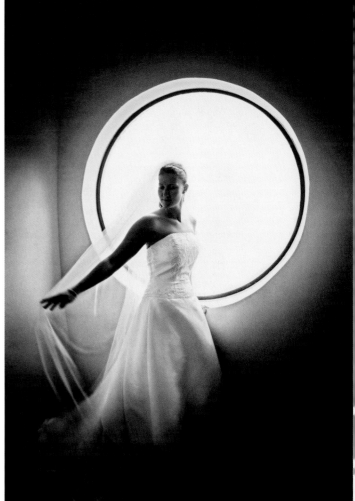

PLATE 446 (LEFT). PHOTOGRAPH BY TRACY DORR.

PLATE 447 (BELOW). PHOTOGRAPH BY TRACY DORR.

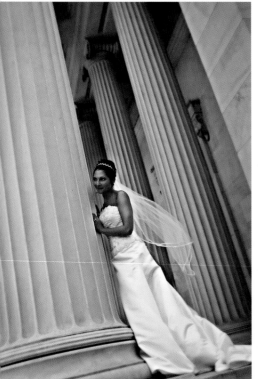

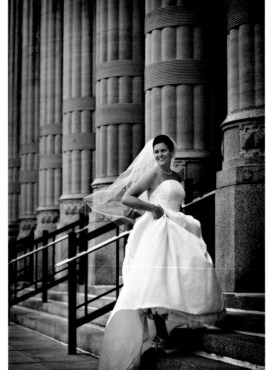

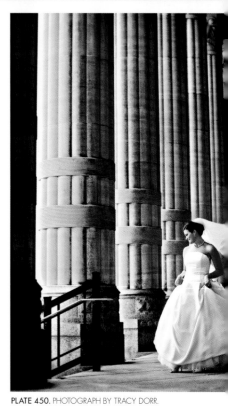

PLATE 448. PHOTOGRAPH BY TRACY DORR.

PLATE 449. PHOTOGRAPH BY TRACY DORR.

PLATE 450. PHOTOGRAPH BY TRACY DORR.

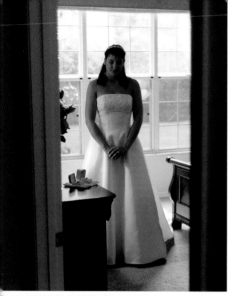

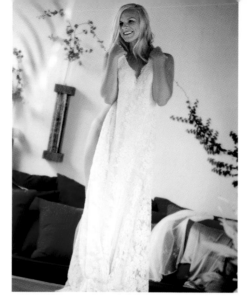

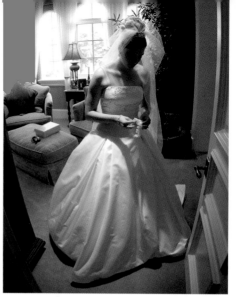

PLATE 451. PHOTOGRAPH BY JEFF AND KATHLEEN HAWKINS.

PLATE 452. PHOTOGRAPH BY KEVIN KUBOTA.

PLATE 453. PHOTOGRAPH BY DAMON TUCCI.

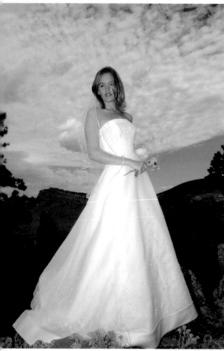

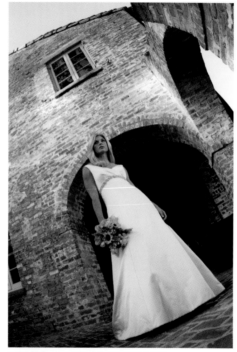

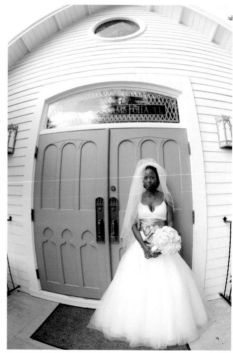

PLATE 454. PHOTOGRAPH BY DAMON TUCCI.

PLATE 455. PHOTOGRAPH BY DAMON TUCCI.

PLATE 456. PHOTOGRAPH BY DAMON TUCCI.

PLATE 457. PHOTOGRAPH BY KEVIN JAIRAJ.

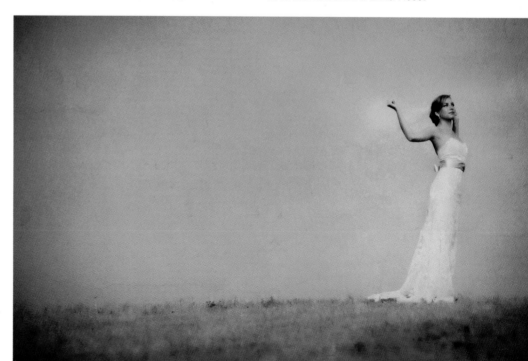

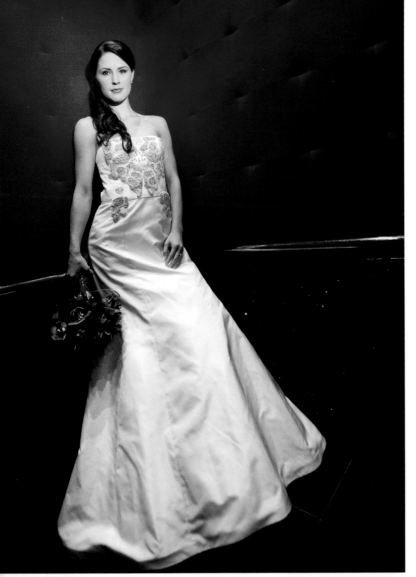

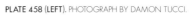
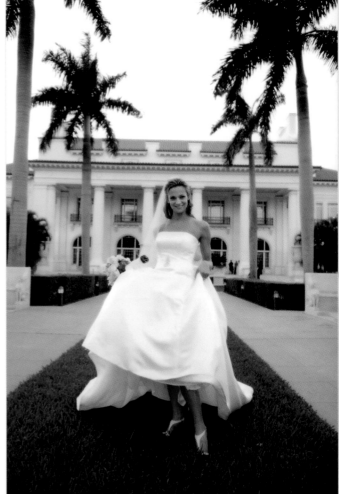

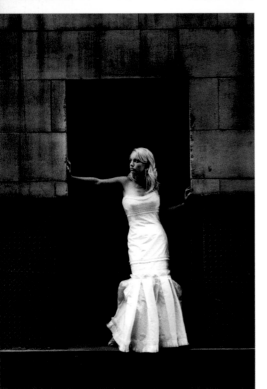

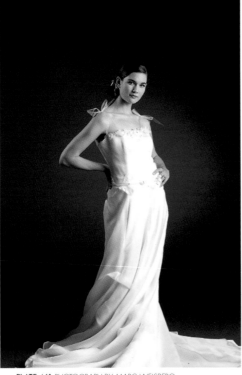

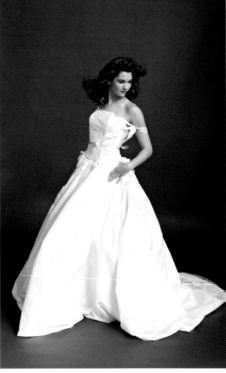

PLATE 460. PHOTOGRAPH BY RICCIS VALLADARES.

PLATE 461. PHOTOGRAPH BY MARC WEISBERG.

PLATE 462. PHOTOGRAPH BY MARC WEISBERG.

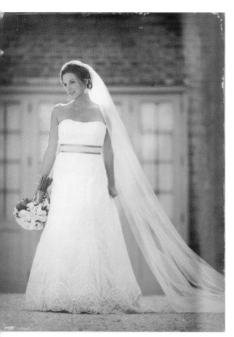

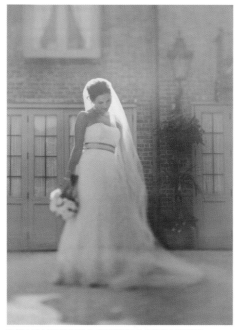

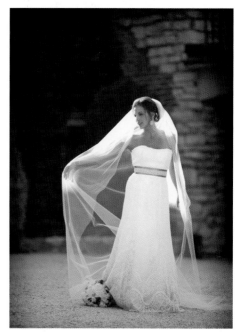

PLATE 463. PHOTOGRAPH BY JEFFREY AND JULIA WOODS.

PLATE 464. PHOTOGRAPH BY JEFFREY AND JULIA WOODS.

PLATE 465. PHOTOGRAPH BY JEFFREY AND JULIA WOODS.

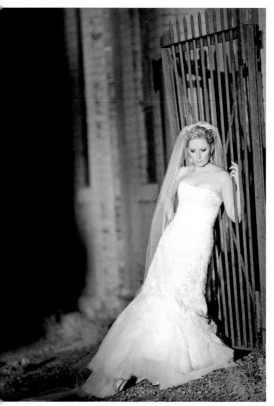

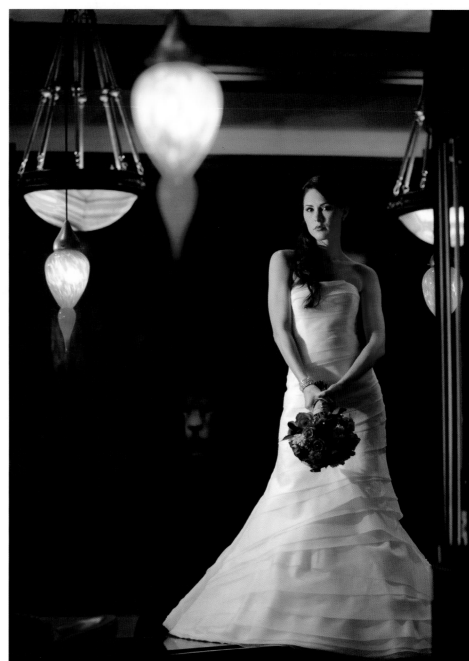

PLATE 466 (ABOVE). PHOTOGRAPH BY JEFFREY AND JULIA WOODS.

PLATE 467 (RIGHT). PHOTOGRAPH BY DAMON TUCCI.

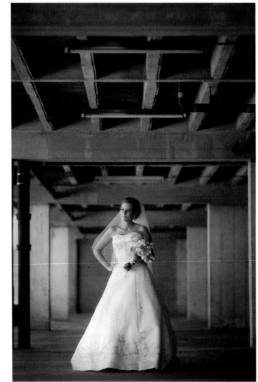

PLATE 468 (LEFT). PHOTOGRAPH BY DAVE AND QUIN CHEUNG.

PLATE 469 (BELOW). PHOTOGRAPH BY KEVIN KUBOTA.

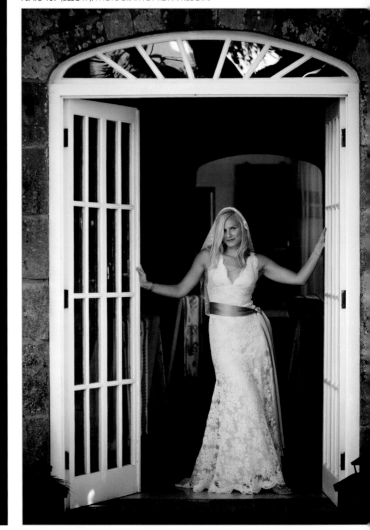

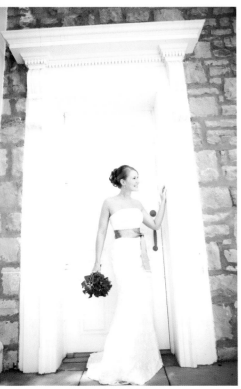

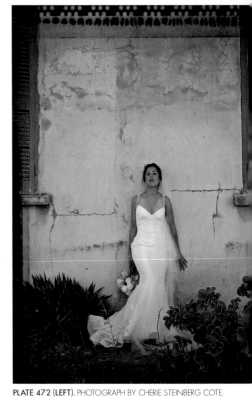

PLATE 470 (LEFT). PHOTOGRAPH BY DAWN SHIELDS.

PLATE 471 (LEFT). PHOTOGRAPH BY JEFFREY AND JULIA WOODS.

PLATE 472 (LEFT). PHOTOGRAPH BY CHERIE STEINBERG COTE.

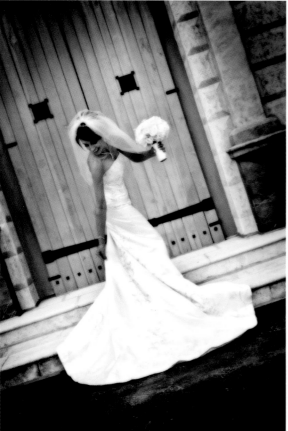

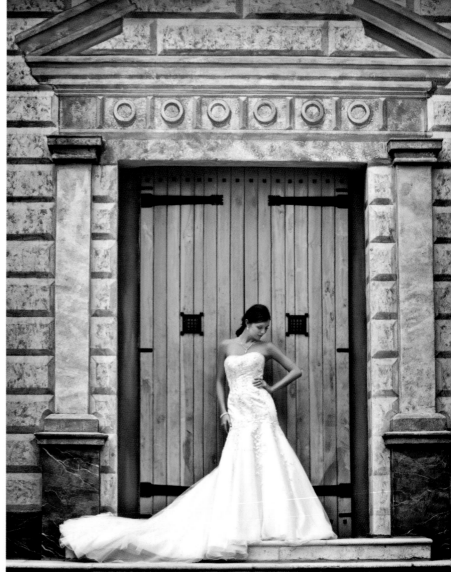

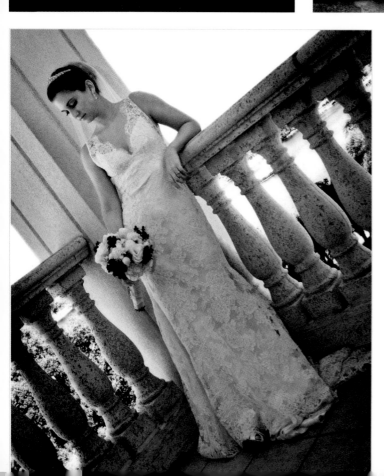

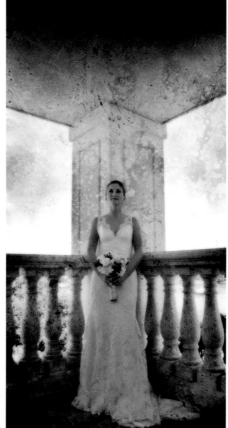

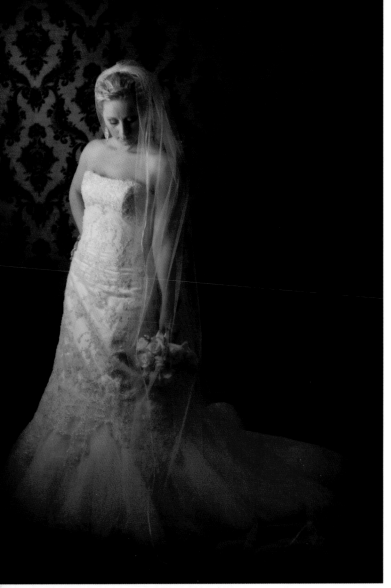

PLATE 477 (LEFT). PHOTOGRAPH BY JEFFREY AND JULIA WOODS.

PLATE 478 (BELOW). PHOTOGRAPH BY JEFFREY AND JULIA WOODS.

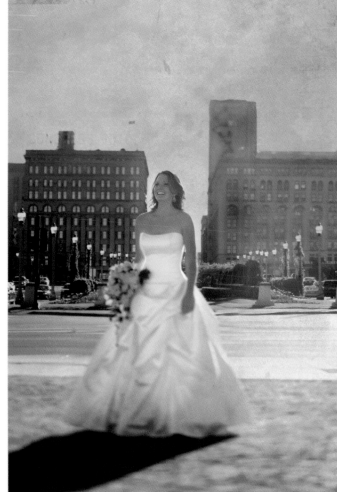

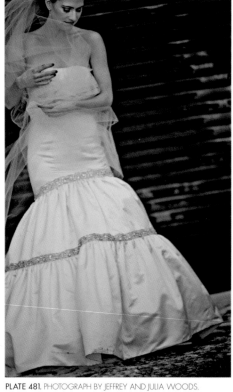

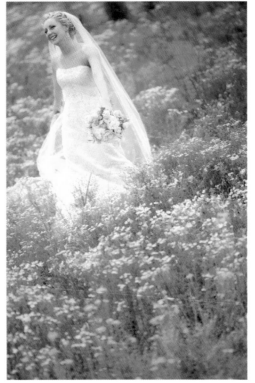

PLATE 479. PHOTOGRAPH BY JEFFREY AND JULIA WOODS.

PLATE 480. PHOTOGRAPH BY JEFFREY AND JULIA WOODS.

PLATE 481. PHOTOGRAPH BY JEFFREY AND JULIA WOODS.

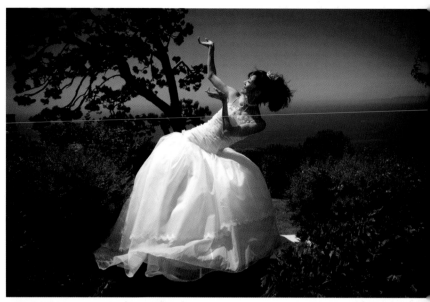

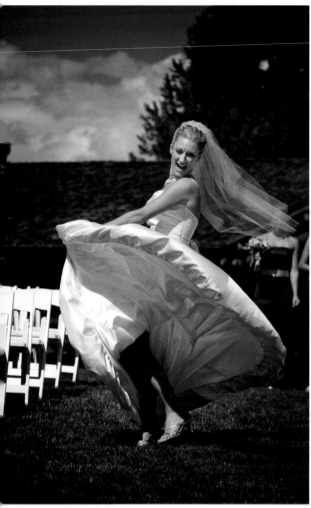

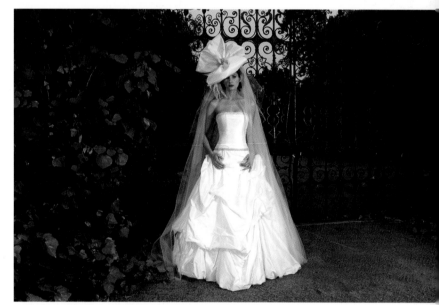

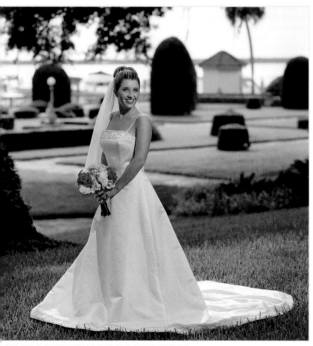

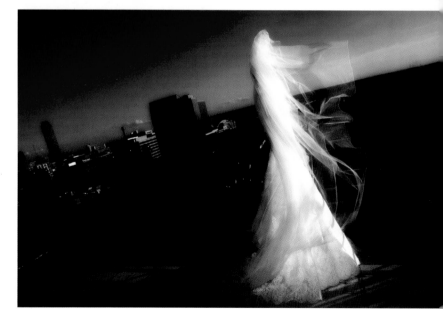

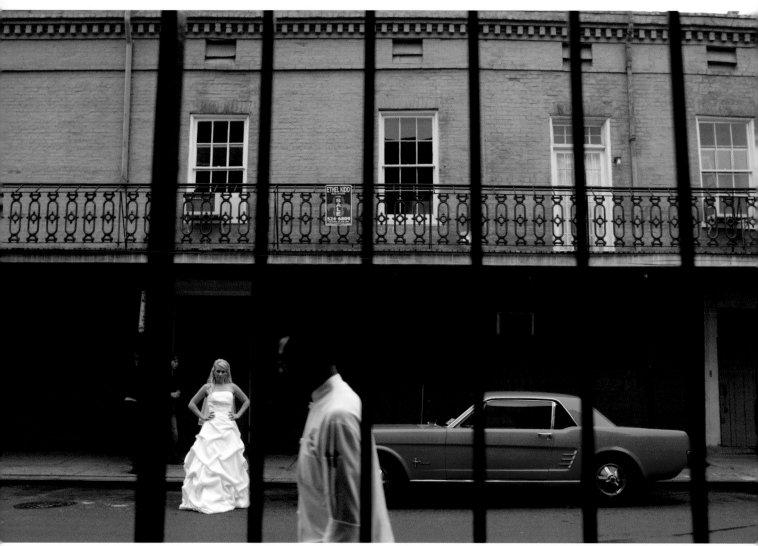

PLATE 487. PHOTOGRAPH BY HUY NGUYEN.

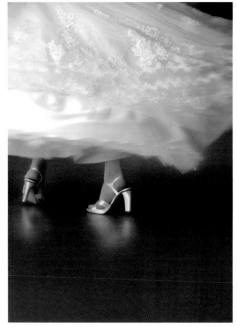

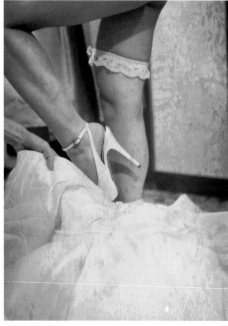

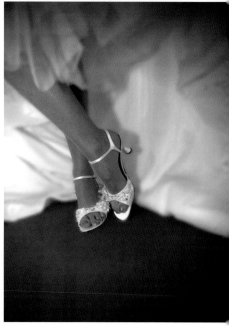

PLATE 488. PHOTOGRAPH BY MARK CHEN.

PLATE 489. PHOTOGRAPH BY DAVE AND QUIN CHEUNG.

PLATE 490. PHOTOGRAPH BY JEFF AND KATHLEEN HAWKINS.

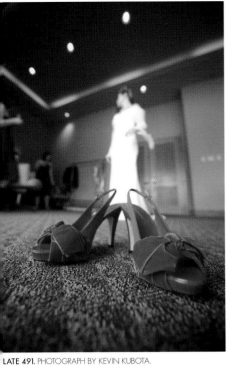

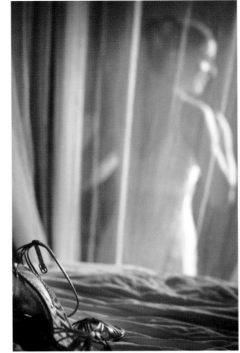

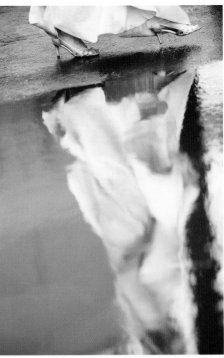

LATE 491. PHOTOGRAPH BY KEVIN KUBOTA.

PLATE 492. PHOTOGRAPH BY KEVIN KUBOTA.

PLATE 493. PHOTOGRAPH BY JEFFREY AND JULIA WOODS.

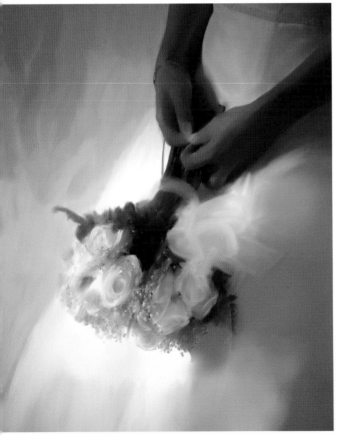

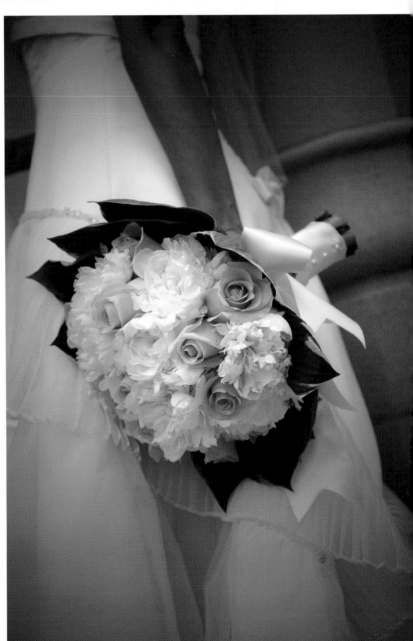

PLATE 494 (ABOVE). PHOTOGRAPH BY JEFF AND KATHLEEN HAWKINS.

PLATE 495 (RIGHT). PHOTOGRAPH BY JEFF AND KATHLEEN HAWKINS.

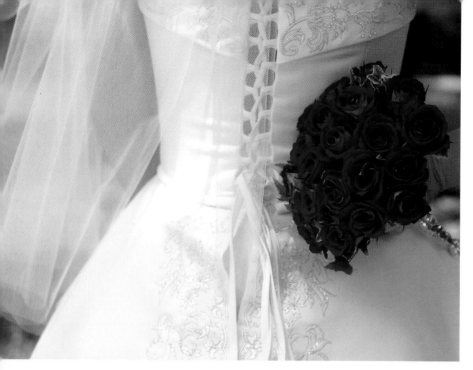

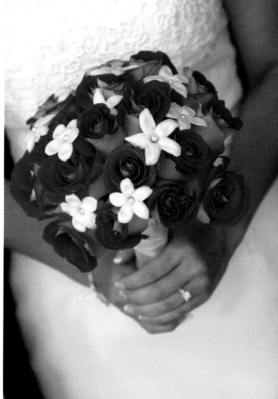

PLATE 496 (TOP LEFT). PHOTOGRAPH BY JEFF AND KATHLEEN HAWKINS.

PLATE 497 (ABOVE). PHOTOGRAPH BY DAMON TUCCI.

PLATE 498 (LEFT). PHOTOGRAPH BY JEFF AND KATHLEEN HAWKINS.

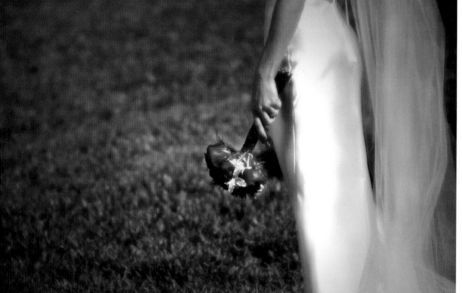

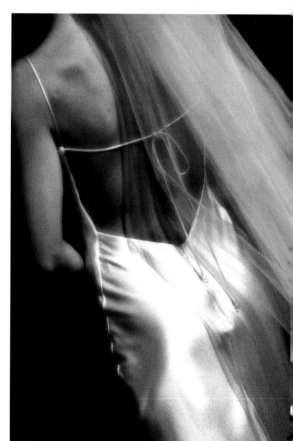

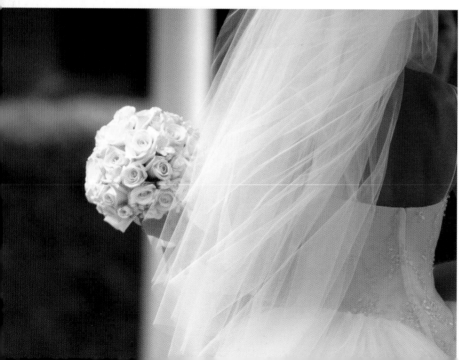

PLATE 499 (ABOVE). PHOTOGRAPH BY JEFF AND KATHLEEN HAWKINS.

PLATE 500 (LEFT). PHOTOGRAPH BY JEFF AND KATHLEEN HAWKINS.

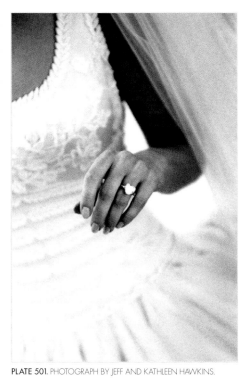

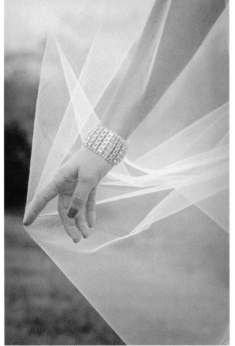

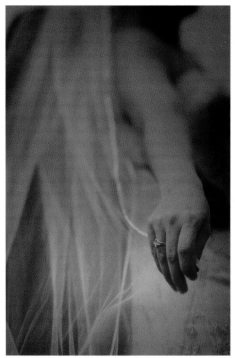

PLATE 501. PHOTOGRAPH BY JEFF AND KATHLEEN HAWKINS.　　PLATE 502. PHOTOGRAPH BY JEFFREY AND JULIA WOODS.　　PLATE 503. PHOTOGRAPH BY JEFFREY AND JULIA WOODS.

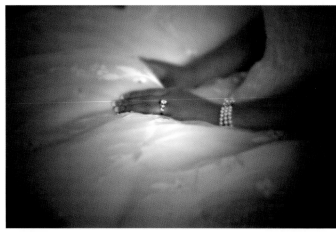

PLATE 504. PHOTOGRAPH BY JEFF AND KATHLEEN HAWKINS.

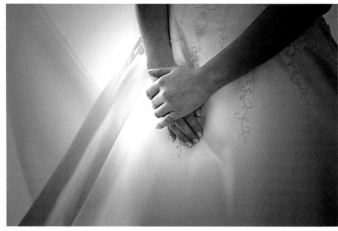

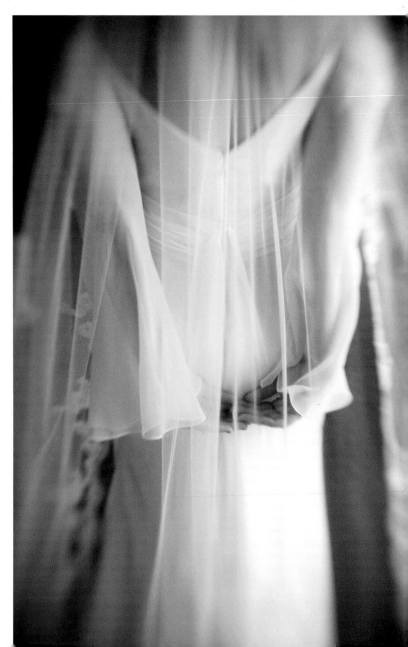

PLATE 505 (ABOVE). PHOTOGRAPH BY JEFF AND KATHLEEN HAWKINS.

PLATE 506 (RIGHT). PHOTOGRAPH BY KEVIN KUBOTA.

Posing Basics

This section covers the fundamental rules of traditional posing—techniques that are illustrated in many of the images in this book. While these rules are often intentionally broken by contemporary photographers, most are cornerstones for presenting the human form in a flattering way.

Portrait Lengths

There are three basic types of poses, each defined by how much of the length of the subject's body is included in the image. Head and shoulders portraits, or headshots, show the subject's head and shoulders. If the hands are lifted to a position near the face, these may also be included. Waist-up portraits include the subject's head and shoulders along with at least some of the torso. In portraits of women, these images are often cropped just below the bustline or at the waist. (Waist-up portraits are sometimes considered a type of headshot.) Three-quarter-length portraits show the subject from the head down to the mid-thigh or mid-calf. In some cases, one foot may be visible. Full-length portraits that show the subject from the head down to the feet (or at least the ankles). In some cases, only one foot may be visible.

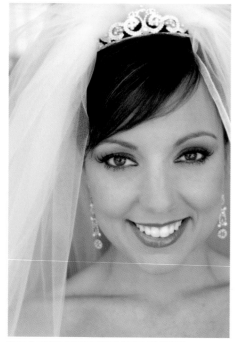

HEAD AND SHOULDERS PORTRAIT BY DAMON TUCCI.

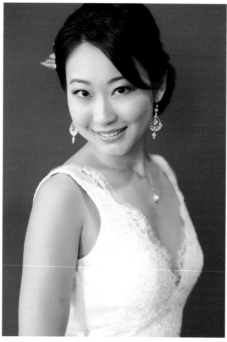

WAIST-UP PORTRAIT BY REGETI'S PHOTOGRAPHY.

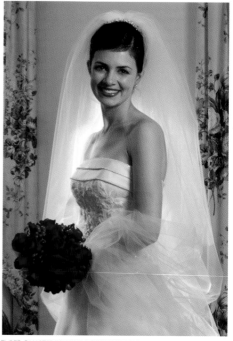

THREE-QUARTER-LENGTH PORTRAIT BY DOUG BOX.

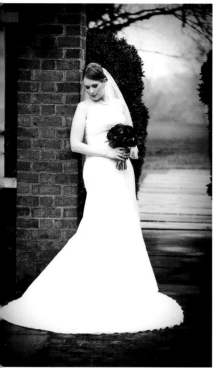

When including less than the full body in the frame, it is recommended that you avoid cropping at a joint (such as the knee or elbow); this creates an amputated look. Instead, crop between joints.

Facial Views

The most flattering facial view depends on the bride, the lighting, and the mood you are attempting to create.

In the full-face view, the subject's nose is pointed at the camera. This is the widest view of the face, so it may not be well suited to brides with rounder faces.

In the three-quarters view (sometimes called the two-thirds view), the subject's face is angled enough that one ear is hidden from the camera's view. This is a flattering, slimming view for most faces. In this pose, keep in mind that the far eye will appear smaller than the near eye because it is farther away from the camera. Also, be sure not to turn the head so far that the tip of the nose extends past the line of the cheek or that the bridge of the nose obscures the far eye.

In the profile view, the subject's head is turned 90 degrees to the camera. When creating a profile, be sure to turn the bride's face so that the far eye, eyebrow, and eyelashes are obscured.

The Shoulders

The bride's shoulders should usually be turned at an angle to the camera. Having the shoulders face the camera directly makes her look wider than she really is and can yield a static composition. With a slim bride, however, squaring the shoulders to the camera can give the image an assertive mood that is quite appealing.

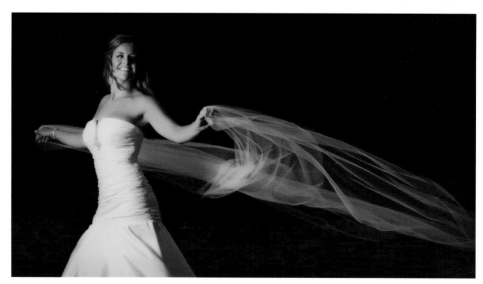

The Head

Tilting the Head. Tilting the head slightly produces diagonal lines that can help a pose feel more dynamic. In portraits of women, the head is traditionally tilted toward the near or high shoulder, but this rule is often broken. The best practice is to tilt the bride's head in the direction that most flatters her.

Chin Height. A medium chin height is desirable. If the chin is too high, the bride may look conceited and her neck may appear elongated. If her chin is too low, she may look timid and appear to have a double chin or no neck.

Eyes. In almost all portraits, the eyes are the most important part of the face. Typically, eyes look best when the eyelids border the iris. Turning the face slightly away from the camera and directing the bride's eyes back toward the camera reveals more of the white of the eye, making her eyes look larger.

Arms

The bride's arms should be separated at least slightly from her waist. This creates a space that slims the appearance of her upper body. It also creates a triangular base for the composition, leading the viewer's eye up to her face. Additionally, keep in mind that simply bending the elbows creates appealing diagonal lines in your composition—and placing these carefully can help direct the viewer of the image to the bride's face.

Hands

Keep the hands at an angle to the lens to avoid distorting their size and shape. Photographing the outer edge of the hand produces a more appealing look than showing the back of the hand or the palm, which may look unnaturally large (especially when close to the face). Additionally, it is usually advised that the hands should be at different heights in the image. This creates a diagonal line that makes the pose more dynamic.

Wrist. Bending the wrists slightly by lifting the hand (not allowing it to flop down) creates an appealing curve that is particularly flattering in bridal portraits.

Fingers. Fingers look best when separated slightly. This gives them form and definition.

Props. Hands are often easiest to pose when they have something to do—either a prop to hold or something to rest upon. When photographing the bride holding her bouquet, have her grasp it gently, or opt to hid her hands behind the bouquet. When photographing the bride's rings, give her something to rest her hands upon (her lap, the back of a chair, etc.).

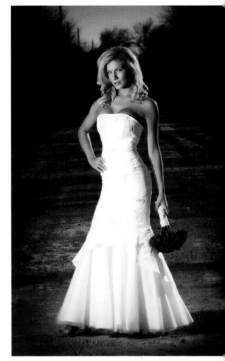

LEAVING SPACE BETWEEN THE ARMS AND THE BODY SLIMS TH TORSO. PORTRAIT BY KEVIN JAIRAJ.

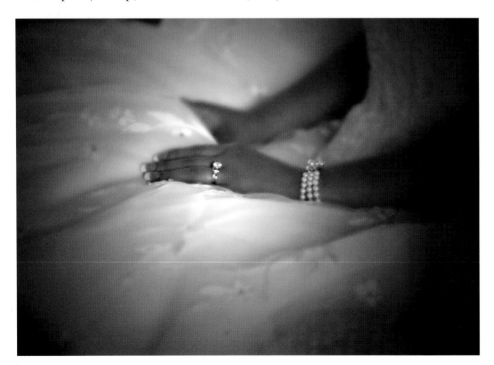

THE HANDS REST GRACEFULLY ON THE BRIDE'S LAP. PORTRAIT B JEFF AND KATHLEEN HAWKINS.

Chest

Selecting a pose that places the torso at an angle to the camera emphasizes the shape of the chest and, depending on the lighting, enhances the form-revealing shadows on the cleavage. Turning the shoulders square to the camera tends to flatten and de-emphasize this area. Good posture, with the chest lifted and shoulders dropped, is also critical to a flattering rendition.

Waist and Stomach

Separating the arms from the torso helps to slim the waist. In seated poses, a very upright posture (almost to the point of arching the back) will help to flatten the stomach area, as will selecting a standing pose rather than a seated one.

Legs

Although most brides wear full-length gowns, posing the legs properly remains desirable because it impacts the posture of the entire body. Asking the bride to put her weight on her back foot shifts the body slightly away from the camera for a more flattering appearance than having the weight distributed evenly on both feet. Having her slightly bend her front knee will also help to create a nice line on the lower part of the gown.

Hips and Thighs

In some gowns, this area will naturally be concealed. If the bride has opted for a gown that is fitted through the hips and thighs, pose her hips at an angle to the camera and away from the main light. In a seated pose, have the bride shift her weight onto one hip so that more of her rear is turned away from the camera.

Feet

Brides are often very proud of their shoes, but pictures of feet with the toes pointed straight at the camera tend to look distorted. Instead, photograph the feet at an angle to the camera—better yet, place them at two different angles to the camera. A good rule of thumb is to ensure that at least one foot is turned enough that the heel is shown.

DETAILS OF EFFECTIVE FOOT POSING. PORTRAITS BY DAWN SHIELDS (LEFT) AND KEVIN JAIRAJ (RIGHT).

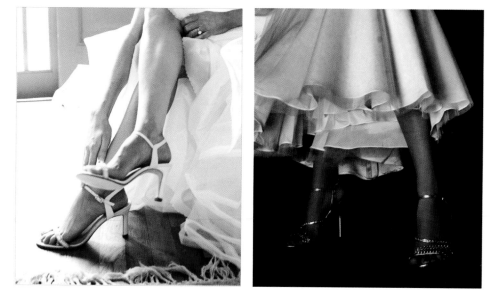

The Photographers

Marcus Bell (www.studioimpressions.com.au). Marcus Bell is the owner and principal photographer of the boutique photography studio Studio Impressions. He has been honored with over one hundred Australian and international awards for his photography, including being named Australian Wedding Photographer of the Year in 2006. Additionally, he has written for and been profiled in numerous pho- tography magazines and lectured to photographers around the world. He is the author of *Master's Guide to Wedding Photography* from Amherst Media.

Doug Box (www.texasphotographicworkshops.com). Besides being an excellent photographer, Doug Box is a dynamic and entertaining speaker who has appeared in a wide variety of seminars around the world. He was also chosen to teach at the International Wedding Institute by Hasselblad University. He is the owner of Texas Photographic Workshops, a year-round educational facility, and the author of numerous books, including *Professional Secrets of Wedding Photography, Professional Secrets of Natural Light Portrait Photography,* and *Doug Box's Guide to Posing for Portrait Photographers,* all from Amherst Media.

Mark Chen (www.markchenphotography.com). Mark Chen is a professional photographer, Adobe Certified Photoshop Expert/Instructor, Photoshop trainer, and owner of Mark Chen Photography in Houston, Texas. In addition to his studio operations, Chen teaches Photoshop at Houston Baptist University and Houston Community College and is touring the nation giving Photoshop training sessions. Mark is the author of *Creative Wedding Album Design Techniques with Adobe Photoshop* from Amherst Media.

Dave and Quin Cheung (www.dqstudios.com). Dave and Quin Cheung are the visual artists behind DQ Studios. Their strong story-telling ability, coupled with their high-fashion eyes, has earned them the love and respect of their clients and won them multiple international image and album awards. Dave and Quin are also highly respected educators of the wedding industry and have taught photographers from around the world on topics ranging from the philosophy of wedding photography to business and sales structure. As co-creators of the QuiKeys workflow system, Dave and Quin continue to innovate workflow solutions from shoot to album design. Dave and Quin make their home in Calgary, Alberta, Canada with their two young boys.

Tracy Dorr (www.tracydorrphotography.com). Tracy Dorr, who holds a BA in English/Photography from the State University of New York at Buffalo, has been shooting weddings in a professional capacity since 2003. She is the owner of Tracy Dorr Photography, and in 2009 won two Awards of Excellence from WPPI (Wedding and Portrait Photographers International).

Rick Ferro and Deborah Lynn Ferro (www.rickferro .com). Rick Ferro and Deborah Lynn Ferro operate Signature Studio, a full-service studio that provides complete photography services for families, portraits, children, high-school seniors, and weddings. In addition to the acclaim they have received for their images, Rick and Deborah are also popular photography instructors who tour nationally, presenting workshops to standing-room-only audiences (for more on this, visit www.ferrophotographyschool.com). Rick and Deborah have also authored numerous books, including *Wedding Photography: Creative Techniques for Lighting, Posing, and Marketing* and *Artistic Techniques with Adobe Photoshop and Corel Painter,* both from Amherst Media.

Jeff and Kathleen Hawkins (www.jeffhawkins.com). For the past twenty years, Jeff and Kathleen Hawkins have operated an international award-winning wedding and portrait photography studio in Orlando, Florida. Industry sponsored, they are both very active in the photography lecture circuit and take pride in their impact in the industry and in the community. Jeff holds the Master of Photography, Certified Professional Photographer (CPP) and Photographic Craftsman degrees. Kathleen is also an award-winning photographer and takes pride in the connection she establishes with her clients. Together, Jeff and Kathleen have authored

nine books on photography, including *Professional Techniques for Digital Wedding Photography* from Amherst Media.

Kevin Jairaj (www.kjimages.com). Kevin Jairaj is an international award-winning fashion and wedding photographer based in Dallas, Texas. His colorful style and flair for the dramatic have garnered him worldwide acclaim. His work has been published in countless books and magazines around the globe and he is an in-demand speaker in the photography industry. You can get updates and information from Kevin at www.thekjblog.com.

Kevin Kubota (www.kubotaimagetools.com). Kevin Kubota is a professional wedding photographer and, with his wife Clare Kubota, owner of Kubota PhotoDesign. In 2007, *American Photo* named him one of the top ten wedding photographers in the world. Kevin is the founder of Kubota ImageTools.com—an award-winning company he created to produce training DVDs, album-creation software, and Photoshop action sets—and a popular speaker at major photographic conventions. He is also the author of *Digital Photography Boot Camp* (from Amherst Media), a book based on his popular workshop series.

Huy Nguyen (www.fwworkshop.com). Huy Nguyen's creative vision and photographic skills were shaped by years of experience as a staff photojournalist at major newspapers including the *Chicago Tribune* (1993–1994), the *Virginian Pilot* (1995–1998) and the *Dallas Morning News* (1998–2004). Now, he is focused on rocking the wedding world with innovative projects and new ideas. He is the founder of the Foundation Workshop (www.fwworkshop.com), the Foundation Workshop Forum (www.fwforum.com), and teaches the Ying Yang Workshop (www.yinyangworkshop.com). In 2005, Huy was recognized as the Wedding Photojournalists Association's (WPJA) Photographer of the Year.

Srinu and Amy Regeti (www.regetisphotography.com). The Regetis are internationally recognized for their skill in telling stories through photography. As a talented husband and wife team, they are also well known in the photography industry as motivational speakers. Their images have been featured in such magazines as *Grace Ormonde, Engaged!,* and *Virginia Bride,* as well as on ABC's *Nightline.* The Regetis operate a full-service studio located in the quaint historic town of Warrenton, Virginia, in the rolling hills outside of Washington, DC.

Dawn Shields (www.dawnshields.com). Dawn Shields is an award-winning professional photographer and studio owner who has been featured in *Rangefinder* magazine and *PDN.* She is the owner/publisher of *Metropolitan Bride* magazine and the Metropolitan Bride wedding shows—as well as a popular educator featured as a platform speaker at the national WPPI convention in 2010. She is proud to be among the prestigious photographers on Grace Ormonde's *Wedding Style* Platinum List.

Jeff Smith (www.jeffsmithphoto.com). Jeff Smith is an award-winning photographer who owns and operates two studios in Central California and is well recognized as a speaker on lighting and senior photography. He is the author of many books, including *Corrective Lighting, Posing, and Retouching for Digital Photographers* and *Jeff Smith's Lighting for Outdoor & Location Portrait Photography* (both from Amherst Media), and *Senior Contracts* (self-published).

Cherie Steinberg Cote (www.cheriefoto.com). Cherie Steinberg Cote began her photography career as a photojournalist at the *Toronto Sun,* where she had the distinction of being the first female freelance photographer. She currently lives in Los Angeles and has been published in *Grace Ormonde, Los Angeles Magazine,* and *Town & Country.* She is also a Getty Image stock photographer and an acclaimed instructor who has presented seminars to professional photographers from around the country.

Damon Tucci (www.damontucci.com). Damon Tucci holds a degree in film-making from Florida State University and worked for Disney Photographic Services, shooting at least 250 weddings a year, before opening his own studio. Damon has now photographed nearly 4000 weddings, and seeks to hone his methods every time. An award-winning photographer who has been featured in numerous bridal and photography magazines, Damon is an eager pioneer in wedding photography techniques who is always willing to share his insights with his fellow professionals. He is the author of *Step-by-Step Wedding Photography* from Amherst Media.

Riccis Valladares (www.riccisvalladares.com). Riccis Valladares is a fine-art and documentary wedding photographer whose work is regularly commissioned by clients across the world. His work has garnered honors in WPPI competitions and is regularly featured in top industry and bridal publications, such as *Rangefinder, Inside Weddings, Martha Stewart Weddings,* and *The Knot*—and even on television shows, such as WE's *Platinum Weddings.*

Marc Weisberg (www.mwphoto.net). Marc Weisberg holds a degree in fine art and photography from UC–Irvine and also attended the School of Visual Arts in New York City. His studio in Newport Beach, California, specializes in wedding, portrait, and commercial photography but also photographs editorial and fashion work on a regular basis. Marc's images have earned more than a dozen national and international awards and have been featured in numerous magazines, including *Riviera, Los Angeles Confidential, The Knot, Ceremony,* and *Rangefinder.*

Jeffrey and Julia Woods (www.portraitlife.com). Jeffrey and Julia Woods are award-winning wedding and portrait photographers who work as a team. They operate a successful

wedding and portrait studio specializing in highly personalized images that reflect the unique tastes and experiences of each client. Their elegant portraits have been featured in *Rangefinder* magazine and in numerous photography books. In addition, their acclaimed marketing strategies have become the basis for a successful educational program for professional photographers, which they run out of their studio in Washington, Illinois. They were awarded WPPI's Best Wedding Album of the Year for 2002 and 2003, eight Fuji Masterpiece Awards, six Kodak Gallery Awards, and two Kodak Gallery Elite Awards.

Bibliographical References

1. Bell, Marcus. *Master's Guide to Wedding Photography: Capturing Unforgettable Moments and Lasting Impressions* (Amherst Media, 2007); page 59.
2. Ferro, Rick. *Wedding Photography: Creative Techniques for Lighting, Posing, and Marketing, Third Edition* (Amherst Media, 2005); page 48.
3. Perkins, Michelle. "A Date for Three with Riccis Valladares" (*Rangefinder*, April 2008).
4. Jeff Smith. *Posing for Portrait Photography: A Head-to-Toe Guide* (Amherst Media, 2004); page 41.
5. Bell, Marcus. *Master's Guide to Wedding Photography: Capturing Unforgettable Moments and Lasting Impressions* (Amherst Media, 2007); page 78.
6. Perkins, Michelle. "A Date for Three with Riccis Valladares" (*Rangefinder*, April, 2008).
7. Box, Doug. *Doug Box's Guide to Posing for Portrait Photographers* (Amherst Media, 2009); page 24.
8. Dorr, Tracy. *Advanced Wedding Photojournalism: Techniques for Professional Digital Photographers* (Amherst Media, 2010); page 27.
9. Perkins, Michelle. *Professional Portrait Posing: Techniques and Images from Master Photographers* (Amherst Media, 2007); page 10.
10. Ferro, Rick. *Wedding Photography: Creative Techniques for Lighting, Posing, and Marketing, Third Edition* (Amherst Media, 2005); page 46.
11. Perkins, Michelle. "Dawn Shields: Love in the Heartland" (*Rangefinder*, February 2009).
12. Perkins, Michelle. *Professional Portrait Posing: Techniques and Images from Master Photographers* (Amherst Media, 2007); page 111.
13. Ferro, Rick. *Wedding Photography: Creative Techniques for Lighting, Posing, and Marketing, Third Edition* (Amherst Media, 2005); page 64.
14. Tucci, Damon. *Step-by-Step Wedding Photography: Techniques for Professional Photographers* (Amherst Media, 2009); page 98.
15. Kubota, Kevin. *Digital Photography Boot Camp: A Step-by-Step Guide for Professional Wedding and Portrait Photographers, Second Edition* (Amherst Media, 2009); page 11.
16. Hawkins, Kathleen. *The Kathleen Hawkins Guide to Sales and Marketing for Professional Photographers* (Amherst Media, 2008); page 62.
17. Ferro, Rick. *Wedding Photography: Creative Techniques for Lighting, Posing, and Marketing, Third Edition* (Amherst Media, 2005); page 46.
18. Perkins, Michelle. "Huy Nguyen: Defying the Norm" (*Rangefinder*, March, 2007).
14. Tucci, Damon. *Step-by-Step Wedding Photography: Techniques for Professional Photographers* (Amherst Media, 2009); pages 32–33.
20. Ferro, Rick. *Wedding Photography: Creative Techniques for Lighting, Posing, and Marketing, Third Edition* (Amherst Media, 2005); page 46.
21. Perkins, Michelle. "A Date for Three with Riccis Valladares" (*Rangefinder*, April, 2008).
22. Chen, Mark. *Creative Wedding Album Design with Adobe® Photoshop®* (Amherst Media, 2010); page 20.
23. Mues, Patricia. "Kevin Jairaj: Texas Tradition" (*Rangefinder*, March 2008).
24. Bell, Marcus. *Master's Guide to Wedding Photography: Capturing Unforgettable Moments and Lasting Impressions* (Amherst Media, 2007); page 53.
25. Perkins, Michelle. *Professional Portrait Lighting: Techniques and Images from Master Photographers* (Amherst Media, 2006); page 65.
26. Box, Doug. *Doug Box's Guide to Posing for Portrait Photographers* (Amherst Media, 2009); page 8.
27. Jeff Smith. *Corrective Lighting, Posing, and Retouching for Digital Portrait Photographers, Second Edition* (Amherst Media, 2005); page 38.
28. Perkins, Michelle. "Dawn Shields: Love in the Heartland" (*Rangefinder*, February 2009).

WEDDING PHOTOGRAPHY
CREATIVE TECHNIQUES FOR LIGHTING, POSING, AND MARKETING, 3rd Ed.

Rick Ferro

Creative techniques for lighting and posing wedding portraits that will set your work apart from the competition. Covers every phase of wedding photography. $34.95 list, 8.5x11, 128p, 125 color photos, index, order no. 1649.

WEDDING PHOTOGRAPHY WITH ADOBE® PHOTOSHOP®

Rick Ferro and Deborah Lynn Ferro

Get the skills you need to make your images look their best, add artistic effects, and boost your wedding photography sales with savvy marketing ideas. $34.95 list, 8.5x11, 128p, 100 color images, index, order no. 1753.

MASTER'S GUIDE TO WEDDING PHOTOGRAPHY
CAPTURING UNFORGETTABLE MOMENTS AND LASTING IMPRESSIONS

Marcus Bell

Learn to capture the unique energy and mood of each wedding and build a lifelong client relationship. $34.95 list, 8.5x11, 128p, 200 color photos, index, order no. 1832.

ADVANCED WEDDING PHOTOJOURNALISM

Tracy Dorr

Tracy Dorr charts a path to a new creative mindset, showing you how to get better tuned in to a wedding's events and participants so you're poised to capture outstanding, emotional images. $34.95 list, 8.5x11, 128p, 200 color images, index, order no. 1915.

PROFESSIONAL SECRETS OF WEDDING PHOTOGRAPHY, 2nd Ed.

Douglas Allen Box

Top-quality portraits are analyzed to teach you the art of professional wedding portraiture. Lighting diagrams, posing information, and technical specs are included for every image. $29.95 list, 8.5x11, 128p, 80 color photos, order no. 1658.

PROFESSIONAL TECHNIQUES FOR
DIGITAL WEDDING PHOTOGRAPHY, 2nd Ed.

Jeff Hawkins and Kathleen Hawkins

From selecting equipment, to marketing, to building a digital workflow, this book teaches how to make digital work for you. $34.95 list, 8.5x11, 128p, 85 color images, order no. 1735.

DIGITAL PHOTOGRAPHY BOOT CAMP, 2nd Ed.

Kevin Kubota

This popular book based on Kevin Kubota's sellout workshop series is now fully updated with techniques for Adobe Photoshop and Lightroom. It's a down-and-dirty, step-by-step course for professionals! $34.95 list, 8.5x11, 128p, 220 color images, index, order no. 1873.

CORRECTIVE LIGHTING, POSING & RETOUCHING FOR
DIGITAL PORTRAIT PHOTOGRAPHERS, 2nd Ed.

Jeff Smith

Learn to make every client look his or her best by using lighting and posing to conceal real or imagined flaws—from baldness, to acne, to figure flaws. $34.95 list, 8.5x11, 120p, 150 color photos, order no. 1711.

STEP-BY-STEP WEDDING PHOTOGRAPHY

Damon Tucci

Deliver the top-quality images that your clients demand with the tips in this essential book. Tucci shows you how to become more creative, more efficient, and more successful. $34.95 list, 8.5x11, 128p, 175 color images, index, order no. 1868.

DOUG BOX'S
GUIDE TO POSING
FOR PORTRAIT PHOTOGRAPHERS

Based on Doug Box's popular workshops for professional photographers, this visually intensive book allows you to quickly master the skills needed to pose men, women, children, and groups. $34.95 list, 8.5x11, 128p, 200 color images, index, order no. 1878.

500 POSES FOR PHOTOGRAPHING WOMEN

Michelle Perkins

A vast assortment of inspiring images, from head-and-shoulders to full-length portraits, and classic to contemporary styles—perfect for when you need a little shot of inspiration to create a new pose. $34.95 list, 8.5x11, 128p, 500 color images, order no. 1879.

MASTER LIGHTING GUIDE
FOR WEDDING PHOTOGRAPHERS

Bill Hurter

Capture perfect lighting quickly and easily at the ceremony and reception—indoors and out. Includes tips from the pros for lighting individuals, couples, and groups. $34.95 list, 8.5x11, 128p, 200 color photos, index, order no. 1852.

50 LIGHTING SETUPS FOR PORTRAIT PHOTOGRAPHERS

Steven H. Begleiter

Filled with unique portraits and lighting diagrams, plus the "recipe" for creating each one, this book is an indispensible resource you'll rely on for a wide range of portrait situations and subjects. $34.95 list, 8.5x11, 128p, 150 color images and diagrams, index, order no. 1872.

PROFESSIONAL WEDDING PHOTOGRAPHY

Lou Jacobs Jr.

Jacobs explores techniques and images from over a dozen top professional wedding photographers in this revealing book, taking you behind the scenes and into the minds of the masters. $34.95 list, 8.5x11, 128p, 175 color images, index, order no. 2004.

THE ART OF CHILDREN'S PORTRAIT PHOTOGRAPHY

Tamara Lackey

Learn how to create images that are focused on emotion, relationships, and storytelling. Lackey shows you how to engage children, conduct fun and efficient sessions, and deliver images that parents will cherish. $34.95 list, 8.5x11, 128p, 240 color images, index, order no. 1870.

SCULPTING WITH LIGHT

Allison Earnest

Learn how to design the lighting effect that will best flatter your subject. Studio and location lighting setups are covered in detail with an assortment of helpful variations provided for each shot. $34.95 list, 8.5x11, 128p, 175 color images, diagrams, index, order no. 1867.

JEFF SMITH'S GUIDE TO HEAD AND SHOULDERS PORTRAIT PHOTOGRAPHY

Jeff Smith shows you how to make head and shoulders portraits a more creative and lucrative part of your business—whether in the studio or on location. $34.95 list, 8.5x11, 128p, 200 color images, index, order no. 1886.

PROFESSIONAL PORTRAIT LIGHTING
TECHNIQUES AND IMAGES FROM MASTER PHOTOGRAPHERS

Michelle Perkins

Get a behind-the-scenes look at the lighting techniques employed by the world's top portrait photographers. $34.95 list, 8.5x11, 128p, 200 color photos, index, order no. 2000.

PROFESSIONAL PORTRAIT POSING
TECHNIQUES AND IMAGES FROM MASTER PHOTOGRAPHERS

Michelle Perkins

Learn how master photographers pose subjects to create unforgettable images. $34.95 list, 8.5x11, 128p, 175 color images, index, order no. 2002.